D1033916

The Arnold and Caroline Rose Monograph Series
of the American Sociological Association

Different worlds

For other titles in the series, turn to p. 207

Different worlds

A sociological study of taste, choice and success in art

Liah Greenfeld

Harvard University

The right of the
University of Cambridge
to print and sell
all manner of books
was granted by
Henry VIII in 1534.
The University has printed
and published continuously
since 1584.

Cambridge University Press

Cambridge

New York New Rochelle Melbourne Sydney

Published by the Press Syndicate of the University of Cambridge
The Pitt Building, Trumpington Street, Cambridge CB2 1RP
32 East 57th Street, New York, NY 10022, USA
10 Stamford Road, Oakleigh, Melbourne 3166, Australia

First published 1989

Printed in Great Britain by
Redwood Burn Limited, Trowbridge Wiltshire

British Library cataloguing in publication data

Greenfeld, Liah
Different worlds: a sociological study
of taste, choice and success in art. –
(The Arnold and Caroline Rose monograph
series of the American Sociological
Association).
1. Israeli paintings. Sociological
perspectives
I. Title II. Series
306′.47

Library of Congress cataloguing in publication data

Greenfeld, Liah.
Different worlds.
(The Arnold and Caroline Rose monograph series of
the American Sociological Association)
Bibliography.
1. Art and society – Israel. 2. Art, Israeli –
themes, motives. I. Title. II. Series.
N72.S6G74 1989 306′.47′095694 88–11901

ISBN 0 521 36064 1

RB

*To the memory
of Joseph Ben-David*

Contents

Introduction

This book is a sociological study of stylistic changes, patterns of success, judgment and taste in two art worlds: the world of abstract avant-garde art, and the world of figurative painting, which is aesthetically traditional. The two art worlds are the two subsystems in the social structure of Israeli painting. This case-study in the sociology of art is meant for anyone interested in culture and society.

Sociology of art may have two orientations. On the one hand, one can use sociology to deepen one's understanding of art; on the other hand, art can be used in order to add to one's understanding of social reality. It is the second orientation which lies at the basis of this book.

Art is, of course, a social phenomenon. Besides being a product of a specific activity, it is, at any given time, this activity itself, patterned and performed by people assuming certain roles and acting in the framework of certain norms and expectations, which is related to a certain set of values. This amounts to a definition of a social institution. Being a social institution, art is as good a subject for the study of society as any other social institution – say the family, or science. But, like these, it is also a social institution *sui generis*, and is, therefore, more suitable for some studies and less suitable for others. The nature of its specificity will not concern us here (this subject demands more than a few passing remarks); suffice it to say that art is a cultural institution which is explicitly concerned with the production and manipulation of symbols.

All human social relations are intrinsically symbolic. The specificity of human societies, as we have recognized at least since Weber, consists in that these societies are also, by necessity, cultures. Created culture, a human artifact, performs for us the function which instincts perform for other species. Systems of symbols vary, and societies are shaped in accordance with this variation. I do not want to imply that culture is the only factor in the formation of specific social systems; various structural conditions, that is the non-symbolic parameters of situations, environmental and economic, undoubtedly contribute to this too. But one cannot deny the extraordinary

importance of the symbolic sphere in this context, without at the same time severely limiting the significance and the scope of applicability of one's sociological explanations.

Being explicitly concerned with the production and manipulation of symbols, art is in fact a better subject for the study of the immensely important sociological problem of the effects of values in social systems than many other social phenomena, which, on the face of it, may look more "sociological." Furthermore, even among the symbol-producing institutions, art has important research advantages over some of the better-studied ones, such as science. Sociology of science is, probably, the best-developed area in the sociology of culture. Unlike the sociology of art, it can boast of a distinguished tradition built by several generations of scholars, which can serve as a foundation for further research. Yet, science only rarely provides us with a possibility to study ways in which socially significant symbols, values and norms, are produced, as well as to observe the variation in the effects they may have on social structures among, and behavior of, people adopting them. The symbols produced in it have, for the most part, only scientific significance (although they may, of course, have social implications). The social values of science are the same for different scientific disciplines, sciences of different societies and periods. One can be more or less optimistic as to the nature of truth and the possibilities for objective knowledge, but there is a consensus that, however realistic such an orientation, science is *about* the understanding of empirical reality. Sociologically speaking, there is one science; this is why, for most ears, expressions like "bourgeois biology" or "Aryan physics" sound absurd. And because of this uniformity of social values, science is not well suited for the study of socially significant symbols.

The symbolic structure of art is infinitely more variable than that of science. In art, socially significant symbols vary together with aesthetically significant ones. Different values and norms correspond to every artistic style and, in fact, enter its very definition. In most cases, one can separate what is aesthetically significant from what is socially significant in a style only with great difficulty. Every style, unlike a scientific theory or even a subdiscipline, is a social institution in itself, and each one offers us a possibility to study the crucial interactions between culture and social behavior. Of course, art is not the only such phenomenon; political ideologies, religion and law, for example, may provide similar possibilities. But then, art is a convenient subject for explorations of this nature, in which significant comparisons are readily available and which, not being directly involved in

the bread-and-butter matters of the world, evolves relatively unimpeded by exigencies which more "serious" phenomena constantly encounter, and provides better possibilities for analytical isolation of important variables.

I hope it is possible to discern, behind the analysis of the case chosen here – namely, the social system of the art of painting in Israel – issues preoccupying sociologists of any area. These are: the effects of *anomie* and possibilities for charismatic leadership; the conditions for and structural effects of rational versus "social" (namely, determined by social influences)[1] behavior; the implications of these essentially different types of conduct on the part of the non-elites for the nature of the complementary elites and their attitudes towards the led. Another set of issues of general sociological interest concerns the nature and social determinants of creativity and freedom: the structural conditions of innovation and their effect within different ideological frameworks on its character.

The central problem of the book is a Weberian one of the interaction between different systems of values (or ideologies broadly defined) and social structures, and of the effects of these ideologies on the structures and on the social behavior of people acting within them. It is concerned with the social implications of, on the one hand, ideologies which treat conflicting sets of values as equal, precluding the formation of commitment to any one of them and, on the other hand, of ideologies in themselves representing a commitment to one or another set of values.

The specific aim of the book is to arrive at a theoretical framework necessary for the systematic explanation of artistic careers and factors in the formation of sets of preferences, or taste, in art. With this target in mind it depicts a *complete* system in which art is created and evaluated, taking into account its artists, "gatekeepers" (such as curators, critics and dealers, who mediate between artists and the public), government officials responsible for the allocation of government support for art and the public of this art. The relatively small scale of Israeli society made it technically possible to investigate an entire, largely self-sufficient, modern art world – an undertaking that would certainly be unrealistic in any of today's major art centers. The unusual history of the Israeli art world, as the reader will see, provided a unique possibility of isolating the social system which supported avant-garde art from the one formed around figurative painting. This, combined with the similarity, if not identity, between the styles developed in other Western nations, such as France or the United States, and in Israel (the art history of which represents in a compressed form the general history of Western art in the last 120 years) justified the sometimes implicit treatment of the two

Israeli art worlds as ideal-types of the social structures corresponding to abstract avant-garde and figurative styles, and their use as a basis for theoretical generalizations.

At the basis of the theoretical framework suggested here lies the assumption that art worlds connected to different styles – and therefore different artistic ideologies – may differ radically both in terms of the factors that affect the formation of taste, the process of evaluation and patterns of success in them, and in terms of the nature of the influence these factors exert. The art worlds differ in accordance with the variation in the value-systems guiding both the production and the consumption of art, namely in artistic ideologies and outlooks or perspectives of the public. The difference can be expected to be especially significant if in one case the values make possible rational action, while in another they are conducive to "social," or charismatic, behavior. Rational action is here defined as behavior consisting of choices between alternative paths of action, made by individual actors on the basis of their knowledge. This is, in essence, individual action. "Social" action, in distinction, is such in which acts of the individuals are acts of compliance with social influence. The significant (and independent) actor in this case is the group. A predisposition to "social" behavior seems to be a necessary condition for the emergence of structures of charismatic authority, and thus is characteristic of followers of the charismatic leaders. For this reason, and also to avoid confusion (since the word "social" will be frequently used in this book in other meanings), we may sometimes refer to expressions of "social" action as "charismatic."

More precisely, the argument is guided by the following considerations. The rationality of the public is expressed in the ability of its members to provide reasons for their decisions concerning acceptance or rejection of works of art, which they derive from a system of criteria for the evaluation of, or relatively definite requirements towards, such works. When the public can be characterized as rational, the artists addressing such a public are accountable to it, since without meeting the requirements of the public, they cannot succeed; the public will not sustain them. The judgment of the public represents an important factor in the determination of the artists' success. The system of criteria is provided, however, at least in part, by the artists themselves, by the artistic ideology.

In contrast, when the behavior of the public is "social," when the public searches for and willingly submits to charismatic leadership in art – it will lack definite requirements towards artistic performance. Therefore, artists will not be responsible to their public, the judgment of the public will not be independent and artists themselves will to a great degree determine their

own success. The nature of this determination will depend on whether the artistic ideology corresponds, or does not correspond, to the predisposition of the public, namely on whether it too is or is not conducive to "social" behavior.

The behavior of the public will affect:

a The activity of the "gatekeepers." In the case of the rationally behaving public, "gatekeepers" will have to take the opinion of the public into consideration while making decisions concerning promotion or rejection of artists. The opinion of the public in search of charismatic leadership will not be considered; instead, the preferences of the "gatekeepers" will be forced upon it.

b Patterns of success and career routes of the artists. We would expect to find elements of competition in the careers of artists appealing to the rationally behaving public, for their success depends upon answering the public's requirements and these can be answered in a more as well as in a less satisfactory fashion. The artists' careers, in this case, would fit the model of "contest mobility." In contrast, a public, whose behavior is "social" or charismatic, in itself has no effect on the artists' careers; it serves merely as a condition making possible almost anything in this regard. At the same time, when such behavior on the part of the public is combined with an artistic ideology also conducive to "social" behavior, we would expect that the elements of competition among the artists will be absent and that, instead, their success will depend upon the identification with and the affiliation with an elite artistic group. In this case, the artists' careers would approximate the model of "sponsored mobility."

c The nature of artistic production. The behavior of the public will reinforce tendencies present in the artistic ideologies of a corresponding nature. In the presence of a public possessing relatively definite criteria for artistic performance, we would expect the success of styles conceiving art as endowed with objective meaning. We would also expect that in such a case emphasis will be on the individual work of art to embody this meaning. In the presence of a public searching for charismatic leadership in art, we expect a dramatization of the artist's personality expressed not in an individual artistic work, but in other forms of activity, and the success of styles in which art is regarded as having a subjective meaning only.

The interplay between the behavior of the public and artistic ideology is complex and cannot be described in terms of an unchanging causal connection. Both serve as necessary conditions for each other, with the rational public playing a more active role than the charismatic one, and "charismatic" artistic ideology having much more influence on its public, than the

"rational" one. The reason for the rationality of the public's outlook and behavior versus its longing for charismatic leadership – apart from the availability or lack of evaluation criteria in corresponding artistic ideologies – we expect to find in differing social backgrounds of people belonging to the two publics.

A few words on the data and the organization of the book are in order here. The data necessary to answer the questions posed in this book were collected in the following manner:

1 Biographies of all (477) Israeli painters who lived, worked and achieved at least minimal recognition in Israel between 1920 and 1980 were analyzed. These biographies are kept in the Israeli Art Archives of the Israel Museum in Jerusalem. Painters were classified according to the forms of training (school, apprenticeship), prizes, gallery shows, exhibitions in museums, length of career routes (short–long), the share of painting in the overall income of a painter and the style in the framework of which the painter worked. The subject's style was defined as the style in which the artist worked at the time of his or her first success (whether an exhibition in a gallery, a show in a museum or a prize). However, changes of style in the course of a career in this population were so rare, that it is possible to disregard them. Painters were also classified according to their output, the frequency of exhibitions and the prices of paintings, as well as according to the sequences of successes in the course of a career: the character of the first exhibition, whether it was abroad, in a museum, in a gallery, in which type of a museum or a gallery it was, whether an exhibition was preceded by a prize, what kind of prize. These data made possible the depiction of the patterns of success, career routes and the factors affecting success of artists.

2 Thirty-one painters considered to be the most prominent representatives of their respective styles were interviewed in open interviews. Sixteen of the painters were representatives of the abstract styles, while fifteen others represented figurative painting (for classification of styles see chapter 2, pp. 42–44). These interviews were made in order to obtain information about professional ideologies of different styles and about their characteristic conceptions of the functions of art and artists. In addition, the interviews with artists helped to illustrate and refine by concrete examples the picture emerging from the analysis of the painters' biographies.[2]

3 Articles and reviews dealing with group exhibitions in daily newspapers since 1950 were surveyed for the purpose of constructing a picture of the aesthetic "spirit of the age" and its changes. 1950 was chosen as a starting point, because before that date the data were scarce. The following news-

papers were surveyed: *Haaretz, LaMerchav, Zemanim, Heruth, Haboker, Yedioth Ahronoth, Maariv, Davar, Hazofe, Masa, Mevooth, Al Hamish-mar, Jerusalem Post*, as well as local newspapers of the central cities, such as *Haifa Haovedeth* and *Hadashot Tel-Aviv – Jaffo*. These materials were also placed at my disposal by the Israeli Art Archives of the Israel Museum.

4 Twenty art critics (representing the entire population of critics writing in Hebrew who were active in 1980) and ten curators (including all the head curators and curators of Israeli art at the three central museums, as well as curators of international exhibitions, appointed by public institutions) were interviewed in open interviews. Open interviews were also conducted with fifty-seven art dealers – owners of private galleries. During the period of the research the Israeli Association of Gallery Owners listed sixty-four galleries. It was intended to interview every one one of the owners. For various reasons, such as the absence of a number of dealers from Israel and the lack of technical possibility to arrange a meeting with three galleries in Beer-Sheva, only fifty-six were interviewed. The owner of the only gallery which was not a member of the association (he considered it a useless body) was also interviewed.[3]

5 Open interviews were conducted with spectators at the show openings, which took place during the exhibition season of 1979–1980 (400 inter-views), and with the relevant officials of the Ministry of Education and Culture. These interviews were undertaken in order to investigate the patterns of judgment characteristic of the publics of different styles and to assess socio-economic characteristics of these publics.[4]

6 In order to follow the developments in the exhibition opportunities, exhibition-forums (private as well as public) that were active during any period between 1940 and 1978 were counted. The data for this purpose were obtained mainly from the biographies of the painters and the survey of daily newspapers. However, literature dealing with Israeli painting and pro-fessional journals (referred to in the next article) were also helpful.

7 Selected catalogues, in most cases including manifestos of different artistic groups, of exhibitions held in Artists' Houses and museums, as well as professional journals (such as *Gazit* – the oldest of the art journals in Israel, *Painting and Sculpture, The World of Art* and *Line* – all in Hebrew) and the secondary literature discussing Israeli painting helped to obtain some general notion about the course of Israeli art: the sequence of events and the appearance of styles. The secondary literature on this subject consisted of little more than a handful of picture albums, supplemented with a few lines of biographical material and short introductions locating the artists included in them in Israeli art. Two detailed monographs on the

history of Israeli art appeared in 1980. One is a book by G. Efrat and D. Levite, edited by B. Tammuz, *The Story of Israeli Art*. It is a lengthy and accurate account (although manifesting a clear ideological bias) of the stylistic developments in Israeli painting up to 1980. The other is a book by G. Blas, dedicated to the history of "New Horizons" and bearing the name of this group. (Both works were written in Hebrew.)

Before the publication of these histories there existed only two general historical articles (both in Hebrew), short summaries of the developments in Israeli painting up to the date of their publication. The one is "Painting and sculpture in Israel: artistic creation in Palestine during the last 50 years," by Haim Gamzu, published in 1957.[5] The other is Jonah Fisher's "Painting," which appeared in the book *Israeli Art*, edited by B. Tammuz and published in 1963. In addition, there was a book by Karl Schwartz: *New Jewish Art in Palestine*, published in 1941.

The information gained in this way was supplemented by interviews with people who had lived through this history for many years[6] and by the original research of developments in the art market and exhibition-forums. The resulting historical picture furnished a background for the sociological analysis of the contemporary art world.

The three sections of the first chapter of the book are devoted to this historical background and attempt to explain why and how two different social systems emerged in the Israeli art world. They are followed by chapters devoted to each of the factors related to the production and consumption of the art of painting in Israel. Several chapters (2, 3, 7 and 8) deal with artists: their demographic characteristics, career routes and patterns of success, as well as their conceptions of art and definitions of the artist's role. Other chapters (4, 5 and 6) are devoted to various "gate-keepers," art critics, curators and art dealers: the way they function, the bases of their judgment and the patterns of decision-making characteristic of them, their definitions of their roles and their attitudes towards the artists, on the one hand, and the public, on the other. Chapter 9 deals with the publics of different styles (including the officials of the Ministry of Education and Culture); it discusses the forms of art consumption and patterns of judgment characteristic of these publics. The focus of the concluding chapter is the general picture which emerges on the basis of the juxtaposition of the separate descriptions and analyses of each of these factors. The analysis of all the factors of this complex system and the conclusions derived from it make possible the formulation of some general theoretical suggestions which, it is hoped, will be of interest to students of culture, whatever the specific area they choose to study.

1 Historical background

The pre-State period: intelligible art

The history of Israeli painting begins with the establishment of the Bezalel
art school in Jerusalem in 1906. Since this time Israeli art has undergone
many important changes. In seventy years the artists of this country tra-
versed a path which in other countries lasted twice that time. This pace
resulted in the simultaneous existence of numerous styles which developed
side by side in a relatively small place. All these styles were imported to
Israel; none was indigenous. At most the subjects took on local shades. In
the majority of cases, when a certain style appeared in Israel and was
beginning to spread there, it usually already ruled abroad. However, differ-
ent styles which exist in Israel today were not accepted simultaneously. The
order of their appearance, roughly parallel to the sequence of their emer-
gence abroad, was among other things, an expression of the changing
relationship between art and society in Israel and of the place and role of the
artist in this society.

Bezalel gave its name to the first style of Israeli art. Its chief characteristic
was academic Naturalism or Realism which incorporated the elements of
German Jugendstil and oriental ornamentics. The ideology it was based on
required unity between the artist and the ideals of his people, which ex-
plained its main subjects: heroes of the Old Testament, contemporary
Jewish leadership and Holy Places in Palestine.

The activities the Bezalel school engaged in were not purely or even
primarily artistic activities. Its founder and long-time director, Boris Shatz,
was a nation-builder; he wanted to transform, or rather form, a new,
enlightened Jewish society. Bezalel was not his only creation; he was also
among the founders of the first national theater, the first orchestra, the first
choir, the Israeli society for the study of Palestine and its antiques, and
more. Before long, Bezalel was the center of cultural life and entertainment
in Jerusalem. Within its walls, alongside exhibitions, were organized sym-
posiums, delivered lectures, staged theater performances. The balls given

there were the central social event in the life of the non-religious inhabitants of the city. All these activities were fully covered by the press. In addition, Shatz, himself a plastic artist, wanted art in Israel to be economically useful. The complete title of Bezalel was Bezalel School of Artistic Crafts, and the art department was only one among thirty-two departments of the school. Bezalel patronized numerous craftsmen in Jerusalem and helped organize workshops and provide them with work. With such interests in mind, the professors in Bezalel did not consider the development of new artistic forms (or technical innovation) important, but were concerned solely with the content which they expressed through means already available.

Most of these professors were recruited by Shatz in Germany, which, at least until 1915, was also the source of financial support for the school. During the period between 1917 and 1926 the school was a recognized institution of the World Zionist Organization. From the early 1920s on, financial support of the school by the Zionist institutions rapidly diminished. In 1926 the school's workshops were transferred to private hands and in 1929 it had to close.

However, from 1920 on it was no longer the only center of visual art in Israel. A number of its students left the institution and turned to artistic values different from those which it represented. Their secession received the name of "The Revolt against Bezalel." Among the rebels were some of the now most respected "old masters" in Israel, such as Gutman, Reuven and Zaritsky. Their opposition to the school, as they later explained it, derived from two sources: (1) Bezalel was estranged from the Palestinian reality; it turned to Diaspora and drew its inspiration from abroad rather than from its immediate surroundings, (2) it explicitly preferred applied art and lacked sympathy for the new artistic trends. The art library of Bezalel was closed to the students, because Shatz believed that "young talent must be forbidden to read art books, to protect it from evil influences."[1]

The dispute between the rebelling students and Bezalel was echoed in the press of the 1920s. An observer wrote: "Bezalel is only a museum of unsuccessful efforts to revive an epoch . . . All those Magen-Davids, portraits of Yemenite Jews and lions, which can be found in Bezalel do not reflect the presence of Hebrew art in this place . . . These artists prevent themselves from seeing the new life emerging in this land, from seeing the growing National Home, the pioneer spirit . . ."[2]

These became the subjects of the representatives of the new style, created by the students of Bezalel who rebelled against it. It was named The Style of the Land of Israel. Its means were the ones forbidden within the walls of the old school; "it utilized Primitivist techniques and manifested influences of

several contemporary trends: Fauvism, Expressionism, Cubism and Abstract."[3] In other words, it stressed pure colors, accentuated contour lines, used expressionist elements and tended to abstraction.

The two trends now existed side by side. They met at annual exhibitions in *Migdal David* (David's Tower), which gave its name to this period in the history of Israeli art. The exhibitions in David's Tower were group shows. In the beginning the rebels had almost no representation there. They were excluded from the Committee of the Hebrew Artists' Association founded in 1920, which served as a jury for these exhibitions and was composed solely of the professors of the Bezalel. While the artists faithful to Bezalel principles participated in *Migdal David* shows, and exhibited in private houses in Jerusalem, the younger, rebelling artists found a forum in Tel-Aviv, where a private collector, newly arrived from Europe, organized a permanent exhibition in 1922. Among those involved in its organization and responsible for the decisions made were a committee of Bezalel professors, and the cooperative of Tel-Aviv–Jaffa artists which they formed in 1920.

Though Bezalel tradition still ruled in Jerusalem, already in 1921 negative criticisms of it appeared in the Hebrew press. And in 1924 the rebels represented the dominant style. This year only their works were exhibited in David's Tower and were positively reviewed in the press. The works by Bezalel people, entirely disregarded by the critics, were simultaneously displayed in the school building itself. Already in 1925 two of the three members of the jury for the *Migdal David* exhibitions were representatives of the Land of Israel style.

The difference between the Land of Israel artists' definition of art and that of the Bezalel painters paralleled the distinction between the Hebrew versus Jewish national self-definitions. The representatives of the new style saw themselves as the direct descendants of the Ancient Israel and the inheritors of its heroic tradition; they deliberately skipped over the long years of the European Jewish history. One of them wrote: "In Arab coachmen I saw a direct line of expression, the appearance of our Biblical heroes . . . I loved these Arabs more than the characters of Sholom-Aleichem."[4]

The frames of reference of the two styles were different, but both of them could well be defined as "art in the service of society." Like its predecessor, The Style of the Land of Israel tried to adapt itself to the ideals of a certain collectivity and to express these ideals; its representatives perceived themselves as participants in the general pioneer effort. The social involvement of the Land of Israel artists was expressed in the Tent (*Haohel*) shows during the years 1926–1928, with the opening of which the center of the style moved from Jerusalem to Tel-Aviv. The Tent was a dramatic studio, and the

curator for the shows was an actor. The management of the studio endorsed
the manifesto issued by the first group of painters (who now called them-
selves The Group of Modern Artists) on the occasion of the show's opening
in 1926. The manifesto urged to see visual art as just a part of a larger cultural
entity. It said:

Palestine is a point of a territorial and spiritual concentration. Slowly the creative
forces of the Hebrew people gather here, in all their manifestations. The new volition
is being born, efforts and searches . . . The "Tent" is willing to create a platform,
which will be the undiversified concentration of all the manifestations of the creative
spirit . . . so that they will join in a unified expression upon the same platform, the
platform of the masses.[5]

We read elsewhere: "The Tent regarded itself a representative of the
working-class culture, not in the narrow meaning of a certain art, but in the
sense of expressing the ethos of the working class."[6]

Before long the controversy between Bezalel and the style of the Land of
Israel became history. These two styles still existed in the 1930s, but two
additional styles appeared and vied for the hegemony on the Israeli art
scene. These were two varieties of Expressionism: German Expressionism,
imported to Palestine by immigrants from Germany – in Jerusalem; and
French Expressionism – in Tel-Aviv. French Expressionism was preferred
by artists either born or at least educated in Palestine. Therefore, it was in
part an indigenous growth, in sympathy with different Impressionist and
Post-Impressionist tendencies. Its characteristic was a new emphasis on
color which became the most important element in a painting, while the
story, the depicted object, was assigned a secondary place. The signs of this
new style already appeared in the Tent shows in the mid twenties when some
artists (including a rebel against Bezalel and a representative of the Land of
Israel style, Joseph Zaritsky, who was yet to play a major role in the
development of Israeli art) accentuated technical elements in their work
"with no concessions to the ideological aspects."[7] They opposed the Land of
Israel style because they claimed it represented the art of "immigrants from
Eastern Europe, who tried their best and gave birth to saccharine orien-
talism in hope that they would bring salvation to this country by means of
their original paintings."[8] However, although the object of painting in their
case served solely the purpose of providing material for technical exercises,
it is worth emphasizing that nevertheless their art was still "intelligible";
namely, this was still figurative art which presented no difficulties in identifi-
cation of the objects.

Paris was the Mecca of these artists. Many of them went to Paris, lived

there for a while and, upon their return, became the focus of everyone's attention. These voyages, characteristic of the 1930s, had the nature of a "mass pilgrimage"[9] and contributed to the spread of French influences. Three artists (Frankel, Steimatsky and Zaritsky, the future leader of Israeli avant-garde) formed studios in Tel-Aviv which were the first institutions of art training in Israel outside Bezalel. The students in these studios used reproductions of contemporary, or in any case, "modern," Post-Impressionist French artists as their models, and were encouraged to study in France. Zaritsky, however, did not do this himself.

Going to France was considered essential by many artists because no art, besides the exhibitions of the same few local painters, could be seen in Palestine. Original collections did not exist yet, and even reproductions were very rare. Yet, in the thirties the ranks of Israeli painters already included people who were born in Palestine, and who, therefore, lacked the cultural opportunities of the immigrants.

However, this situation was already changing. In the beginning of the 1930s the first art journal was founded by a former Dadaist, Gabriel Talpir, an enthusiastic admirer of modern art; and the first museum of art – the Tel-Aviv Museum – was opened with the explicit goal "to develop people's sensitivity to Beauty." It was not partisan. The first three exhibitions held there presented the works by a French Expressionist, a representative of the Land of Israel style, and by Boris Shatz, the founder of Bezalel. Not everyone was satisfied with this policy. Zaritsky wrote: "The Tel-Aviv Museum is an unsuccessful imitation of 'Bezalel.' There is such a chaos around some 2–3 paintings in the Tel-Aviv Museum, that it is impossible to see even these 2–3 miserable paintings."[10] Other painters refused to exhibit in the general shows held in the museum, because every painter who was a member of the Artists' Association could participate in them (and at that time everyone was, or could and was likely to be, a member).

Many artists influenced by modern French trends exhibited in the Tel-Aviv Museum general shows, or held one-man exhibitions there. They also exhibited in the first private gallery in Tel-Aviv and soon became an accepted and even banal part of the local artistic scenery. The Paris influences continued to be felt through all of the 1930s and early 1940s. But already in 1932 works manifesting these influences were criticized as expressions of "Francomania" and were compared to "meaningless jabber about the peculiar Israeli light,"[11] a conventional accusation against the now outdated Style of the Land of Israel. A representative of the new Group of Modern Artists (the French Expressionists also adopted this title in due course) answered to this criticism: "As to the influences from France – the center of

all art – the group announces, that it wants it, for the acceptance of an influence and learning is the way to culture, and without influence there is no creation, particularly creation which is independent and original."[12]

The important innovation brought by the French influences into Israeli art was the focus on the intra-artistic, technical problems and the estrangement of the artists from the general social questions, central to the life of the Jewish settlement. What engaged the artists of this trend was not the expression of diverse social values, but the exploration of artistic–technical possibilities for their own sake.

All this, however, was in Tel-Aviv. The Jerusalem art world, at the same time, was dominated by German Expressionism. The difference between the two kinds of Expressionism was great. German Expressionism was deeply concerned with social and human issues; its characteristic features, the twisting of shapes and use of bright colors, were the means to express these concerns. There was no common language between the representatives of the two styles. One of the German Expressionists remembered: "Painters, immigrants from Germany were not welcomed by the Palestinian artists. The former, who did not submit to the order of the French Post-Impressionism were accused of coldness. They did not receive prizes either . . ."[13] Bezalel, the administrative management of which always was in close contact with Berlin, became the center of absorption for the representatives of the German school. The new Bezalel, opened in 1935 (after being closed since 1929) was "purely German Bezalel."[14] Some of the German Expressionists are still teaching in the school.

These artists' definition of their activity differed greatly from that of their Tel-Avivian contemporaries and colleagues, but had much in common with earlier definitions of the Bezalel style and the Land of Israel style. Like these two, the German Expressionists adhered to the idea of "art for the sake of life."

The representatives of this trend came from Germany in a difficult and tragic period. Many of them left their brushes for years and only towards the 1940s returned to painting as their main occupation again. They exhibited in Bezalel and in private galleries, three in Jerusalem and one in Tel-Aviv, opened during these years by German immigrants.

As if the appearance of four different schools of painting in the course of thirty years was not enough, already in the beginning of the 1940s new trends were emerging in Palestine. A group of artists and poets organized "to encourage the culture of the Motherland, based on the national Hebrew revival, nursed by the authentic values of this land, and to spread this culture among all those who inhabit this country."[15] These aspirations, responsible

for the name of the trend, Canaanic Art, deeply influenced the art of many important artists inside as well as outside the group. The Canaanic ideology in art was expressed in the choice of objects related to the ancient history of the Middle East (from Nile to the Euphrates) and by the use of elements of Assyrian, Accadian, Shumeric and Canaanic Arts. This trend reached its height at the end of the 1940s and fell into decay during the period immediately following. A number of its former members became its most aggressive critics, several others moved to the New Horizons, which, as regards its orientation, as we shall see later, presented an exact antithesis to the based upon a firm ideological basis Canaanic Art.

There are several sociologically intriguing points in the history of Israeli art during the pre-State period. First, all the styles which appeared in Palestine at that time were styles "intelligible" to the spectator: the point of departure in a painting was a recognizable object. All the styles were embedded in certain values expressed in the works of art; in other words they possessed professional ideologies which included answers to such questions as "What is the purpose of art?," "What is good art?" With the exception of the French Expressionist trend, in which the technical elements of the execution were primary and in which, therefore, the question of how something is painted was prior to the question of what is depicted, the ideologies that provided bases for other styles were clearly social in character. These social ideologies were integrally related to and were determining factors in the artists' professional ideologies, or scales of preferences.

Secondly, every stylistic innovation, namely the appearance of every new style in Israeli art (except the case of such a passing phenomenon as Canaanic Art), was connected to the formation of a new social system, which provided the innovating artists with a "frame of reference" and supported them through the organization of exhibitions, etc. Not only specific art institutions but even cities, Jerusalem and Tel-Aviv, had different art histories. However, the social systems existing in the two places were quite similar. For example, although the German Expressionists exhibited in Jerusalem and the French Expressionists exhibited in Tel-Aviv, both exhibited in public museums and in private galleries.

From the foundation of the State to the mid 1960s: the appearance of Abstract art and the beginning of the split into subsystems

The period immediately following the foundation of the State of Israel brought with it a number of significant changes.

A new group professing a different style appeared on the stage of Israeli art with the declaration of the State. The group called itself the New Horizons. An historian relates its appearance in the following way:

There is no other group in Israeli art, the importance of which in our naturally shortsighted historical perspective is greater than the importance of "New Horizons"; and there is no other group, the influence of which on the generations of artists that came after it was so traumatic and deep. After "New Horizons" Israeli art was constantly in struggle with the principles and the style of this group – the style called "Lyrical Abstractionism." This very struggle went on within the group itself. Only de-jure did "New Horizons" adopt the principles of this style, *de-facto* it hung in the air like mere ideology till the last years of the group's existence.[16]

The group was active between 1948 and 1964. It came into being because of Zaritsky's violation of the rules of the Artists' Association, and emerged, according to an influential critic, thus:

A short time after the foundation of the State of Israel it became known to Joseph Zaritsky, then the president of the Painters' and Sculptors' Association in the country, that there was a possibility to exhibit Israeli art at the Biennale in Venice. With the help of his friends he prepared a list of artists, who were to participate in the international exhibition, without informing the members of the Association. In a special session the Association decided to remove Zaritsky from his office. Then Moshe Kastel stood up, defended Zaritsky and his choice and left the hall, calling: "Those, who are for the Lord, come with me!" The small number of artists that left with him and stopped at the cafe *Kasit* to calm down, formed the nucleus of the New Horizons group. (In a private conversation Kastel regretted that some of these artists were actually very mediocre, but the very fact of their presence during this historical moment was sufficient to convert them into "immortals.")[17]

The painters in Zaritsky's group broke with the Association and wanted to establish an independent organization. However, this wish, and these are the words of a sympathetic historian, "met with great difficulties, because of the lack of a specific ideology to justify the emergence of a separate body. Thus the ideology of the 'New Horizons' was created by the order of the hour, to satisfy an organizational need."[18]

The kernel of the ideology Zaritsky and his group adopted was Abstract art. Abstract art, declared the painters in the catalogue for their second exhibition in 1949, was "the Beauty, which corresponds to the pace of the time."[19] However, during this year only a small number of painters among the members of the group actually worked in the abstract manner. Most of them were figurative artists with certain inclinations toward Cubism. The Lyrical Abstractionism characteristic of the group in the later years of its

existence was not created by or within the group itself in response to an internal need or preference of its members for it, but was imported into the group from different sources to function as an identification symbol. Despite the lack of any meaningful difference between the members of the group and other Israeli artists during the first years of the group's existence, its borders were very clearly drawn and there were numerous expressions of "a kind of paranoia and fanaticism in everything pertaining to the uniqueness of the New Horizons."[20] Members of the group demanded, that their works be exhibited separately from the works of other artists even at the exhibitions of Israeli art that were sent abroad and frequently refused to send their works to such exhibitions at all, if painters whom they did not like, were to participate in them. In the mid 1950s they broke all of their remaining connections with the Artists' Association and finally founded a separate association. In the course of time their opposition to figurative styles, the styles in which they themselves worked for years, increased.

From the very beginning the New Horizons group defined itself and behaved like a movement of protest. We learn, however, that "although it waved the banners of revolt, and despite its efforts to be true to the image of a classical protest movement, it did not meet with any opposition on the part of the Art Establishment, the museums."[21] Its first exhibition was held in the Tel-Aviv Museum, the then Director of the Museum delivered an opening speech which – like the catalogue for this exhibition – resembled a manifesto of an underground movement. He insisted that the artists were rebels, that "they rebelled against the embalmed art and demanded from themselves and from other painters living and effervescent art instead."[22]

The New Horizons was a group of great importance for Israeli art for two different reasons. It was abstract; "it managed to finally banish the art for tourists by means of its interpretations of abstraction."[23] And it represented a new organizational structure.

The Lyrical Abstractionism of the New Horizons was a kind of *tachisme*, a free painting, focusing on the process without intending to bring it to a definite result. "There is no final conception of a work lying before the eyes of the beholder, for this conception is not important, but only happens to be one end-point among numerous possibilities of similar end-points."[24] These painters aspired to create universal painting; they opposed localism in art. On the other hand, they wanted their Abstractionism to be authentically Israeli, and the famous color-scales characteristic of the most prominent artists among them, in which the shades of blue and green predominated, derived from this.

The structure of the group could be compared to the "Renaissance

court,"[25] at the head of which stood Joseph Zaritsky, a very influential person in his time.[26] The relationship with the head of the group had a profound influence on a painter's chances of success; numerous young Abstractionists, even those active after the group ceased to exist, began their careers with participation in the exhibitions of the New Horizons.

This group not only strove to separate itself from figurative painters, but hostilities soon broke out within it as well. Since it was not an ideological group, the reasons for hostilities were not ideological but personal, usually related to disputes over authority between Joseph Zaritsky and other artists. As a result of these hostilities some important artists left the group, though they are still regarded as its members.

Many Israeli artists who never belonged to this group opposed it from the very beginning.[27] The members of the New Horizons would not agree to exhibit with other painters, while these latter thought that a group such as this, which at least in its first years lacked an ideology, had no right to make such demands. Later certain painters opposed the New Horizons insistence on the universality of art and their rejection of the local, specifically Israeli styles. Another group was founded in the 1950s on the basis of such an opposition. It was named The Group of Ten and possessed a well-defined platform. The majority of the members of this group studied in the studio headed by two prominent members of the New Horizons, but in their manifesto they wrote: "We felt the need to search for new ways of expression in art, the source of which is the Israeli scenery and people . . . we were convinced, that the estrangement from the reality around us and imitation of alien sources would bring us to dry and rigid formalism and to sterile art."[28] The exhibitions of The Group of Ten (which did not exist in its original composition but for one show), two one-man shows of the painters affiliated with it, and four exhibitions of the Kibbutz artists represented the countervailing force to the exhibitions of New Horizons.[29] One of the Ten wrote about this period: "An evil spirit descended upon numerous circles, a spirit of escape from reality and the flight to Abstraction, to cosmopolitanism . . . It is just an imitation of something which is no longer alive."[30]

The style adopted by The Group of Ten and by those close to it can be characterized as a free but figurative style, focusing upon specifically Israeli subjects, Israeli scenery and people, painted from nature, and utilizing elements of modern painting that became generally accepted. These and a number of other painters tended in the 1950s toward Socialist Realism, in the sense that their paintings were devoted to life in the new settlements and to working-class people. The center of these painters' activity was Haifa, where they organized into a Circle of Realist Painters, and many of them

were Kibbutz members. They were very few. Although they considered the creation of people's and workers' art to be their calling, the trade-union organizations disregarded them and offered them no support. Ironically, they were supported by a millionaire, a private person sympathetic to socially concerned Realist art. The New Horizons militantly opposed these painters. The hostility reached its peak, when one of the Realists, Naftali Bezem, was awarded the Dizengoff prize during the general exhibition of Israeli artists in 1957. In protest New Horizons turned to the wall all of their own works included in the show.

Toward the 1960s the character of the works of Socialist Realist artists changed. From a technical point of view they were rather far from actual Realism from the start. The change which occurred was in the choice of subjects which manifested less and less socialist but increasingly national concerns. The most common of those were the War of Independence, defense of the settlements, the Holocaust, nationally significant events from the Old Testament and Israeli history. The artists saw themselves as fighters "against the sick world" for the sake of "healthy values,"[31] a unique culture and unique Jewish painting. The choice of subjects was supplemented by a symbolic treatment of these subjects. Jewish symbols such as *menorahs*, the sacrifice of Abraham as a symbol of national tragedy, symbols of immigrants' ships and of the conquest of the desert constantly reappeared in their works. These works had a pronounced emotional character, they used elements of German Expressionism and Cubist art, such as that of Picasso in *Guernica*. It was also possible to discern in them influences of Chagall, Rouault and other painters. The National Artists (as they were called by the critics) almost never exhibited together, they did not organize in a separate group and did not issue a common manifesto. Yet, their determination and the unity of opinion among them, "their uncompromising struggle against institutions, persons and tendencies firmly established in Israeli painting . . . [the fact that] they resented the Israeli Avant-garde as an expression of false internationalism"[32] makes it possible to identify them as a body.

Simultaneously with these stylistic developments, a number of changes occurred in another sector of the Israeli art world, namely in art criticism. Prior to the foundation of the State, art criticism was virtually non-existent in Israel, or at least it had little importance. The critics who did exist were mostly people who had turned to art criticism by pure chance: liberal professionals, art lovers of different kinds and so forth. In most cases, a personal acquaintance with an editor of a new magazine, who was interested in having an art section, served as an admission ticket into the profession.

Very few (and one has to bear in mind that we are talking about very small numbers) were educated in art history or related fields, such as the history of the theater – an education brought from Europe.

In the middle of the 1950s young native Israelis, educated in the country and somehow related to art (for example, employed in a museum during the summer), were joining the ranks of the art critics. Several immigrants from the United States entered with them. Soon these new people became the majority among the critics, and with this change of personnel, the spirit of art criticism changed too. Though no survey of the press criticism in the pre-State period has been attempted, the available data (from the 1950s on) makes it reasonable to relate the two phenomena: the change in the population of critics, which began in the middle of the 1950s, and changes in the contents of criticism, first becoming evident during the same period.

Characteristic of the attitude of the press in the first half of the 1950s was a demand for professionalism, the stress on the skillful craftsmanship in execution; this remained significant until the end of the decade. The most important duty of the artist and the only sign of his being an artist was the command of painterly skills: an ability to draw, a feeling for composition – an ability to organize the depicted objects on canvas, control of the color-plate and an ability to bring a painting to its conclusion (that is to produce a finished work of art, not just a sketch). Through this entire period we witness the accentuation of these relatively clear criteria in criticism.

A work of art was considered good if it manifested "a professional skill," "a good technique," "competence in drawing, excellent technical skills." It was criticized if there was "a neglect in a compositional structure and in use of colors," a weakness in drawing and composition – "a certain sketchiness about the work which made it seem as if it were a study for a painting and not the actual painting itself," and, in general, "lack of competence."[33]

This stress upon the elementary principles of professional painting, as well as the demand that they be present in every work of art and that works of art be selected in accordance with them, were related to a sense of respect for the public. "It is the duty of a critic to be a mediator between the public and the artist's work," writes one critic. "For this reason criticism must be detailed and intelligible."[34] Critics praised or censured artists accordingly; the inability to answer the professional requirements was "not only a sign that these artists do not develop, but the evidence of their lack of respect for the public as well."[35] The art they found commendable was that "deserving to be shown to the eyes of the public . . ."[36] The public was considered capable and was expected to form its own judgment; for this reason the artists were required to make their art understandable.

Abstract art, to which professional criteria were inapplicable, and which, in the opinion of the critics, was destroying the borders between art and not-art, was not among their favorites. "A recognized, objective authority must exist in order to evaluate Abstract art," a critic demanded in a certain article, "for if there is no such authority, the public loses the ability to distinguish between real works of art and immature and meaningless experiments."[37] The critics themselves were able to make this distinction, and they found Abstract painting "lacking any relation to reality . . . confused, boring, meaningless."[38]

According to the criticism of the 1950s, art had to be connected to reality. Even works executed in accordance with professional criteria, but unrealistic in their subject, were criticized rather harshly. The requirement for a correspondence to reality was complemented by an opposition to the technical experiments for their own sake, and led to the accentuation of the subject in works of art. The critics would make some concessions to both technical experiments and unrealistic subjects, if those served the goals of "the advancement of the artistic culture in the country." But, on the whole, it was "realistic" art (a general title, according to the criticism of the 1950s, equally applicable to all figurative styles – ranging from Realism *sui generis*, existing only in a tiny minority of the cases, through Impressionism, Expressionism and so forth – which related to reality and in which the object was easily recognizable) that aroused most favorable reactions among them. They wrote proudly of the 1957 Biennale in Venice: "90 percent of all the exhibits . . . are abstract, or semi-abstract – it is geometrical, speculative, dry and academic art. Only Canada, Turkey and Israel manifest an encouraging realistic tendency." Even the New Horizons were praised for "their new Realism, which is much better than the works they exhibited before." What pleased the critics in the 1950s, was, generally, "rich, healthy and prolific imagination, without sickly efforts to distort reality."[39]

Already during this period the supporters of Realism were competing with other views and had to fight for their principles. Criteria were becoming problematic; the borders between art and not-art were being erased. An older critic wrote sadly in 1955: "It is difficult not to recognize . . . an echo of a certain transformation, of the self-destruction tendencies in the world of art in our times which slowly bestows the right of citizenship within its borders not only upon the dilettants, but upon such 'external' phenomena which resemble plastic arts or are close to them as well."[40] And even earlier one could notice a sense of nostalgia and "longing towards those days in which we still could raise ourselves above reality in a spirit of revelation and ideal . . . and could allow ourselves to create realistic paintings."[41]

The tendencies characteristic of the criticism in the 1950s, entirely disappeared only in the beginning of the 1960s. But the new approaches, virtually opposite to those which we have reviewed until now, were gaining strength since the second half of the 1950s.

It was then that the first sympathetic criticisms of Abstract painting appeared, while insufficiently Abstract works were first met with negative criticism. For example:

After you deeply meditate upon the canvases by Zaritsky, you are able to understand why he was considered worthy of such a large and serious exhibition abroad. If the beholder searches for plastic definition in his paintings, he is searching for it in vain . . . [the] painter not only waives any definite subject, he also waives plastic moulding; he builds his world solely upon color. But if the beholder agrees to enter the world which is entirely a current, a becoming, a sea, a river, a sea of the soul and a sea of experience, then indeed he will find in Zaritsky a great treasure.[42]

According to the critics sympathetic to Abstract art, "the meaning of a work of art does not depend upon its subject, but upon what happens in the dimension of form in the framework of this subject." Consequently, there was no need for correspondence to reality. On the contrary, attachment to reality came to be viewed as a fetter, and the lack of any connection to it as an expression of the liberation from fetters: "Naturalism . . . clinging to all the details of a photographical reality certainly does not allow a painter to develop a personal approach," they wrote. And: "There is no doubt, that the emancipation of art from its utilitarian function (and especially from its duty to immortalize the human face) was a strong factor in the process of the liberation of painters from the fetters of imitation of nature." Attempts to link art and reality were believed to result from extra-artistic goals and social concerns, which, according to these critics, the artist had to avoid since they did not help to create anything new, but instead led to "the depression of the soul."[43]

Since art was not expected to correspond to reality or to have a subject, there was no possibility to apply professional criteria to it. The skills of drawing, composition, etc. were seen as interfering with original creativity and hindered rather than helped the production of a worthy work of art anyway. A worthy work of art was defined in terms of technical innovation. Artists who did not innovate met with sharp criticism. They, as the critics said, did not "create in the deep meaning of the word."[44] Who did create in the deep meaning of the word, according to these critics? A creative person was one, who wanted to express himself, to give vent to his feelings. Such an expression, apparently could be found not only in art of traditional painting or sculpture; anything could become a channel of creativity. For example,

"Many people, who tried in vain to give vent to their feelings while searching for their expression in composing music, writing novels or painting, found satisfaction or self-expression . . . in ceramics."[45] In any case there was creativity "in a deep meaning of the word" and elementary principles of professional painting had nothing to do with it. Unwillingness to rely upon relatively definite and measurable criteria such as drawing, composition, rules for the application of color, resulted in the lack of clarity and vagueness of formulation increasingly characteristic of this trend in criticism.

Here are a number of examples: "In a number of still-lives the decorative element is increasing; it is almost vociferous in determination of definite, clear, rhythmical in their swing facts." "The works are imbued with . . . intensive values." "The scale of colors is orientally-fresh . . . the scenery is imaginary, or, to be precise, synthetic."[46] All these tendencies were expressed in a passage from the catalogue for the exhibition, "Israeli scenery in the Haifa Museum," which was quoted in an article published by the daily *Davar*, on July 13, 1956: "The colors . . . negate the description, every material precision, in order to become means of painting . . . We do not have before us a collection of Israeli landscapes, but a survey of tendencies and kinds of creativity that will rule in the Israeli painting of tomorrow . . . This art of painting is liberating itself from every doctrine and every 'credo' . . . Instead of measurable dimensions, the dimensions of Euclid, values without measure appear . . . Paintings exhibited here are complex and severe, they do not flatter the spectator, they do not arouse in him that joy of recognizing and identifying in a glance a tree, a road or sky, but offer him Israeli scenery converted into form and color. In short, our painters do not imitate, they create."

Art critics of the following decades continued to write in this spirit, while the earlier type of criticism, more typical of the 1950s, disappeared without a trace. No objections were heard anymore to the assertion that "the great adventure called 'Modern Art' consists of rendering a dynamic expression to personal conceptions . . . which must serve as a code of the period characterized by unceasing rhythm of search and innovation." Critics wanted nothing but "new aesthetic experiments and contemporary stylistic reactions." Art, as it was conceived in the 1960s, and a typical piece of criticism looked like this:

These works wish to present new tendencies in art, to demonstrate daring experiments and to "stimulate" the spectator . . . They try to express the times . . . they also want the artistic doing for themselves. Simply "to do." To paint. To sculpt. Not to engage in "literary" painting which lacks values of its own, besides the fact that it narrates a story or "depicts" . . . What is the intention of these bold creators? To

stimulate. To do. To bring a new "handwriting" to the contemporary art which, as we said, derives from the "Now," from the everyday . . . Whatever their intention, they make art; they do something which is called creative art in this time.[47]

It is clear that art of this kind did not have to correspond or simply to relate to reality. The critics of the 1960s and thereafter, in fact, reacted with utter amazement to artists who did consider such relation desirable. "It seems that the Soviet artist," the paper *Latest News* (*Yediot Ahronot*) reported as the latest and, apparently, incredible news, "really, wholeheartedly and most decidedly believes, that any serious work of painting or sculpture must be founded upon the representation of the visible reality . . ."[48] Art was also not required to have a subject; the subject did not add meaning to the work of art, only technical innovation did. "A great deal of artistic content is concealed in yearning for the new instead of routine techniques," wrote one critic, "since it renders conspicuous the element of the artist's personal choice. This choice, as is well known, is one of the most important factors in the creative process in art. And when the choice is dramatically expressed in technique, this latter becomes the meaningful content itself."[49]

During the 1960s the focus of the critics' attention was Lyrical Abstractionism. Figurative styles were noticed and mentioned in the press only when the artists were mentally ill patients or when they were Naive painters, people who never studied art and did not know what professional painting is; as such the Naives, as well as the mentally disturbed, could be defined as spontaneous creative artists, unfettered by professional learned skills or philosophies compelling them to seek correspondence to reality, two qualities which had no place in creative art.

The course of events in Israeli art between the foundation of the State and the mid sixties, like its earlier period, included several sociologically significant developments. First of all, for the first time in Israeli art there appeared an Abstract style, namely, a style the essence of which was the lack of dependence upon the object, painting which did not depict, but merely painted. As such this style could not be judged by the public because the public did not have any possibility of comparing it with anything it was acquainted with outside painting. From this point of view, this style was not "intelligible" to the public.

Another difference was of even greater sociological importance. The main reasons for the emergence or adoption of all the other styles in the country were ideological. Works of the artists representing these styles expressed their attempts to implement their (social and/or professional) ideology or to embody the values upon which it was based. Affiliation with a

particular style-group was dependent upon, and followed, the individual artist's adherence to the ideology that the style expressed. In contrast, in the case of the New Horizons, the group which introduced Abstract art in Israel, the adherence to the ideology and the very fact of creative work in the framework of this style was the result of the group affiliation. The adoption of the style in this case served the function of creating a symbol of identification for the group which emerged as a result of purely political considerations and not in consequence of a change in aesthetic values among the artists.

As in previous years, the appearance of new styles was connected to the emergence of new networks of support: new museum directors, new patrons – millionaires, changes in the population of the art critics in the press. However, a tendency absent in the previous period became apparent. Less conspicuous, and maybe still non-existent in the case of exhibitions, it was very clear in criticism. The direction of change in the contents of art criticism leaves an impression of unilinear stylistic development from figurative painting (Realist as well as Free) to Abstractionism, namely of a development, in the course of which figurative styles disappeared, being replaced by Abstract art. However, as we learn from the history of styles in Israel, this was not a unilinear development. Groups of artists continued to work in the frameworks of those styles which emerged previously, and new figurative styles continued to appear; Abstractionism existed alongside these styles, not in their stead. Nevertheless, art criticism devoted its attention more and more exclusively to the Abstract style. While the exhibitions (in galleries as well as in museums) were still within the reach of all the painters, coverage of these exhibitions by the press towards the mid sixties became almost exclusively a prerogative of the Abstract artists.

The result of such an exclusive adoption of Abstract styles by the art critics was that different styles did not confront similar social systems anymore, which signified the beginning of the split in the Israeli art world.

From the mid 1960s to the present: the split into two subsystems

The changes in the possibilities of selling and exhibiting works of art, which took place since the second half of the 1960s, accelerated the tendency towards differentiation in the Israeli art world.

In the forty years between 1940 and 1980 those Israeli artists for whom one-man show catalogues could be obtained from the Archives of the Israel Museum have exhibited in 300 places. Public institutions accounted for 122 out of these 300 places; among these, thirty may be treated as institutions the

main purpose of which, or at least one of the main purposes, was the display and preservation of works of art. The remaining places (178) were private galleries.

The distribution of the exhibition-forums changed during these years. In the 1940s the painters studied exhibited in fourteen places, seven of which were public institutions (two of these seven were art institutions), while the remaining seven were private galleries. All the galleries were located either in Tel-Aviv, Jerusalem or Haifa. A number of these galleries discontinued their activity in later periods and, although a number of new names appeared among them, in 1954 still only seven galleries existed in Israel.[50] Until the end of the 1950s, fifteen private galleries were active: eight in Tel-Aviv, three in Jerusalem, three in Haifa and one in Tiberias. In addition to these forums, painters could exhibit in thirty-five public institutions, of which fifteen were art institutions.

The number of exhibition-forums continued to grow during the 1960s, but the rate of growth in different sectors changed. During the decade between the end of the 1940s and the end of the 1950s the number of galleries doubled; the number of public institutions in which one-man shows were held increased fivefold; and the number of public art institutions increased sevenfold. While in the next decade the number of galleries grew more than threefold; the number of public institutions a little more than doubled; and the number of art institutions increased 1.4 times (from fifteen to twenty-one).

The geographic distribution of exhibition-forums changed too. In the 1940s public institutions were distributed as follows: two in Tel-Aviv, two in Jerusalem, two in Haifa, one in the periphery. In the 1950s there were fourteen in Tel-Aviv, two in Jerusalem, eight in Haifa and eleven in other cities. In the 1960s the periphery was leading with thirty-eight public institutions, compared with fifteen in Tel-Aviv, five in Jerusalem, eleven in Haifa. In the case of galleries, the periphery with its six galleries almost equaled Jerusalem's seven and actually exceeded Haifa's four. In Tel-Aviv during this period there were thirty-one private galleries, a number which was the result of a fourfold growth in ten years (from eight during the 1950s), as compared with the sixfold increase in the periphery.

A critic, summarizing the events in the Israeli art world of the past Jewish Calendar year, wrote in the fall of 1969: "The exhibition season was full of commercial activity in private galleries, which sprang like mushrooms after the rain in all of the tourist sites in the country and especially in Tel-Aviv and Jerusalem . . ."[51] In the 1970s the number of galleries tripled once more; it increased from forty-eight to 128. Public institutions, in contrast, grew only

1.3 times (from seventy-four to ninety-six). This was also approximately the rate of increase in art institutions (from twenty-one to twenty-nine).

The number of galleries in the periphery increased four fold (from six in the 1960s to twenty-seven in the 1970s); it more than trebled in Haifa (from four to fifteen), almost trebled in Jerusalem (from seven to nineteen) and doubled (increased 2.16 times) in Tel-Aviv (from thirty-one to sixty-seven). The numbers for public institutions during the 1970s were: eighteen in Tel-Aviv (of which number five were art institutions); nine in Jerusalem (three art institutions); ten in Haifa (four art institutions) and fifty in other cities (seventeen art institutions).

The important point which this data reveals is an accelerated expansion of the private market starting in the end of the sixties. The majority of the galleries (approximately 90 percent) were commercial enterprises, their main purpose was bringing profits to the gallery owner. Alongside such galleries there existed a handful of others whose owners saw their goal in the advancement of art, in which they desired to participate. These latter regarded public acclaim and social honor as more valuable than economic profits. Such galleries were referred to as "quality galleries" in the press and affiliated themselves with avant-garde art. "Commercial" galleries, in contrast, had catholic, though increasingly figurative, preferences.

Complemented by the public institutions which included museums, this private market created an extensive system of exhibition-forums, capable of simultaneously sustaining numerous and different styles (see appendix A). Museums in this period also underwent changes which had a significant effect on the exhibition opportunities. However, in this case the changes were qualitative rather than quantitative.

In 1965 the Israel Museum was founded in Jerusalem. It had a large art department which replaced the Bezalel Museum as the central art institution of the city. At the head of the department stood Jonah Fischer, formerly on the staff of the Bezalel Museum, an art critic who started to write in the mid fifties and a person with Modernist preferences in art. The Tel-Aviv Museum, at this time, had as its director Dr. Haim Gamzu, one of the outstanding art critics in the early fifties and a believer in the clear professional criteria in art. Upon his retirement in the early 1970s he was replaced by Mark Sheps, a sculptor in his own right, who worked for a while under the supervision of Jonah Fischer in the Israel Museum. With these changes the two most important museums in Israel adopted an unequivocally Modernist position and took the side of Abstract styles. These developments strengthened the growing tendency toward a split in Israeli art, the seeds of which had been planted during the previous period.

Art criticism in the press continued to disregard almost all figurative painting. There was, however, a change of taste among the critics which they described thus: "From the 1940s on, under the influence of European artists, the most prominent of whom was Marcel Duchamp, the most rationalistic of the 20th-century artists, the evolution in the realm of philosophy of art reached a high level of realization and vigor in United States. This evolution extended the realms of plastic creativity to the extreme, which denies the very essence of art as a sensual, experiential and aesthetic expression of the individual."[52] Since this rationalistic Duchampist philosophy arrived in Israel in the early 1970s, the critics were no longer satisfied with art defined as expression of feelings. Conceptual Abstractionism replaced the *tachist* Lyricism as their favorite style, and they desired art capable of influencing the environment. Here is a description of an artistic work, which answered the requirements of criticism in this period:

An exemplar of the "conceptual" effort . . . is the documentation of the supporting columns in the Museum, the work of Moshe Gershuni . . . He put a copy of the building plan on every column in the building, adding to every copy a sign of a given column. These plans are not exhibited because of their plastic value. The information they convey is, of course, also redundant.

The only motive which can, in my opinion, justify this idea, and apparently this is actually Gershuni's motive, is the power of these plans to divert the spectator from the habit of frontal observation of a separate and isolated object and its aesthetic evaluation, and to bring him into the condition in which he becomes conscious of the fact that he stands within an organized and systematic environment (the columns are organized in definite order), that he is standing, simple as it is, inside a building.[53]

Such psychological experiments attracted the attention of the critics because of their scientific nature which became a great merit in their eyes. In the course of time, scientific experiments of the artists grew more and more daring, as for instance, in the following work a critic described and commended:

Zvi Goldstein is engaged in the composition of descriptive exercises since the time of his stay in Milan in 1971. In every intermission, empty space or absence (of contents) existing in an organized continuum of shapes, there is concealed an imaginary shape, completed by our consciousness and filling in the place of the lacking form which does not occur in reality. A similar act of completion performed by consciousness provided Aristotle with a proof of the dynamic motion in Nature. Goldstein creates imaginary moves in the gallery by means of series of numbers he draws on the floor so that any number pulls to the next one, situated at some distance from it. His aspiration is to dictate to the imagination (or, in this case, the feet) a certain shape in the space which has a simple solution. This is in contrast to mystical and wild shapes

that spring up in our imagination in presence of a work of traditional, abstract or even conceptual art. This creation of spiritual, concrete shape, which comes into existence by means of given points of connection, he calls "demistification." Goldstein believes, that the spectators will know to derive from this exercise relevant interpretations . . .[54]

However, the orientation of an artwork did not have to be psychological–experimental, it could affect the spectators in a different way. For example, the work described in the following passage received very sympathetic reviews:

The painters Isika Gaon and Shaul Shatz covered an information board with colors. The abstract "composition" which resulted upon the information board would possibly not attract much attention in a museum exhibition. However, within the incessant noise of vehicles and people, mixed smells . . . it received a new meaning. The painted board aimed at surprising people on the street . . . in fact, it was a spontaneous expression, a-political and lacking any manifest target, of two young people loving Jerusalem and Jerusalemites and wishing to let them participate in their joy of life. A similar artistic event occurred near the railway station in Jerusalem. A young sculptor, Israel Hadani, found a pile of scrap-iron in one of the city neighborhoods. With the assistance of Jerusalem Municipality he moved it to the traffic-island in front of the railway station and divided it into two groups: one vertical and one horizontal. In this way the groups are perceived as powerful independent units, and at the same time they are integrated with the scenery and the architectonic structure of the railway station. The work of art is successful because it is a perfect work of art from every angle . . . None of the two works of art, neither the painting on the information board, nor the collection of the junk near the railway station, pretend to be *chefs d'œuvre*, and they are not supposed to stay in their place forever . . . The artists treat these works as a "temporary holiday" . . . The artistic significance of these works, then, is less important than its actual and ecological aspects . . . The three artists proved to us, that with minimal investment, small effort and a bit of imagination it is possible to convert junk into art. By means of their works they brought to us a social message.[55]

The majority of the critical reviews of these years though were dedicated to works with implications which did not reach this far, and intentions that were purely artistic. In most cases these works bore titles such as "A composition" or "An object," used various unconventional materials, lacked a subject and were unrelated to reality. A few samples of criticism are sufficient to demonstrate its spirit in the 1970s, and the nature of the works that most regularly attracted its attention:

Delightful and interesting is a small object, made of a round pipe and colored plastic sparks . . .

This exhibition . . . like all those that preceded it, is built around its own common

ground. In the present case this is the controlled and intelligent use of ringlings, rattlings, tinklings, jinglings, clappings. Scribbling, paper garbage and printworks, seemingly, lacking any significance or artistic value, that were brought together as if childishly and by pure accident.

Most of the works are constructed in the following way: bare plywood, newspaper collage, photographs of saccharine scenery, pencil scribblings, erasings, meaningless writing . . .

The canvases are simultaneously based upon two dimensions: on the one hand there are structured, almost geometric forms of surfaces filled with plain and saturating color, while on the other – amorphous spots, executed by free and trembling brush strokes . . .[56]

Very rarely it is possible to run across a favorable, though surprised, reaction to a work of art or a painting which contains some reference to reality (usually it appears in a review of some exhibition in Jerusalem; Jerusalem and Haifa, it seems, tarry a little behind Tel-Aviv). However, such reviews sank in a sea of negative criticism against the same or similar works of art and artists, which were blamed for using "anachronistic technique" and for not being sufficiently innovative.

Innovation continued to serve as the sole criterion for the evaluation of the quality of artistic performance. Insufficient innovation represented a sufficient reason for a harsh criticism of an exhibition or a work of art. At the same time the critics lacked an explanation as to why innovation was necessary. In addition, innovations had a tendency to become outdated. The news of today turned into yesterday's news the day after. Already in the early 1970s critics were talking about "new ideas in which there is nothing new." "How many times can one be shocked in the end?" they asked. The style of criticism became increasingly aggressive and even the works of innovative artists left the critics dissatisfied. We come across such a passage, for instance: "The last 'invention' of Rafi Lavie and Ran Shchori is not amusing. These mattresses manifest laziness, lazy hands and even more lazy thought. There is this foolish conformism of a well-known kind. By the way similar 'tricks' were already invented forty years ago." Or: "A dozen of Israeli artists exhibit in the Elharizi House, and try in vain to create an environment and to frighten the public. A storm would have burst perhaps were this exhibition held a number of years ago. In the meantime the Israeli public got used to seeing much more shocking and enraging things in the exhibition halls . . . Such expositions had lost their power to arouse in us a feeling of 'what-is-going-on-here-really?'" Innovations became routinized. They reminded the critics of "exercises in a very conservative school of a

very avant-garde art. After the collages of Rauschenberg . . . these works [looked] miserable and dilettantish."[57] In themselves, innovations were not sufficient to make a work of art satisfactory and guarantee its quality. Moreover, critics were realizing that innovation did not provide a criterion for judgment; that in fact, it lay outside the domain of judgment itself, although in the past it was thought to have replaced professional criteria. The critics were troubled and this could be easily discerned in numerous reviews. One of them expressed this concern early in the period:

> The significance, the importance of the very deviation from the traditional ways of expression has been dissolved, now the point of gravity has to return to its true place, namely to the specific formation of the work of art, to its characteristic quality and to its power to stimulate feelings and thoughts. In this exhibition, called "Avant-gardist–Experimental", forty-one artists participate of whom many have not yet finished their initial "trip" of liberation from tradition. They do not distinguish clearly between an excitement deriving from the use of unconventional means for its own sake and the creation of worthy works of art by these unconventional means. It is not enough to place live chickens in a colorful cage [as Leon Goldberg has done] and to be satisfied by surprising the public . . . [This is] innovation at the expense of quality and deeper understanding.[58]

However, where this "true place" of the "point of gravity" was the critics had no idea. Innovation did not satisfy them, but innovation was, nevertheless, the only criterion which they had for the comparison between works of art and their evaluation. In this chaos there was no choice left for criticism but to blur further the clarity of formulation, and to split into pure theory on the one hand, and into declarations of judgment on the other. The pure theory did not express any judgment at all, while the declarations of judgment were either enthusiastic and approved of works of art because, as was claimed, they were innovative, or were negative and disapproved of them because they were not innovative enough, the approval and disapproval being based on no additional reasoning.

This is the state of the criticism today.[59] It is particularly important given the background tendency toward differentiation in the Israeli art world. The confusion in which the critics found themselves, the enfeeblement of the traditional criteria, signified a change in the character of judgment in one of the two emerging subsystems which significantly widened the gap between them.

The changes in criticism which led to the above result may be summarized as follows: Art, which in the beginning of the period (the early 1950s) was defined as a means for the expression of objective meanings, was perceived by the 1970s as an egocentric activity of people willing to give vent to their

feelings, and later, as experiments with new materials and forms in order to find new solutions for undefined problems. While in the beginning of the period the artist was required to serve his society, at the end of it he was expected to serve only himself and art. This general change in the attitude of criticism was expressed in specific changes such as: (a) the changes in the attitude towards the public (a wish to please it, to reinforce its values gives way to an intention to irritate the public, to shock it); (b) the changes in the definition of a good work of art and in the criteria of judgment.

The locus of judgmental authority moved from the public to the hands of other agents. The public, which was allowed, and even demanded, to express its opinion in the 1950s – for that reason critics took pains to explain things to it and the artists were required to create in such a way as to make their works understandable to the public and satisfy its demands – gave way to the artist, who was allowed to do whatever he wished. And in the end of the period it gave way also to critics who, being well informed in what was going on in the world of art, were able to distinguish between innovations and imitations and were, therefore, able to formulate requirements towards the artists. However, apart from the general and obscure demand that the artist should innovate and should not imitate what was already done, critics formulated no criteria. The basis for acceptance and rejection of the works of art disappeared.

Meanwhile, approximately 50 percent of Israeli artists were rejected out of hand. Beginning with the early 1960s, the only art considered at all by the press was Abstract and Conceptual art, while figurative styles were reviewed only occasionally and then, in general, negatively, the artists being accused of anachronism and imitativeness.

Stylistic changes continued alongside the changes in criticism. In the second half of the 1960s another figurative style joined those that existed in Israel previously. Together with Conceptual Abstractionism or Conceptualism, to which the press of the 1970s devoted so much attention, this figurative style represented a conspicuous exemplification of the split in the world of Israeli art, which in those years was already an accomplished fact.

In the year 1967 several painters joined the National Artists mentioned in the previous section in the exhibition Image and Imagination, organized in the Tel-Aviv Museum. This exhibition signified the appearance of the new style. It was titled Jewish Surrealism. In contrast to classical Surrealism, its representatives did not express their individual unconscious, but the National Unconscious. One of them wrote: "The contents of Jewish Surrealism are connected with Jewish history and mythology, and very frequently rooted in the trauma of the Holocaust."[60] In 1968 a representative of the

Viennese Fantastic Realism, a painter, Ernst Fuchs, visited Israel. He gave a number of courses to groups of teachers and students in Bezalel and elsewhere; he also gave Summer courses in Austria where many of the Israeli Surrealists came to study. "The courses represented a figurative reply, extreme in its classicism, to the Lyrical Abstractionism which was the dominant style in Israel during this period."[61] The Jewish Surrealists exhibited in private commercial galleries and were among the best-selling Israeli artists both at home and abroad.

Another figurative style, which rose to prominence in Israel in the beginning of the 1960s, was the Naive painting. Isolated representatives of this style (the famous model of which is Henri Rousseau) were active already in the 1920s. However, only in the 1960s "a chase to discover Naive geniuses began."[62] In Israel, in addition to the typically Naive elements, the style was characterized by specifically Jewish subjects. This style also reached tremendous commercial success in Israel as well as abroad, so that the author of a survey of Israeli art, published in *Art News*[63] concluded that the Naive painter Shalom Moshkovitz of Zafed was the best-known Israeli artist in the world.

The New Horizons group was dissolved in 1963, but already one year later another group arose to fill in its organizational place. This group, called The Look-out (*Tazpit*), was the largest artistic organization outside the Artists' Association since the foundation of the New Horizons. With its ascendance it is possible to speak about the appearance of Conceptualism in Israel. On the occasion of their only exhibition the members of this group issued a manifesto in which they stated: "We oppose the classical expression built upon external impressions which trades on Jewish consciousness and uses symbols which lost their meanings long ago."[64] A sympathetic historian writes:

The manifesto sounds familiar. It is not different from those declarations uttered by the representatives of the "New Horizons" in their day in reproach of the use of narrative and folklore contents. What was, then, the function of the "Look-out?" It seems that the importance of the group lies in the fact of its organization, and not in the ideology it adhered to. It enabled artists to exhibit within the walls of the museum. One must keep in mind that in those days there were few private galleries, and those that did exist demanded large sums of money as a fee for exhibiting. The Museum in Tel-Aviv (museum in Jerusalem did not exist yet) and its director Haim Gamzu were accused of disregarding Israeli painters and favoring the French Academic art which had no connection with Israeli reality. The exhibition of the "Look-out" was a demonstration of the burgeoning Abstractionism . . . it was also possible to recognize foreign influences and new developments. Here the working trousers and the cast shoe of Igal Tumarkin were exhibited . . .

The most important organization in the 1960s, though, was another group which appeared in 1965 under the title 10+. Its appearance was also an answer to an organizational rather than ideological need. The director of the Tel-Aviv Museum intended to organize an exhibition of young abstract painters, but omitted certain artists. In response to this omission, a painter Rafi Lavie organized thirty artists to boycott the exhibition until all those artists whom Lavie and his friends wanted to participate were included. "The power of group organization, as a means of pressure to force the recognition of artists and as a means of organization of exhibitions, became more and more clear and worthwhile." Members of the group became members of the jury for annual autumn salons held in the Tel-Aviv Museum.

10+ was not an ideological group, it did not even pretend to be such. It was not connected to a style, but to a situation . . . Its members saw themselves as a public relations agency whose duty it was to bring the existence of the artists – group members to the public's notice. "There was no thesis, there was only Rafi Lavie, a lobbyist," said Rafi Lavie . . . "the contribution of 10+ to Israeli art consisted in that it allowed you to exhibit every couple of months and this was a remarkable gain" . . . remembered another artist . . . the conversations among the artists – members of the group were not devoted to artistic matters – but mostly to the press and the power of mass media to bring artists' work to the public's notice . . . the collective character of the group expressed itself in the mutual support of its members . . .[65]

What exactly was the meaning of the "lack of ideology" among these artists? Not that they did not believe in anything. The members of 10+ were the disciples of the New Horizons masters; they shared the militant avant-gardist ideology characteristic of this group in its later years. According to this ideology, also taken for granted by many of the avant-garde groups abroad, the only art worthy of its name was abstract art which served nobody's needs but its own, and therefore was radically different from figurative, "narrative" painting, which usually related to extra-artistic values. This ideology, however, to which they wholeheartedly subscribed, had already lost its novel character, and therefore, could not demand an emergence of a new style on its basis. The requirement for innovation in art derived from the political need which brought about the organization of the group. This organization and its demands toward Israeli art institutions needed some legitimation, and there was no better justification than the claim that this group was the carrier of the progress in art. The innovation, naturally, was in the spirit of the New Horizons ideology, supplemented with borrowed ideas from avant-garde groups (Conceptualists of all sorts) abroad.

Not "good painting," but "interesting" art was the ideal of the 10+

members. Exhibitions of the group were dedicated to what the artists called "themes" which were divided into formalistic subjects such as "In Red," "In a Circle" and the subjects drawing on the History of Art: "The Nude," "Venus," "Miniatures." "Those invited to participate in the shows knew that they were expected to produce a gimmick. An artist who would exhibit with the group searched for something more interesting, more funny, more sophisticated." The members of the group viewed it as existing exclusively for their personal and professional benefit. "The main goal was to bring as large a number of people as possible to as many exhibitions as possible, to irritate, and through this, to stir up; to take the artists as well as their public out of the routine. In this the members of 10+ were, doubtless, highly successful."[66] The statutes of the group stated that, in distinction to the New Horizons, there would be no stylistic coercion and that the organization served the good of the artists and not of an ideological current.[67] To create an avant-garde atmosphere, the group, apart from exhibitions, organized evenings of poetry, electronic music, film and theater.

Typical exhibitions of the 10+, however, needed little help in creating avant-garde atmosphere: at an exhibition the "theme" of which was "The Nude," one of the women artists performed a sitting on a lavatory pan. At the exhibition "In a Circle" Rafi Lavie exhibited a round table with plates stitched to it. At the exhibition on the subject "Venus" another artist presented a negative of a photograph of Botticelli's Venus pasted to a wooden chest. The last exhibition of the group in 1970 was called "Mattresses show" and it consisted of piles of mattresses thrown on the floor and hanging on the walls. According to an historian,

the "Mattresses show," apart from being a grandiose funeral and an obsequial meal for a period in which the artists left the Ivory Tower of the Muses, was also the first Tel-Avivian attempt to create environmental art. 10+ artists did not view the show as a joke. They wanted to create an environment of soft objects, to ponder on the sense of softness in the total environment. The fact, that they did not succeed does not change the other fact, that in this experiment a daring and a fresh thought was present which would develop into a genuine artistic approach later.[68]

Many of the 10+ artists continued its path to Conceptualism when the group as a body ceased to exist. Until 1970 (beginning with 1965) Israeli avant-garde artists exhibited every autumn in the "Autumn Salons" of the Tel-Aviv Museum. With the establishment of the Israel Museum in Jerusalem the center of this art moved to the capital and starting with the end of the 1960s critics frequently referred to the New Jerusalem school to which many of the prominent representatives of today's Conceptualism belonged. These artists also exhibited in "quality" galleries, one of which, Rina gallery in

Jerusalem, was particularly important. Its owner devoted her energies to the cultivation of the New Jerusalem school, opened a branch in New York and organized exhibitions in other cities in the United States. (These exhibitions, however, failed to arouse reactions of any significance where they were held, and were important only for the Israeli art world.)

The year 1968 is considered to be a turning point in the development of the New Jerusalem artists because of the following artistically significant events.

Arie Aroch created folds of paper, conceived by him as lines. Aroch, who attacked what he named "French sensitivity," brought about a clear change in the conception of Jonah Fischer, the curator of Israeli art in the Israel Museum, as a result of which he moved from the "French sensitivity" of Lyrical Abstractionism to "drastic sensitivity" of absurd games – a passage of an utmost significance for the exhibitions held since then in the Museum . . . In the same year . . . Neustein exhibited "an unsuccessful painting": a painting torn into four parts and framed, in autumn 1968 Gershuni produced a series of spots on paper and works on checked paper. These were the spots of margarine oil, signed and documented in pencil on little pieces of paper. Approximately in the same period, the end of 1968 and the beginning of 1969, Beni Efrat in London worked on folded sheets of paper and on checked paper. These and other points of departure made the year 1968 into a turning point, and the American critic Robert Pincus-Vitten wrote about this year in Israeli art: "Then it became clear that a new system of visual–artistic activity emerged, provable and verifiable one – system which I call Conceptual Abstractionism. An artist working in Conceptual Abstractionism possesses a system of verification of his own; he will not compare art with Nature, but only with certain absolute concepts." (Catalogue for Neustein's one-man show in the Tel-Aviv Museum, 1977, p. 8.) Since then artistic events, analogous rather than connected or deriving from these, occurred.[69]

Here is a short list of such events: two artists had a show in Jerusalem Artists' House, the headquarters of the Jerusalem branch of Artists' Association, called "Boots." Seventeen-thousand old army boots were transported to the Artists' House in Jerusalem from a field near Atarot and thrown on the floors in the exhibition halls. In 1971 an exhibition called "Concept + Information" was held in the Israel Museum. In it Joshua Neustein presented three "barrier-works" "which he regarded a gesture in honor of the philosopher Ludwig Wittgenstein . . . He photographed part of the wall, the internal structure of the wall, the other side of the part of the wall, the situation behind the wall and the other side of the picture of the part of the wall." Another important artist, Pinchas Cohen-Gan, exhibiting in 1972 in Tel-Aviv, used "new means of drawing, such as cutting, folding, multiplying the levels of paper and the like. He surprised the visitors also by means of a nylon bag with a goldfish in it, which he hung in the hall . . ." In 1974 this artist held a one-man show of "projects" in the Israel Museum. Here is its description:

Since 1972 Cohen-Gan has been engaged in intergeographical projects. In the autumn 1972 he started to work on the "Dead Sea" project, an attempt to transplant a habitat of live fish in the Dead Sea by means of polyethylene pipes, filled with fresh water. In the summer 1973 he made a tour to Alaska, the aim of which was the experiment in artist's ability to adapt to an alien and frozen territory. In the beginning of 1974, accompanied by a number of friends, he went to the borders of the country and advanced until he was stopped by the defense forces, at which point he drove a metal stake into the spot where he was stopped. In February 1974 he erected a temporary tent in the refugee camp near Jericho, and lectured there on the subject of the refugee problem. In the same year he went to the Cape of Good Hope and spilt there water from the Dead Sea. These were just some of Cohen-Gan's projects exhibited at his show in the Israel Museum.[70]

In 1975 Conceptualism and the name of the New Jerusalem school were already commonplace phenomena; even the state television devoted a program to it. In the framework of this program one participant "presented a German shepherd dog, which urinated at different spots on the Golan Heights while the artist followed the dog and at each point of urination drove stakes with an index – 'Vital Space'."[71]

Conceptualists dominated the Israeli "art establishment" in the 1970s, especially after the change in the management of the Tel-Aviv Museum when Mark Sheps became a director instead of Haim Gamzu, and the Tel-Aviv Museum, in the words of the historian of this period, "joined the struggle [sic] – of the Israel Museum and the Rina gallery."[72] A significant number of the New Jerusalem artists became professors in the "Bezalel" school of Art which by then was recognized as an institution of higher education with the status of an Academy (which included the right to grant degrees, etc.). A number of the members of this group held the office of the chair of the art department there during certain periods. In Tel-Aviv at this time the attention of the critics was drawn to the College School, named after the State College for Art Teachers, in which several Conceptual artists taught and studied. The school was, "in fact, a group with tight social connections, with a tradition of exhibiting together, with common 'fathers,' encouraged by certain galleries and critics. There was no common manifesto . . ."[73]

These years also witnessed a rise of a number of "quality" galleries in Tel-Aviv and Jerusalem. These galleries together with the museums in both cities organized numerous exhibitions (one-man and collective) of Conceptualist artists. In addition, starting with the summer of 1975 the Israel Museum organized workshops to enable avant-garde artists to work together and with an active participation on the part of the public. One such workshop, we read, "caused a number of tendencies to meet each other and gave birth to a number of works of art, almost all of which had conspicuous

political (leftist) implications: Pinchas Cohen-Gan sent a large banner of the United States, which was hung on the wall as a clear symbol; Moshe Gershuni sang day after day the ritual songs of Muslim *moedzin* (with loudspeakers from the roof of the museum); Gideon Gechtman mourned there over the death of the Hebrew labor and demonstrated day and night in the museum to protest this death . . . Gabi and Sharon, Bezalel graduates, brought Arab workers who erected an Arab wall made of bricks they cut on the spot in the museum (photographs of the workers' families were hung on the wall)." "Performance" became another way of expression frequently used by these artists. As an example, artist Gideon Gechtman put himself to sleep with a large dose of sleeping pills "while he left his beating heart as an object of his creation." "Performances" too took place in the museums and "quality" galleries. Summarizing the activities of Conceptualist artists in the 1970s, their historian wrote: "The achievements of these groups are recognized today and attract the interest of people of art in the Western World. The 1970s proved that Israel can boast of 'a collective avant-garde movement'."[74]

Alongside these artists, other painters were still active and continued to develop different and opposing tendencies present in Israeli art since the earliest years. Thus, after the Yom-Kippur War, a group called The Clime (*Aklim*) was formed, which, in its composition as well as in its ideological orientation, represented a continuation of the Group of Ten of the 1950s.[75] The artists tried to counter the orientation of the Conceptualist artists towards New York and attempted in their works to express what was uniquely Israeli: Israeli scenery and light, Israeli identity. Their purpose was to elevate the values of the local culture in their works, to resist "estrangement, bordering on alienation and the defeatism which lately have nagged at all the healthy parts of the Israeli people." The first exhibition which the group held in the Jerusalem Artists' House "clearly attempted to oppose the tendencies of the Israel Museum in Jerusalem and what was more and more identified as Israeli avant-garde."[76] This group had a number of other shows in such public institutions as the Culture Palace, Artists' Houses and the museum in Haifa. At the end of 1974 the Clime group was attacked by other artists at a public meeting and a number of leftist artists accused the members of the group of chauvinism. In 1975 another group was founded, called Leviathan; it continued the ideology of National Painters.[77] It consisted of three artists, two of them being new immigrants from the Soviet Union. They held a number of shows encouraged by the Ministry of Absorption in Jerusalem and in Tel-Aviv and also presented "Collective works outside the studio" – similar to the "projects" of the Conceptualists.[78]

Despite the fact that in numerous cases the artists composing both these groups used elements of avant-garde art, they were not recognized by "the movement of Israeli Avant-garde" and their own works were time and again attacked as reactionary.

To summarize:

From its beginning, the social system around Israeli art underwent numerous changes. Until the end of the 1950s the Israeli art world consisted of one social system, or rather several, very similar and interdependent, subsystems. Towards the 1960s the situation began to change and there emerged a tendency toward a split which later (in the end of the 1960s and in the 1970s) resulted in the existence of two different systems: one affiliated with figurative art and the other affiliated with Abstract art.

The causes of this split lay in the repeated efforts of the Abstract stylegroups (Lyrical as well as Conceptualist) to divide themselves from other artists for different political reasons which, in configuration with independent developments in art criticism and museums, led to the emergence of a totally new social system.

In contrast to the earlier pattern in which artists organized because of the change in aesthetic perceptions, their organization being based upon the assumption that universal aesthetic values exist and that they represent aesthetic "truth" which must somehow win, the basis for the organization of Abstract artists was different. New Horizons were founded in response to a political need, the secession from the general Artists' Association and the establishment of a new one. As a result of the specific constellation of circumstances existing at the time of their emergence they became protégés of the new art critics and of the then new director of the Tel-Aviv Museum. Likewise, 10+ and the Look-out emerged because of the war against Dr. Haim Gamzu, the director of the Tel-Aviv Museum in their period, who prevented them from exhibiting in the museum, while no other exhibition-forums equal to it in prestige existed.

After the foundation of the Israel Museum and the change in the management of the Tel-Aviv Museum (when Marc Sheps became a director), the groups of Abstract and Conceptualist artists came under the aegis of these institutions.

The reason why the new curators and art critics took the side of the Abstract styles and not the others can be explained as follows. These styles were identified with innovation in art as well as with opposition to the status quo in general. Had the new style not been an abstract one, but something

else, the new groups of curators and critics would have identified with it with equal enthusiasm. This is what actually happened in the past with the appearance of new figurative styles in the country before the Abstraction-ism. History of art and histories of other intellectual activities supply numer-ous examples of the support for innovations which is partly or wholly explained by utilitarian considerations. (The rule seems to be that those who identify with departures from the status quo do so in order to secure a position in systems which have limited resources and undergo a process of differentiation. This strategy on the part of the supporters of innovation is akin to product differentiation strategy on the part of the innovators, which seems to be the driving force behind the tendency to specialization in general.) As a result of their identification with the artistic innovation, the new art critics and curators were defined as Creators and Founders of the New and could establish new roles which had not been performed by anyone before.

These groups' identification with innovation shares the characteristics of such identification in many fields. However, in addition to this point, a number of circumstances were present which made it easier for the new curators and critics to identify with (Lyrical and Conceptual) Abstraction-ism. On the one hand, they lacked other organizational or ideological affiliations and were committed to no other values. For that reason art existing for the sake of art only and serving solely its own internal needs was not likely to arouse opposition on their part. On the other hand, given the spirit of the age, these critics and curators were sympathetic to a relativist approach to culture, imbued with a certain popular version of Wittgenstein-ian philosophy expressed in visual art by the conception that art is anything one wishes to define as art. In the 1970s, most of them were professionals in their field (namely, they had some kind of special training) and were per-fectly informed about the developments of avant-garde art schools abroad. The avant-gardist ideologies were not alien to them. On the contrary, an aura of progress and revolt around them made them particularly appealing. These circumstances made natural the connection between the new curators and critics on the one hand, and Lyrical Abstractionism, and later, Concep-tualism on the other.[79]

Figurative styles, in contrast, were enabled to exist by an independent development which occurred due to different social and economic changes in the private art market. Without this development in the private sector figurative styles might have slowly disappeared from the Israeli art scene, for had the market been entirely in the hands of the public sector, only the styles supported by this sector would have continued to exist. One of the indicators

of such a possibility (also an additional expression of the split which occurred in the Israeli art world) may be seen in the unequal chances which Abstract and figurative styles have of entering the history of Israeli art, which is being written in our times by art critics supporting Abstract art. The ratio between the quantity of quotations devoted to these styles and those devoted to figurative painting in this chapter reflects the distribution of the historians' attention which results in a somewhat distorted history of the stylistic developments in the country.

The two systems which evolved from the processes described in this historical introduction differ in regard to rewards they are able to bestow upon artists as well as in patterns and grounds of judgment typical to them.

In the following chapters we shall examine the patterns of success in the two systems, and therefore in the different styles; the forms of judgment characteristic of "gatekeepers" in the two systems; the ways their behavior affects the patterns of success; and characteristics of the publics sustaining the two systems.

2 The population of painters and the split into subsystems

In order to describe the existing systems of painting, painters must be classified according to their styles. Since the names they used to identify themselves during different periods varied, it was decided to create a uniform terminology for the description of styles. According to this terminology, the painters were divided into seven style-groups; these include all styles that appeared in the course of the history of Israeli art.

The classification was made according to two principles: (1) the visual similarity among the works of art, their stylistic–technical features; and (2) the place of a certain artistic school on the continuum of the individual freedom of an artist vs. the rigidity of professional requirements towards him.

The seven style-groups are:

1 Lyrical and Geometric Abstractionism;
2 Conceptualism;
3 Surrealism;
4 Free Figurative Painting;
5 Naive Painting;
6 Expressionism;
7 Realism.

The style-group of Lyrical and Geometric Abstractionism consists mainly of the Abstract Expressionist painters (approximately 90 per cent of the group) and a few Geometric Abstractionists. The works of Abstract Expressionism (the synonyms are Lyrical Abstractionism, *tachisme*, action painting, art *informel*) are characterized by the total independence of color and brushwork from the subject, so that the subject becomes unrecognizable. These works are "color, space and movement, presented without any specific reference to observed nature." The effect of these works of art is achieved by a free spilling or daubing of paint on the canvas and by the use of "the blot, the stain, the spot or the drip." This is "meaningless art"; its essence is "creation with no desire for, nor preconception of, control,

geometric or otherwise. It is painting which begins with the brush and blank canvas and may go anywhere."[1] The works of Geometric Abstractionism, which are but a small portion of this category, are the works that, independently of images, landscapes or still life, organize on canvas lines and colored shapes that interlace in different fashions. In contrast to Lyrical Abstractionism (Abstract Expressionism), the organization and constant character of the geometrical forms in Geometric Abstractionism demand a certain intention or preconception on the part of the artist. The stylistic category Lyrical and Geometric Abstractionism includes painters of the New Horizons, such as Zaritsky (see pp. 16–17).

The definition of Conceptualism is based upon a claim that a work of art in its essence is an idea of an artist and not the physical object which is created on its basis. This category includes the artists whose works answer the requirements of the following definition: "Conceptualism takes as many different forms as there are individual artists . . . [it] ranges from an artist's performances documented in minute photographic detail to various forms of *lettrisme* including endless numerical repetitions to room constructions in which the studio or the gallery becomes, in effect, the work of art. Conceptualism adapts elements of happenings, video art, earth art, body art, pop art and light art, or rather, all these forms begin to interact with one another."[2] The stylistic category of Conceptualism includes Conceptualist artists mentioned in chapter 1.

The Surrealist category includes painters whose works depict subjects in which reality merges with dreams (of a sickly character, in general, like nightmares, or full of loneliness and nostalgia) which are executed in an absolutely realistic, almost photographic technique. This category includes both Jewish Surrealist painters, and Fantastic Realists, namely, Surrealist painters with pronounced national inclinations and those who lack such inclinations.

The category called Free Figurative painting refers to all those artists whose works represent a definite subject taken from reality and who use for this purpose free techniques resembling Impressionists and Post-Impressionists such as Cezanne. The painters belonging to the Land of Israel style, to the French Expressionism, to the Canaanic style and some of the members of The Group of Ten are included in this group.

The Naive artists retain their original name in this study. This category refers to artists whose works are characterized by folklore subjects executed in relatively primitive technique (such as the space in which all the elements

are presented flatly and frontally; lack of perspective, schematism of anatomy complemented by a great attention to every detail of a represented object).

"Expressionism" is here defined according to the model of German Expressionism; this category includes painters, the visual form of whose works is dependent upon the message they want to express (messages being implied in subjects with strong emotional overtones, taken from the social reality). There is no difficulty in recognizing the objects taken from reality (images, landscapes or still lifes), but their shapes and shades are distorted in accordance with feelings the painter wants to arouse in the spectator. The historical groups mentioned in the previous chapter, which are included in the stylistic category of Expressionists, are German Expressionists and most of the National Artists (those who do not belong to Jewish Surrealism).

The stylistic group of Realists includes painters who devote themselves to painting portraits, landscapes and still lifes, drawn from nature in realistic technique, namely a technique aspiring to the best possible approximation to nature. This category includes the Bezalel style.

It is possible to organize these styles (stylistic categories or groups) on a continuum of the rigidity of professional requirements, or the individual freedom of an artist, in the following way:

individual freedom of the artist

Conceptualism
Lyrical and Geometrical Abstractionism
Naive
Free Figurative
Expressionism
Surrealism
Realism

rigidity of professional requirements

In a more schematic and simplified fashion, it is possible to divide the population of artists into two groups: figurative styles and abstract styles. The professional requirements for the figurative painters are much more rigid than for the abstract artists; while the abstract artists enjoy much greater individual freedom.

The numerical distribution of artists among the stylistic groups is presented in table 1.[3]

Table 1. *The distribution of the population among the stylistic groups*

Style	Painters (in %)
Lyrical and Geometric Abstractionism	34
Conceptualism	10
Free Figurative	35
Surrealism	10
Naive	4
Expressionism	4
Realism	3

N = 477

Between the years 1921–1978, different styles appeared during different periods and the distribution of the population among the stylistic groups constantly changed (see table 2).

The change was in the direction of diminishing rigidity of professional requirements and increasing freedom of the individual painter. This change had two expressions. First, the relative proportion of the abstract styles in the population increased almost twofold, and in contrast to them, the population of figurative styles diminished greatly. Secondly, there occurred a proliferation of styles. (This development also increased the artist's freedom of choice among different systems of norms, and therefore, diminished the necessity of obeying any one of them.) For example, artists working in Lyrical Abstractionism and Free Figurative style decrease from the 85 percent of the population of the group which embarked on its career in the 1920s to 58 percent of the group beginning in the 1970s. Two other styles represent an additional 30 percent; these are Surrealism and Conceptualism which appeared, in fact, only in the 1950s, while the majority of the representatives of these styles joined the population in the 1960s and 1970s.

The other 11 percent are distributed more or less equally among the remaining styles. They represent but a small portion of the population. However, they were defined as distinct categories because the professional requirements confronting painters in the frameworks of two of them, Expressionism and Realism, are much more rigid than in the Free Figurative style, and while they are as rigid, or even less rigid, than in Surrealism, the nature of the restrictions is different in their case: the freedom of the Expressionist or Realist artist is more restricted in his relation to and choice

Table 2. *Artists by painting style and year of beginning of painting career in Israel (in %)*

Style	21–30	31–40	41–50	51–60	61–70	71–78
Lyrical and Geometric Abstractionism	23.1	28.6	38.6	42.3	33.3	26.7
Conceptualism	0.0	0.0	2.3	4.5	12.7	14.3
Surrealism	0.0	0.0	2.3	7.2	11.9	16.2
Free Figurative	61.5	64.3	47.7	37.8	27.8	31.4
Naive	7.7	0.0	4.5	2.7	5.6	3.8
Expressionism	0.0	0.0	4.5	3.6	5.6	2.9
Realism	7.7	7.1	0.0	1.8	3.2	4.8

N = 477

of subjects. It is rather difficult to place Naive style in this framework. There are no professional requirements for a Naive artist; he is by definition a dilettante, a Sunday painter, not a professional. A painter manifesting a high degree of professionalism in execution will not be defined and will not be accepted as a Naive painter. At the same time, a Naive painter is not as free in his work as an Abstract or a Conceptualist artist, he has to be faithful to the object of the painting. Most of the Naive painters joined the population in the 1960s and 1970s. These are, therefore, the years when the styles in which there are no rigid professional requirements and in which the freedom of a painter is the highest, flourished.

The distribution of the styles according to years of immigration of the painters reflects the periods in which different styles appeared or were imported to Israel. Among the Realists and Free Figurative painters very many immigrated before the foundation of the State. On the other hand, among the painters working in new styles – Conceptualism and Surrealism – there are high percentages of Israeli-born artists as well as of those who immigrated to Israel after 1948 (see table 3). There is an exception to the general pattern: very high percentages of Realists, Expressionists and Free Figurative painters among the immigrants of the 1970s. This phenomenon may be explained by the immigration from the USSR which brought many artists working in these styles.

The distribution of the population of painters according to countries of origin does not add much information. It shows the preference of Eastern European immigrants for figurative styles, more or less equal distribution by styles among immigrants from Western Europe, and the preference for

Table 3. *Artists by painting style and by years of immigration (in %)*

Style	Israeli born	Immigrated in the years			
		before 1948	1948–1959	1960–1969	1970+
All the population	25.9	37.9	23.2	6.5	6.4
Lyrical and Geometric Abstractionism					
1921–1978	30.5	46.6	16.0	5.3	1.5
1970s	44.4	11.1	22.2	14.8	7.4
Conceptualism					
1921–1978	44.1	8.8	17.6	14.7	14.7
1970s	35.7	7.1	0.0	21.4	35.7
Surrealism					
1921–1978	36.8	7.9	42.1	10.5	2.6
1970s	42.9	0.0	42.9	7.1	7.1
Free Figurative					
1921–1978	16.8	45.6	24.8	4.7	8.1
1970s	19.4	22.6	16.1	6.5	35.5
Naive					
1921–1978	12.5	56.3	25.0	6.3	0.0
1970s	33.3	0.0	33.3	33.3	0.0
Expressionism					
1921–1978	13.3	20.0	40.0	6.7	20.0
1970s	0.0	0.0	0.0	0.0	100.0
Realism					
1921–1978	7.7	30.8	23.1	15.4	23.1
1970s	0.0	0.0	40.0	0.0	60.0

N = 401

abstract styles among all other groups, especially among Israeli-born painters and immigrants from North America (see table 4).

In relation to the education of the painters, the points worthy of consideration are the following: in all the groups, with the exception of Expressionists and Realists beginning their careers during the last decade, there is a certain percentage of artists with no formal education. This proportion increased twofold among the Lyrical and Geometric Abstractionists who began their careers in the 1970s. Among the representatives of all styles there is a certain percentage of artists who in addition to formal education had some experience of apprenticeship. Especially notable is the proportion of Realists who had such an experience. Among the painters who were

Table 4. *Artists by painting style and by countries of origin (in %)*

Style	Eastern Europe	Western Europe	Asia–Africa	Latin America	Israel	North America
All the population						
1921–1978	48.2	12.7	7.4	2.2	24.7	4.8
1970s	43.7	6.8	8.7	3.9	29.1	7.8
Lyrical and Geometric Abstractionism						
1921–1978	38.0	16.2	9.2	2.1	30.3	4.2
1970s	21.4	10.7	14.3	3.6	42.9	7.1
Conceptualism						
1921–1978	22.5	7.5	7.5	5.0	42.5	15.0
1970s	20.0	6.7	13.3	6.7	33.3	20.0
Surrealism						
1921–1978	48.8	7.0	4.7	7.0	32.6	0.0
1970s	43.8	0.0	6.3	12.5	37.5	0.0
Free Figurative						
1921–1978	58.1	14.2	6.1	0.7	16.2	4.7
1970s	60.6	9.1	3.0	0.0	18.2	9.1
Naive						
1921–1978	68.8	0.0	18.8	0.0	12.5	0.0
1970s	33.3	0.0	33.3	0.0	33.3	0.0
Expressionism						
1921–1978	66.7	20.0	0.0	0.0	13.3	0.0
1970s	100.0	0.0	0.0	0.0	0.0	0.0
Realism						
1921–1978	76.9	0.0	7.7	0.0	7.7	7.7
1970s	100.0	0.0	0.0	0.0	0.0	0.0
All Abstract styles	31.4	49.1	51.6	55.5	58.2	60.0
All Figurative styles	68.6	50.9	48.4	44.5	41.8	40.0

Table 5. *Artists by painting style and by education (in %)*

Style	Apprentice-ship	No formal education	Bezalel	Avni institute	Other institutions in Israel	Institutions abroad
All the population						
1921–1978	44.0	16.6	6.7	7.0	11.3	58.3
1970s	35.5	21.8	7.2	9.0	15.4	46.6
Lyrical and Geometric Abstractionism						
1921–1978	50.3	15.6	9.2	9.9	12.8	52.5
1970s	32.1	21.4	10.7	10.7	28.6	28.6
Conceptualism						
1921–1978	30.6	15.2	12.1	6.1	18.1	48.5
1970s	23.0	15.3	7.6	7.6	23.0	46.5
Surrealism						
1921–1978	42.9	17.5	2.5	2.5	12.5	65.0
1970s	31.2	33.3	6.7	6.7	6.7	46.7
Free Figurative						
1921–1978	43.0	13.2	3.3	6.6	10.5	66.4
1970s	43.7	15.6	3.1	9.3	15.6	56.4
Naive						
1921–1978	27.8	58.8	11.8	0.0	0.0	29.5
1970s	25.0	50.0	25.0	0.0	0.0	25.0
Expressionism						
1921–1978	20.0	0.0	13.3	6.7	6.7	73.4
1970s	33.0	0.0	0.0	0.0	0.0	100.0
Realism						
1921–1978	59.3	16.7	16.7	0.0	0.0	66.6
1970s	40.0	0.0	20.0	0.0	0.0	80.0

N = 433

Table 6. *Artists by painting style and by patterns of staying abroad (in %)*

	Artists living abroad for periods exceeding one year	Artists living abroad for the purpose of study only
All the population		
1921–1978	70.0	46.0
1970s	55.0	
Lyrical and Geometric Abstractionism		
1921–1978	66.2	36.8
1970s	50.0	
Conceptualism		
1921–1978	77.1	34.3
1970s	78.6	
Surrealism		
1921–1978	61.5	43.6
1970s	47.1	
Free Figurative		
1921–1978	75.7	58.3
1970s	62.5	
Naive		
1921–1978	29.4	23.5
1970s	0.0	
Expressionism		
1921–1978	75.0	62.5
1970s	100.0	
Realism		
1921–1978	33.3	33.3
1970s	20.0	

N = 477

trained in Israel the relatively high percentage of Conceptualists educated in the Bezalel Academy of Art attracts attention. In general, more Conceptualists and Lyrical Abstractionists were educated in Israel than representatives of different figurative styles; the proportion of alumni of foreign art education institutions among the representatives of abstract styles is small relatively to other groups (see table 5).

Most of the Israeli painters lived abroad for periods longer than one year at times other than while studying. The proportion of Conceptualists living abroad not for educational purposes is larger than among other groups (with the exception of Expressionists) and increases with time (see table 6).

It is possible to explain the high percentage of Expressionists beginning their career in Israel in the 1970s and living abroad in periods other than during their studies by the fact that all of them are new immigrants arriving in the 1970s. In contrast to them, among the Conceptualists who began their career in the 1970s a very high percentage are Israeli born (see table 3). Nevertheless, the proportion of those who lived abroad for long periods at some time other than during their studies is also very high and increasing relative to other groups.

Apart from these points no demographic characteristics meaningfully distinguish between representatives of different styles.[4]

The sociological analysis of the social structure of Israeli painting in the following chapters will mainly take into account the present situation. For this reason, particular attention will be paid to Conceptualism and Surrealism. These two styles may be viewed as paradigms of the broader stylistic groups to which each of them belongs. In Conceptualism the principles of abstract styles allowing for the maximal freedom of the artist are expressed in the clearest fashion, while Surrealism, similarly expresses the common principles of figurative styles in which an artist is confronted by clear professional requirements. In addition, both styles appeared, as groups significant from the quantitative point of view and possessing definite identity, during the period in which the split of the Israeli art world into two subsystems reached its peak. (Individual Conceptualists and Surrealists were active during the 1950s. This fact is easily explained. Some prominent Conceptualists exhibited together with Lyrical and Geometrical Abstractionists in those years and were not yet defined as Conceptualists. And some of the distinguished contemporary Surrealists began their creative activity in the frameworks of other figurative styles before Surrealism became a recognizable phenomenon in Israel and received its name.) Therefore, even though these styles existed before the split, they still serve as purest examples of the patterns of success in the two subsystems.

For the same reason, special consideration will be given to the generation of the 1970s, those painters who began their careers at the time in which two different systems of support coexisted in Israel.

3 Patterns of success

The patterns of success of the Israeli artists were analyzed along two dimensions. The first dimension was that of the profiles of success, namely the characteristics of a successful artist in each of the different stylistic frameworks, what such success consists of and the nature of the rewards associated with it. The second was the dimension of career routes, the way in which the success is achieved and the factors that affect it.

The profiles of success were constructed by means of the following variables:

1 Exhibitions in art galleries. The galleries were classified according to prestige – from type 1, most prestigious, to type 4, the least – established on the basis of the following characteristics: number of one-man shows held there per decade, location of the gallery, housing group exhibitions considered important, organization of exhibitions in other places (especially abroad) by the gallery, publication of reproductions and catalogues, references to the gallery in press (in the case of galleries specializing in contemporary art in the last two decades), and prices of paintings (in the case of galleries exhibiting figurative art). (See appendices A/a and A/c.)

2 Exhibitions in museums, also classified by prestige. Type 1, the most prestigious category, included the three central museums: the Tel-Aviv Museum, the Israel Museum in Jerusalem (the Bezalel museum till the 1960s) and the Museum of Modern Art in Haifa. These museums are located in independent cultural centers, provide forums for very important cultural events and always attract the attention of the press. Types 2 and 3 include peripheral museums which have an art department. They were classified according to decreasing cultural importance. Type 5 consists of various public institutions that are not specifically artistic in which painters studied in this research had one-man shows. Type 4 is, actually, an exception because it includes the Houses of the Artists' Association which can be used by any of its members as an exhibition-

Table 7. *Artists by type of success and by years of beginning of painting career (in %)*

	21–30	31–40	41–50	51–60	61–70	71–78
Artists whose success is a combined success by means of museums as well as private market	61.6	73.4	68.2	53.0	44.0	34.4
Artists succeeding in separate systems, either through public institutions or by means of private market	38.5	26.6	31.8	47.0	56.0	65.6

N = 451

forum. Exhibitions in the Artists' Houses (despite their being important forums, judging by the kind of exhibitions held there from time to time and the attention of the press to what is going on there), are an ascribed reward rather than an achieved one. (See appendices A/a and A/b.)

3 Prizes, including specifically artistic prizes, prizes in honor of various public events, and scholarships.

4 Sales of works of art to public institutions or execution of such works commissioned by public bodies.

5 Frequency of exhibitions.

6 Pattern of exhibitions; the relative preference for one-man shows vs. group shows in a career.

7 Exhibitions abroad.

8 Participation in international exhibitions on behalf of various public authorities in Israel.

9 Significance of painting as a source of income (exclusive, partial or insignificant).

10 Offices held by the artists.

Career routes were characterized by a set of the following additional variables:

1 Age at the time of the first success; "first success" meaning any reward among the rewards composing success (variables 1, 2, 3, 4, 7, 8 above).

2 The order of exhibitions and prizes: which kind of exhibition and where

Table 8. *Artists whose success is a combined success of the highest level by year of beginning of painting career in Israel (in %)*

	21–30	31–40	41–50	51–60	61–70	71–78
Artists whose success is a combined success of the highest level	46.2	33.4	36.1	20.1	9.1	2.6

N = 451

(type of forum) preceded other shows, were exhibitions preceded by prizes, and so forth.
3 Consistency of exhibitions or mobility: moving up and down the hierarchy of galleries of museums.

In general, the findings show that the success of artists working in styles in which professional requirements do not exist or are not rigid is more glamorous, more conspicuous and includes more varied rewards than the success of the artists working in styles characterized by rigid professional requirements. The success of these latter is also more difficult to achieve, the way to it is longer and artists are supposed to traverse it alone, while the career route of their colleagues in the free styles is relatively short and those advancing there enjoy different kinds of support.

Table 9. *Rates of exhibiting in galleries in different style-groups*

Style	Painters who exhibited in galleries (in %)
Population	75.0
Lyrical and Geometric Abstractionism	81.8
Conceptualism	87.2
Free Figurative	70.3
Surrealism	82.5
Naive	68.7
Expressionism	56.2
Realism	20.0

N = 433

Table 10. *Rates of exhibiting in galleries of type 1 in different style-groups*

	Painters who exhibited in galleries of type 1 (in %)	
	1921–1978	1970s
Population	55.0	31.7
Lyrical and Geometric Abstractionism	61.2	37.1
Conceptualism	64.1	33.4
Surrealism	53.7	50.0
Free Figurative	51.4	22.6
Naive	52.9	50.0
Expressionism	40.0	33.3
Realism	9.1	0.0

N = 433

The first four variables depicting success were joined to construct tentative types of different kinds and levels of success, which can be grouped into two principal categories: the combined success (on various levels) and success by means of one of the separate reward systems (the private market and the system of public institutions). The distribution of these types by the years of the beginning of activity renders the split which occurred in the Israeli art world conspicuous. (See chapter 1, part 3.) More and more, particularly in the last twenty years, the success of an artist is exclusively connected to one of the two systems of rewards. This can be seen in table 7.

As table 8 shows, the proportion of those whose success can be described as combined success at the highest level declines even more drastically.

Specific variables vary in accordance with the style, the determinant dimension in regard to artists' success.

Rates of exhibiting in the galleries are different for artists working in different styles. Artists working in styles that lack rigorous professional requirements, in general exhibit in the galleries more than their colleagues whose styles are characterized by relatively clear criteria of judgment. An exception is the Surrealists who exhibit in the galleries less than Conceptualists, but more than other Abstractionists (see table 9).

The situation is different in regard to exhibitions in galleries of type 1 representing the highest level of success in this sector, particularly when the artists beginning their career in the 1970s are considered (see table 10). The table shows that, in general most of those painting in styles that do not

Table 11. *Rates of exhibiting in public institutions in different style-groups*

Style	Painters who exhibited in public institutions (in %)
Population	72.0
Lyrical and Geometric Abstractionism	72.3
Conceptualism	66.7
Free Figurative	77.1
Surrealism	55.0
Naive	81.2
Expressionism	81.2
Realism	80.0

N = 432

demand compliance with professional standards have a chance to achieve an exhibition in a gallery of type 1, compared to half of the Surrealists, Naives and Free Figurative painters and to an even smaller percentage of the artists painting in styles, in which the freedom of the painter is limited in regard to the subject as well (Expressionists and Realists). However, while half of the

Table 12. *Rates of exhibiting in museums of type 1 in different style-groups*

Style	Painters who exhibited in museums of type 1 (in %)	
	1921–1978	1970s
Population	27.0	7.4
Lyrical and Geometric Abstractionism	26.2	3.8
Conceptualism	46.2	26.7
Surrealism	12.2	0.0
Free Figurative	28.3	6.5
Naive	31.2	25.0
Expressionism	50.0	0.0
Realism	18.2	0.0

N = 432

Surrealists beginning their activity in the 1970s exhibit in the most pres-
tigious galleries, percentages of painters working in free styles and exhib-
iting in these galleries among those who started in the 1970s decline.[1] The
proportion in other groups also declines, and this decline may be viewed as
an expression of the growing selectivity of this type of gallery. The high
percentage of the Surrealists belonging to the generation of the 1970s, who
exhibit in the galleries of type 1, shows that this style, more than any other,
answers in this period the requirements of this system.[2]

The situation in museums and other public institutions in which exhi-
bitions are held provides an interesting comparison. Surrealists and Concep-
tualists exhibit in public institutions less than any other group (see table 11).

However, when the important museums alone are considered, the pro-
portion of Conceptualists exhibiting in them is the second highest. It is the
highest (relative to almost nonexisting rates of exhibiting there in all the
other groups) in the generation of the 1970s (see table 12).

To summarize, the situation in regard to the connections of different
styles to the systems of private market and public institutions is as follows.
Conceptualists exhibit in the galleries more than any other group, the
decisive majority among those exhibiting in the galleries being artists who
exhibit in galleries of type 1, namely artists who achieve the highest level of
success in this sector. Conceptualists are also related to the important
museums and exhibit there more than any other group in the population of
painters. One has to keep in mind that the galleries in which Conceptualists
exhibit are not commercial; the public they address does not buy much while
the part of it that does buy consists mainly of the representatives of the
museums. (Concerning types of the galleries see p. 110.) These painters are,
therefore, affiliated almost exclusively, and much more tightly than other
groups in the population, with public art institutions and are not connected
with the world of "commercial" art or the art market. The decrease of the
proportion of artists exhibiting in galleries of type 1 among the Conceptual-
ists belonging to the generation of the 1970s can be explained by the
decrease of the number of galleries that specialize in this kind of art in Israel.
In contrast, Conceptualists tend not to exhibit in public institutions serving
as provisional exhibition-forums (such as community centers, Soldiers'
Houses, etc.), where having an exhibition is not considered a prestigious
reward.

Surrealists exhibit in the galleries more than any other group, with the
exception of the Conceptualists. As they exhibit only in commercial galleries,
addressing first and foremost the public of buyers, and not in the galleries in
which Conceptualist artists may hold their exhibitions, it is possible to claim

that their rate of exhibiting in this sector is the highest among all the style-groups. It is particularly notable in the generation of the 1970s. In contrast, Surrealists exhibit less than all the other groups in important museums; when the generation of artists who started their activity in the 1970s is considered, Surrealists do not exhibit in important museums at all. They represent a group less inclined than any other to exhibit in public institutions providing occasional exhibition-forums. The success of the artist in this group is exclusively connected to the private market system.

Other styles are located at different points between these two stylistic groups. Abstractionists, in terms of their affiliation with reward systems, represent a less glamorous version of the Conceptualists. Free Figurative painters resemble Surrealists. Patterns existing among the three small groups are less similar to these two patterns. The Naive painters are accepted by both systems and can boast of very impressive achievements. (This can be explained by the special character of the style which, paradoxically, both allows for a great degree of freedom of an individual artist and has rather high professional demands.) The same cannot be said about the two remaining groups. Realists do not succeed in either system; few of them exhibit in the galleries, and among those who do, still fewer exhibit in prestigious galleries. Their market situation looks even worse when the generation of the 1970s alone is considered. Not a single Realist who began in the 1970s exhibited in an important museum. In fact, most of them exhibit in public institutions which are less important artistically and represent provisional exhibition-forums. The Expressionist group can be described as rather successful in both systems. However, a beginning Expressionist has few chances of success and then only on the private market. From the point of view of the museums, the requirements of which this style apparently met in earlier decades, it is now out of fashion.

It is not difficult to explain the present situation of these two style-groups against the background of institutional changes that occurred in the Israeli art world, described in chapter 1. In the beginning Realism was anchored in the old Bezalel and was left without supporting institutional framework already by the end of the 1920s.

Expressionism was affiliated with "new Bezalel" of the 1930s and the 1940s which in its time held the keys to the most important art museum in Jerusalem, and if not the most important in the country, then at least as important as the Tel-Aviv museum. The Bezalel museum ceased to exist and gave its place to the Israel Museum which manifested quite different preferences. However, already from the beginning of their activity in Israel, Expressionists were connected to the first galleries which in time became the most prestigious ones.

Table 13. *Artists sent to international exhibitions by year of beginning painting career in Israel (in %)*

	21–30	31–40	41–50	51–60	61–70	71–78
Artists sent to international exhibitions	53.8	33.3	39.2	26.9	16.2	13.1

N = 449

The differences among the style-groups are not limited to their relationships with galleries and museums. Their characteristic ways of exhibiting abroad differ as well.

Approximately one-fifth of painters participated at different times in international exhibitions on behalf of public authorities in Israel. Usually they were sent by the Ministry of Culture, Ministry of Tourism or, in fewer cases, Ministry of Foreign Affairs, all of which placed the selection of artists in the hands of a special curator for the exhibition. The proportion of those who participated in international exhibitions is directly related to the number of years in art (see table 13). This proportion is much smaller among figurative style-groups than among abstract painters, and among the figurative painters it is especially low among Realists and Surrealists, namely among artists working in styles with particularly strict requirements of

Table 14. *Artists sent to international exhibitions by painting style*

Style	Artists sent to international exhibitions (in %)
Population	22.0
Lyrical and Geometric Abstractionism	29.7
Conceptualism	41.5
Free Figurative	16.2
Surrealism	11.4
Naive	27.8
Expressionism	25.0
Realism	8.3

N = 472

Table 15. *Artists who exhibited abroad by painting style*

	Artists who exhibited abroad	
	1921–1978	1970s
Population	69.0	56.7
Lyrical and Geometric Abstractionism	65.5	36.0
Conceptualism	80.5	86.7
Surrealism	72.7	72.0
Free Figurative	68.5	53.0
Naive	64.7	25.0
Expressionism	75.0	100.0
Realism	83.3	80.0

N = 449

artistic performance; and the highest among the Naive painters whose style can be interpreted in a dual fashion by the "gatekeepers" (see table 14).

If those exhibitions abroad which are independent from public authorities in Israel are considered, the high proportion of Conceptualists participating in such exhibitions, which increases in the generation of the 1970s, stands out against the background of lower and decreasing proportion in other groups once again. This can be seen in table 15. The exception is Expressionists; 100 percent of those who began their painting career in Israel in the 1970s had exhibitions abroad. This can be explained by the fact that all the Expressionists who began their artistic activity in Israel in these years are new immigrants and arrived there only in the 1970s (see table 3).

Another difference among artists working in different styles has to do with their characteristic patterns of exhibiting, the relative preference for one-man shows vs. participation in group exhibitions. The differences among style-groups are especially interesting in regard to the patterns of exhibiting abroad. Remarkable is the proportion of Conceptualists exhibiting solely in the framework of Israeli group exhibitions, namely exhibitions organized by groups of Israeli artists. Particularly interesting is the comparison with Surrealists who almost never participate in shows organized by Israeli groups abroad. In contrast, only few Conceptualists – and once again the comparison with Surrealists attracts attention – participate in foreign group exhibitions, namely exhibitions organized by groups of foreign artists. In

Table 16. *Patterns of exhibiting abroad among different style-groups (in %)*

Style	One-man shows only	Israeli group shows only	Foreign group shows only
Population	20.0	4.0	8.0
Lyrical and Geometric Abstractionism	15.5	5.4	6.8
Conceptualism	17.1	12.2	7.3
Surrealism	20.5	2.3	18.2
Free Figurative	21.4	0.6	7.1
Naive	23.5	5.9	11.8
Expressionism	25.0	0.0	12.5
Realism	25.0	8.3	8.3

N = 449

general, figurative artists participate in exhibitions of this kind more frequently. These artists also, in greater proportion than their Lyrical Abstractionist and Conceptualist colleagues, exhibit abroad solely in the framework of one-man shows (see table 16).[3]

Findings concerning home exhibitions attract attention as well. The proportion of those exhibiting one-man shows only is small among the Conceptualists in particular, and is smaller in general among artists working in free

Table 17. *Artists exhibiting in one-man shows only by painting style*

Style	Artists exhibiting in one-man shows only (in %)
Population	16.8
Lyrical and Geometric Abstractionism	14.2
Conceptualism	14.6
Free Figurative	14.9
Surrealism	18.2
Naive	22.2
Expressionism	43.8
Realism	30.8

N = 434

Table 18. *Order of exhibitions among different style-groups (in %)*

Style	One-man show after group exhibition	Group exhibition after one-man show	Both types of exhibition during the same year	Exhibited abroad after exhibiting in Israel	Exhibited abroad before exhibiting in Israel	Artists who were sent to international exhibitions before they exhibited anywhere else
Population	41.9	26.5	9.9	65.0	35.0	2.0
Lyrical and Geometric Abstractionism	48.0	24.3	8.8	74.0	26.0	0.7
Conceptualism	46.3	24.4	14.6	71.9	28.1	5.0
Surrealism	38.6	22.7	13.6	62.5	37.5	0.0
Free Figurative	39.0	31.8	9.7	58.2	41.8	0.0
Naive	38.9	27.8	5.6	83.4	16.6	0.0
Expressionism	25.0	18.8	6.3	50.0	50.0	0.0
Realism	30.8	15.4	7.7	34.4	66.6	0.0
				N = 298*		N = 101**

N = 434
*Only 69% of the population exhibited abroad
**Only 22% of the population exhibited in international exhibitions

Table 19. *Minimal frequency of activity by style (in %)*

Style	One show per three years	One show per two years	One show per one year	Number of shows per one year
Population	63.9	17.9	17.5	0.6
Lyrical and Geometric Abstractionism	66.4	13.8	19.0	0.9
Conceptualism	47.1	26.5	23.5	2.9
Surrealism	53.6	28.6	17.9	0.0
Free Figurative	67.6	16.2	16.2	0.0
Naive	76.9	7.7	15.4	0.0
Expressionism	60.0	40.0	0.0	0.0
Realism	83.3	16.7	0.0	0.0

N = 313

styles than among their figurative colleagues (see table 17). This feature of the profiles of success of these different styles corresponds to a certain characteristic of career routes among them. If we examine the sequence of exhibitions among artists belonging to different style-groups, it is evident that the proportion of those exhibiting in one-man shows after participating in group exhibitions is higher among the abstract groups than among the figurative painters. The proportion of those exhibiting abroad after having an exhibition in Israel is also higher among them. Furthermore, among the Conceptualists there exists a number of artists who were sent on behalf of Israeli public authorities to represent Israel at international exhibitions before they exhibited in any framework in Israel, before their achievements were exposed before any public (including representatives of the public authority on the behalf of which they were sent) and before it was possible to compare these works with works of other artists. This number is not large but exceptionally significant against the background of other groups which can boast of nothing of the kind (see table 18).

These facts – the high proportion of those participating in Israeli group exhibitions abroad and of those who have one-man shows after group exhibitions in Israel, the high proportion of those exhibiting abroad after having a show in Israel and a certain percentage of artists sent to international exhibitions before exhibiting in any other framework – make it possible to describe the promotion of an artist working in abstract styles

Table 20. *Maximal frequency of activity by style (in %)*

Style	One show per three years	One show per two years	One show per one year	Number of shows per one year
Population	4.8	6.1	21.3	67.8
Lyrical and Geometric Abstractionism	6.9	6.9	17.3	69.0
Conceptualism	0.0	0.0	20.6	79.4
Surrealism	3.6	10.7	28.6	57.1
Free Figurative	1.9	6.6	23.5	67.9
Naive	15.4	0.0	23.1	61.5
Expressionism	10.0	0.0	20.0	70.0
Realism	0.0	16.7	33.3	50.0

N = 313

(especially Conceptualism) in general terms as a promotion by means of a corporate action, sponsored by the group and as an ascriptive, rather than achievement-based success. This conclusion is supported by the data in chapter 1, which described the activity of the pressure groups organized by abstract artists. One may conclude that it is the group which is responsible for the Conceptualist artist's recognition in Israel as well as abroad (this applies to Abstractionists as well, though to a lesser degree). It is the group, which paves the way for him to the one-man shows and takes care of his reputation in various other ways. The most important achievement for the artist working in this style is the admission into the group. The rewards he receives afterwards he receives because he belongs to the group, or because he is defined as a Conceptual artist; they are bestowed upon him on a "party" basis, to some extent. If we were to borrow a concept from a different field, we have here an example of "sponsored" mobility.[4]

Figurative artists and particularly Surrealists (as only they can be regarded as a significant group and only their success is an impressive one which can be compared to the success of Conceptualists) are apparently much lonelier on their way to success; it seems that everything they achieve, they achieve through individual efforts and that there are no agents standing behind and promoting these artists (as a group). This is, by analogy, an example of "contest" mobility.

Another point which attracts attention is the pace at which one important achievement follows another among different style-groups. Once more the

Table 21. *Artists by painting style and by age of the first success (in %)*

	First success reached			
Style	Before 25	25–35	35–45	45+
Population	23.2	55.0	15.6	6.2
Lyrical and Geometric Abstractionism	19.6	55.9	20.6	3.9
Conceptualism	38.9	58.3	2.8	0.0
Surrealism	25.0	60.7	14.3	0.0
Free Figurative	23.3	55.8	16.3	4.7
Naive	0.0	28.6	7.1	64.3
Expressionism	26.7	46.7	20.0	6.7
Realism	25.0	62.5	12.5	0.0

N = 315

proportion of artists that both have a one-man show and participate in a group exhibition during the first year of artistic career is the highest among the Conceptualists (see Table 18). This high frequency of achievements among them can be also detected in the number of exhibitions they had per period of time. For each artist the smallest period of time passing between two exhibitions was taken as an index of the "maximal frequency of activity," while the longest period of time passing between two exhibitions served as an index for the "minimal frequency of activity" (tables 19, 20).

The Conceptualists are far more active than the other groups; both in their most and in their least active periods, their activity exceeds that of all other groups. Only for half of them the minimal activity is one exhibition in three years and only in one other group, the Abstractionists, are there artists whose minimal activity equals the maximal (a number of shows per one year). Surrealists are the second most active group when least active periods are compared. Conceptualists are even more prominent in regard to maximal activity: there is no other group besides them that is concentrated in the two highest categories of maximal activity, and there is no other group, of course, 80 percent of which is concentrated in the highest possible category. The second most active group this time, when most active periods are compared, is Expressionists, while Surrealists are left far behind them; only Realists' achievements are less impressive than theirs.

The fact that Conceptualists' advancement is much faster than in other styles is also clear from the age at which these artists reach their first success.

Table 22. *Exhibition mobility patterns among different style-groups (in %)*

Style	A	B	C	D	E	F
Population	53.0	3.0	18.0	49.0	11.0	12.0
Lyrical and Geometric Abstractionism	61.3	6.0	14.5	46.5	10.1	15.3
Conceptualism	53.8	2.6	30.7	56.4	2.6	7.7
Surrealism	40.0	7.5	3.5	45.0	2.5	7.5
Free Figurative	52.9	2.9	15.5	47.9	15.7	13.6
Naive	50.0	0.0	18.5	81.3	0.0	0.0
Expressionism	43.8	0.0	12.5	50.0	25.0	6.3
Realism	20.0	0.0	0.0	70.0	0.0	10.0

A All the time exhibit in the same type of gallery
B Ascend from less to more prestigious galleries
C Descend from more to less prestigious galleries
D All the time exhibit in the same type of museum
E Ascend from less to more prestigious public institutions
F Descend from more to less prestigious public institutions
N = 398

A very high percentage of Conceptualists reach success early, before the age of twenty-five; in this they differ from all the other groups in the population (table 21).

The pace of receiving rewards or the frequency of activity does not always indicate the pace of advancement, as it is not always possible to speak about advancement in this framework, but rather about a lucky placement at the beginning of the artistic activity. The degree of success of the majority of artists is determined from the beginning, at the moment of their first public appearance. The continuation of their careers consists of repetitions of the initial achievement; usually they continue to exhibit at the same type of exhibition-forum in which they had their first show. There are cases of a temporary or permanent downward mobility, when a prestigious forum of the type an artist already exhibited at is not available or when a style loses its value in the eyes of the "gatekeepers" (Expressionism may serve as an example of such a situation). However, only in very few cases is there an upward movement from a less prestigious gallery to a more prestigious one; important museums do accept painters who previously exhibited in less important institutions, but in this case as well only rarely (table 22).

However, not only in regard to the character, pace and places of exhibitions do the groups of artists working in different styles differ. Other rewards also are distributed unequally in the Israeli art world.

Table 23. *Recipients of prizes among different style-groups*

Style	Painters – recipients of prizes (in %)
Population	28.0
Lyrical and Geometric Abstractionism	31.7
Conceptualism	18.9
Free Figurative	28.3
Surrealism	23.8
Naive	41.2
Expressionism	25.0
Realism	36.4

N = 407

In contrast to exhibitions (which represent an activity that contains its reward within itself) which are the share of all the artists in this study, other rewards are less frequent. Thus, less than a third of the population received prizes. The prizes are awarded by different agencies for works of art at exhibitions or in the framework of special competitions. In this case it is the group of Realists that stands out as the more successful. This is explained by the fact that many of the prizes in question are municipal prizes for works

Table 24. *Painters granted scholarships among different style-groups*

Style	Painters – recipients of scholarships (in %)
Population	9.0
Lyrical and Geometric Abstractionism	8.8
Conceptualism	21.6
Free Figurative	6.2
Surrealism	11.9
Naive	0.0
Expressionism	6.2
Realism	9.1

N = 403

Table 25. *Recipients of commissions from public institutions for execution of works of art by style-groups*

Style	Painters – recipients of orders (in %)
Population	
1921–1978	9.0
1970s	1.9
Lyrical and Geometric Abstractionism	
1921–1978	8.7
1970s	7.7
Conceptualism	
1921–1978	8.1
1970s	6.6
Free Figurative	
1921–1978	7.0
1970s	0.0
Surrealism	
1921–1978	12.5
1970s	0.0
Naive	
1921–1978	11.8
1970s	0.0
Expressionism	
1921–1978	31.2
1970s	0.0
Realism	
1921–1978	9.1
1970s	0.0

N = 402

dedicated to certain subjects, while Realism is the style in which definite subjects are executed in the clearest fashion. In contrast to them, Conceptualists stand out as the least successful in this respect (table 23).

In the case of scholarships which are in essence prizes for potential works, it is Conceptualists who receive them more frequently. In distinction to the distribution of prizes, in which various extra-artistic groups take part, scholarships are usually granted from special funds for art and culture by committees consisting of or supervised by people related to these fields (table 24).

Table 26. *Sales of artistic works to various public institutions among different style-groups (in %)*

Style	Israel museum	Tel-Aviv museum	Museum of modern art in Haifa	Public bodies abroad	Permanent exhibition in galleries
Population Lyrical and Geometric	9.0	8.0	9.0	10.0	4.0
Abstractionism	13.7	11.5	12.5	9.9	3.1
Conceptualism	18.9	10.8	13.9	16.2	8.3
Surrealism	2.6	5.3	7.9	8.1	10.5
Free Figurative	6.4	6.4	7.1	11.3	4.3
Naive	0.0	6.1	6.3	0.0	6.3
Expressionism	12.5	12.5	12.5	12.5	6.1
Realism	0.0	0.0	0.0	0.0	0.0

N = 389

Only a few of the painters receive commissions from public institutions for execution of works of art (in this respect the demand for sculptors is greater than for painters). The group in which the highest proportion of painters received such commissions is Expressionism. Despite the high demand for their work earlier nothing was ordered from them in the last decade. This is true for figurative painters as well. In contrast, the demand for Abstract and

Table 27. *Overall purchases of the three important museums by style-groups*

Style	Israel museum	Tel-Aviv museum	Museum of modern art in Haifa
Population Lyrical and Geometric	100.0	100.0	100.0
Abstractionism	48.6	44.1	43.2
Conceptualism	18.9	14.7	13.5
Surrealism	2.7	5.9	8.1
Free Figurative	24.3	26.5	27.0
Naive	0.0	3.0	2.7
Expressionism	5.4	5.9	5.4
Realism	0.0	0.0	0.0

N = 107

Table 28. *Significance of painting in the overall income of painters by style-groups (in %)*

Style	Painters for whom painting as a source of income is:		
	exclusive	partial	insignificant
Population			
1921–1978	54.8	29.8	15.5
1970s	41.9	35.8	22.2
Lyrical and Geometric Abstractionism			
1921–1978	53.1	30.6	16.2
1970s	32.0	40.0	28.0
Conceptualism			
1921–1978	33.3	53.3	13.3
1970s	18.2	63.6	18.2
Surrealism			
1921–1978	81.4	11.1	7.4
1970s	80.0	10.0	10.0
Free Figurative			
1921–1978	60.5	25.2	14.3
1970s	53.6	25.0	21.5
Naive			
1921–1978	35.7	28.6	35.7
1970s	0.0	33.3	66.6
Expressionism			
1921–1978	46.2	38.5	15.4
1970s	50.0	50.0	0.0
Realism			
1921–1978	50.0	50.0	0.0
1970s	33.3	66.6	0.0

N = 322

Conceptualist artists, though small, remained stable during the period (table 25).

The rates of sales of paintings are also different in different style-groups. Artists working in free styles sell to museums in Israel more than their figurative colleagues. Particularly conspicuous is the difference between the proportions of Conceptualists and Surrealists whose works were purchased by the Israel Museum. Conceptualists are also more successful in selling to public institutions abroad. However, in regard to private galleries, Surrealists, who sell more, surpass them, although "quality" galleries buy the works

Table 29. *Sources of income other than painting in different style-groups (in %)*

	Painters engaged in		
Style	art teaching	book illustrating	art criticism and administration
Population	58.6	5.5	6.3
Lyrical and Geometric Abstractionism	66.7	0.0	4.8
Conceptualism	56.3	0.0	12.6
Surrealism	57.1	0.0	0.0
Free Figurative	51.2	9.3	7.0
Naive	16.7	16.7	16.7
Expressionism	83.3	16.7	0.0
Realism	75.0	0.0	0.0

N = 142

by Conceptualists. In respect to galleries, the ratio between figurative and Abstract painters is different too. The percentage of figurative artists whose works were purchased by the galleries is higher than that of Abstractionists, and this is in contrast to the situation in public institutions (tables 26, 27).

Although Abstract and Conceptualist artists are more likely than other painters to have their works purchased by important public institutions, painting does not usually represent an exclusive source of income for them (table 28).

For all the figurative groups, in general, painting is more important as a source of income than for the Abstract groups. Surrealists earn their living almost exclusively as painters. In contrast to them, Conceptualists only in rare cases rely on painting as a sole source of income. This becomes even more pronounced in the generation of the 1970s. However, a change took place among the Lyrical and Geometric Abstractionists. While most of the Abstractionists who began their activity in earlier decades make their living from painting, for those of them who began in the last decade painting represents usually a partial source of income; Abstractionism does not satisfy the requirements of the private market any more; only the "classics" (the "great masters") can still afford to work in this style, if they want to earn their living from painting. This does not mean, though, that the demands of this market changed. In fact, the private market emerged only in the late 1960s, while the fact that Lyrical Abstractionism went out of fashion in the

public sector was the reason for the reluctance of "quality" galleries, which had earlier attempted to advance the sales of this kind of art, to accept works by new Abstractionists while retaining their relationships with already established artists.

What are the sources of income of those artists who cannot make their living solely by selling paintings? (table 29).[5]

It is worth noting that among the Abstract artists there are more art critics and officials of public art institutions. In contrast, only among the figurative painters are there book illustrators. The case of the Naive painters does not contradict this statement, since first, we are dealing with very small numbers, and second, Naive painters functioning as administrators or critics may be administrators or critics who at a rather advanced age acquired another hobby – painting. The distribution of artists teaching at various art schools, as had become clear in the course of the research, also varies with style. Most of the Conceptualists and Abstractionists teach in the Bezalel Academy of Art and in the college for art teachers in Tel-Aviv, while their figurative colleagues are concentrated in other art schools, the most prominent of which is Avni Institute.

Thus the profiles of success and the career routes corresponding to them are totally different for different style-groups.

The characteristics of these profiles of success and career routes, as determined by the conditions existing today, are made especially visible by Surrealists and Conceptualists. Patterns of success characterizing these two groups represent ideal-types in the framework of our discussion. The success of both groups is most impressive, but each one achieves it in its own way, and the success itself means different things in the two cases.

The group of artists painting in the Surrealist style is conspicuously affiliated with the system of private art market. Surrealists exhibit almost exclusively in galleries; only few of them have shows in public institutions. The important museums boycott the Surrealists both in exhibitions and sales. In the private market, however, they are affiliated with the most prestigious galleries. More than any other group they sell paintings to be permanently displayed in private galleries. The decisive majority of them make a living solely by their creative activity. They are not sent to international exhibitions and do not participate abroad in group shows organized by Israeli artists. At the same time, they do have one-man shows abroad and do take part in group exhibitions organized by local (foreign) artists (that is, in exhibitions, which require personal initiative and effort and represent in themselves rewards based on achievement and not on ascriptive characteristics). Many do so before exhibiting in Israel in order to establish a repu-

tation which can help them in their advancement at home. Usually they do not receive scholarships and are not supported (as representatives of a certain style-group) in any other way. Each one advances by himself. Most of them achieve the longed-for rewards at the age of approximately thirty-five, only a few succeeding before the age of twenty-five. They are rather active, though most of them do not have more than one exhibition per year, many others being content with even less than that. The careers of most of them include periods of quiet activity, namely a small number of exhibitions in a given period of time. To conclude, their route of advancement is rather long, every success is the result of a personal effort, and the main reward in it is money (even the admiration of those who enjoy their paintings is translated into money).

In contrast to them, Conceptualists are conspicuously affiliated with museums and have no connections to the private market. The decisive majority of them do not make a living from painting. Instead Conceptualist artists hold respectable teaching positions as well as administrative offices in institutions and committees dealing with art. They exhibit in the best museums and in what the press calls "quality galleries," namely galleries appealing to museum representatives who form a significant part of their small public. More than any other group they are sent to international exhibitions to represent Israeli art and more than any other group they sell their works to museums and public institutions abroad. Their inclusion in the group of successful artists, their acceptance by it, does not depend on preceding individual achievements; on the contrary, it is such inclusion which makes these achievements possible. Especially remarkable is the fact that a number of Conceptualists were chosen to represent Israeli art at international exhibitions before they exhibited in any other framework and could prove their worth. Many of the Conceptualists start from group exhibitions and most of them go abroad after exhibiting in Israel. Some of them (a relatively small number which is nevertheless bigger than in all the other groups) leave the country in the framework of group exhibitions organized in Israel. They are supported by different local institutions and do not need a reputation won abroad in order to succeed at home. At the same time, the decisive majority of them do exhibit abroad after reaching success in Israel: in contrast to figurative groups and more than Abstractionists these artists address foreign audiences as the public for whom their art is destined. Their activity is exceptionally intense, and their advancement is exceptionally fast; some 40 percent of them reach their first success before twenty-five years of age and all of them before thirty-five. To summarize: the route of their career is short. Not every accomplishment is dependent upon personal

effort; and rewards, besides money (payments for works purchased by museums and salaries these artists receive because they are artists), include respectable positions, prestige and publicity.

Two other styles enjoy impressive success in the world of Israeli art. These are the Naive style and Expressionism.

The small group of Naive artists is remarkable in its success during the last two decades which are, in fact, the decades of its existence in Israel. These painters are connected with the system of private market as well as with the most important museums. They frequently receive prizes. The Naive painters are usually not self-promoted; they are discovered at a relatively advanced age by different agents which take upon themselves the task of their promotion. Thus many of them are sent to international exhibitions. In contrast, few of them exhibit abroad not on the behalf of public authorities, and among those who do, many exhibit only in group exhibitions organized in Israel. Paradoxically, the success of Naive painters in both systems illustrates the split which occurred in the Israeli art world. This is the only style-group which is affiliated with the two systems and the special character of this style enables each of these systems to accept it willingly, but for contrary reasons. By definition of this style, the artists have to satisfy certain professional requirements (the object must be perfectly recognizable, there is a need to represent precise details and so forth), and at the same time they are completely released of all the professional demands, since the Naive artist is defined as an artist who is not a professional.

The fate of Expressionism, the second style enjoying significant success in conditions that exist today, illustrates the split which occurred in the world of Israeli art in a different fashion. During the period of cooperation between important museums and prestigious galleries appealing to the private market, namely before the 1960s, Expressionists were favored by both systems. A high (relative to the population) proportion of them exhibited in important museums; relatively, many of them were sent to represent Israel at international exhibitions and different public institutions commissioned works of art from them. In later generations there were no more commissions, and their connections with museums were completely severed. However, they remained related to the private market and a high percentage among them exhibit in the best galleries. Because of its glorious past, today this group consists of famous artists. Its exhibitions are frequently held in the most prestigious galleries, where in spite of the private character of these exhibition-forums, they attract the attention of the public. Its prestige can explain the individualistic character of artists' activity in it. Expressionists more than any other group exhibit one-man shows and content them-

selves with this type of exhibition only. Apparently they do not need group support.

In contrast to these four groups which enjoy most impressive success, the success profile of the Free Figurative artists turns with time into the profile of mediocre success. This style (like Expressionism, though less conspicuously) was accepted in its time in both systems, the private market and the public art institutions, when they actually represented one system.[6] With the split of this system the group fell out of favor with the important museums. This is expressed in the rate of exhibition there, as well as in sales of paintings to these museums and other public institutions. Not many of the artists achieve a distinction of being sent to international exhibitions. In contrast, most of them go abroad to gain recognition in order to succeed afterwards at home. Clearly these painters are affiliated with the private market and advance in it. For most of them painting is the sole source of income. However, as the prestigious galleries grow more selective because of the increase in the population of painters and the number of galleries, figurative painters turn more and more into the population of the less established galleries. The advancement of artists belonging to this group is independent; there are no supporting institutions behind them.

The group of artists painting in Lyrical and Geometric Abstractionism seems to be more successful than the figurative painters, but not much more. Here too we see an illustration of the split in the Israeli art world.[7] From being a style accepted by the galleries appealing to the private market (before the 1960s they were not numerous and cooperated with museums) as well as by museums, they turn into a style which is not accepted by the private market. This may be inferred from the change in the sources of income of these painters. The majority earning its living by painting only in the earlier generations became a minority in the later ones. During a certain period Abstractionism was the style succeeding by means of public art institutions. Relatively many of the artists were sent to international exhibitions, and from many paintings were purchased by important museums. Even artists beginning their activity in the 1970s received commissions from public bodies, in contrast to all the figurative groups. The important fact in their career route was apparently the inclusion in the group which assisted in their promotion afterwards. A group exhibition opened before most of them opportunities to form connections with the public. They went abroad after exhibiting in Israel and many participated there in group shows organized by Israeli artists. The arena of their activity was not the private market and their way was not the way of individualist advancement characteristic of the private market. Interestingly, however, the generation of the 1970s among

the Abstractionists completely loses the favor of the important museums. This corresponds to the transfer of attention in the press from Lyrical Abstractionism to Conceptual art and to the identification of Conceptualism with innovation on the part of curators. However, Abstract artists continue to exhibit in less important museums.

The success profile of the remaining group can be defined as the profile of low success. The successful Realist cannot be envied. This group does not enjoy the favor of the private market and is even less accepted in it with time. A Realist beginning his activity in the 1970s has no chances whatsoever to reach the pinnacle of commercial success. However, approximately half of them rely on painting as the sole source of their income while for many others it is a partial source. Realists belonging to the last generation also do not have a chance to exhibit in a prestigious museum; after the 1920s Realists had no connections with important museums. The arena of their activity is restricted to the Artists' Houses and public institutions which provide occasional exhibition-forums. In both types of exhibition-forums neither commercial considerations, nor those of prestige (namely considerations of the possibilities of gaining social honor), play any role, and from a certain point of view exhibitions in such forums have the character of charity for the artist. Their connection with Culture Houses of all sorts explains why these painters more than any other group win prizes. Their activity is rather erratic; they do not exhibit much. They are almost never sent to international exhibitions, but most of them exhibit abroad and among those who do so the majority have one-man shows. Apparently, Realists do not satisfy the demands of Israeli art connoisseurs whether these are affiliated with the private market or with the public institutions. However, art consumers, who do not consider themselves experts, accept this style. Their path is difficult and they have to take care of themselves; there is no group of colleagues or any other agency interested in their promotion.

The findings in this chapter showed that patterns of success and career routes are closely related to style affiliations. The question we confront now is, how can this be explained?

4 The "gatekeepers" – critics

In order to explore the connection between painters' styles and their patterns of success, we must examine in detail the agents in the system, whose judgment determines success – the "gatekeepers." It must be asked: (1) How do the "gatekeepers" work? What sorts of judgments are made and what are their grounds? (2) In what way does the behavior of the "gatekeepers" affect the artists' patterns of success?

The role of the "gatekeepers" is performed by different groups in the two systems: by gallery owners in the private market and supposedly by critics and curators in the public system.

The group of critics[1] consists of a small number of people (approximately twenty). Most of them started their activity in the 1970s or late 1960s although among them there are critics that embarked on their career in an earlier period. As was already indicated in chapter 1, Israeli art existed at first almost without criticism. Those who wrote on the matters of art in the press were art lovers of European origin, men of general education, lacking in most cases specific training in art itself. The most important critic of plastic art until the middle of the 1950s was Dr. Haim Gamzu, a theater critic by education who later served as director of the Tel-Aviv Museum. However, with the rare exception of cases like that of Dr. Gamzu, most of these "critics by accident" soon disappeared from the newspapers; their place was taken by young people, mostly Israelis (Israeli-born or those who came to Israel in their childhood and were educated in the country) who "had something to do" with art in one way or another. This new group, which arose in the mid 1950s identified itself with progressive art and supported Israeli abstractionism which, in those days, was synonymous with such art. Some of these critics became important museum curators in the course of time; others continued to write, achieved fame and were offered positions in different newspapers even many years later. Two women, Miriam Tal and Rachel Engel (one had been married to an artist and the other once intended to study art), were central figures in art criticism for a long period of time. In the middle of the 1960s, artists – Abstract and Conceptual – and people with

museological backgrounds started to enter the ranks of critics. The graduates of art history departments in different universities also began to write art criticism for the press. Today, holders of degrees in these fields constitute the majority of the group. However, there are very important critics whose education has no connection whatsoever to art. Education was not the factor which differentiated the new critics from the older generation and turned them into a united group with a different character.

The critics who had supported progressive art in the second half of the 1950s found themselves affiliated with art which was considered "retrograde" in the second half of the 1960s, as Conceptualism took the banner of progress away from Lyrical Abstractionism. The new critics, from the very beginning of their careers, raised the banner of Conceptualism. Artistic innovation, as in many other cases, furnished a new area of advancement not only for the artists but for all those who wished to attach themselves to them. A number of conditions facilitated the attachment of new critics to Conceptualism. Belonging to the generation of the later 1960s they were educated in the Wittgensteinian spirit of this period which viewed art as a way of life – not something immanent to the work of art. The temper of the time demanded "openness" toward the unconventional, and the belief in the creative potential of every human being became predominant.

Had the conditions of the *Zeitgeist* been different, it might have given rise to some demands toward art, but in these conditions the reason for the rise of the new group of critics was the rise of the new style and the character of this style determined the behavior of the critics to a great degree. Criticism, perceived by each of the critics as a personally important activity, is not a major source of income for any of them. The remuneration they receive for their work cannot enable them to make a living, and it is not the remuneration which makes this activity worthwhile. Besides writing criticism, the critics engage in various occupations: they teach in universities, teachers' seminaries and art schools, work as translators, and have other jobs. Nevertheless, art criticism serves as a jumping-off ground from which they sometimes ascend to positions of museum curators. The office of curator is perceived by the critics as a most prestigious position. They aspire to reach it, participate in contests and in the case of success leave their former occupation. However, even without the possibility of promotion, criticism bestows upon its practitioners a valued reward. It enables them to engage in a creative work, as they define it, and to do so publicly, and it turns the critics into the keyholders to the success of the artist. In the Israeli art world, the position of the critic is a position of respect.

In order to analyze the grounds and forms of judgment characteristic of

these critics, I found it useful to quote them at length and bring examples of all the attitudes in matters of art they expressed. I included some attitudes which may seem commonplace (such as the claim that important art must be innovative), and I did it because they take on a new meaning in the general context of the critics' artistic approach. The conclusions deriving from open interviews with the critics present the following picture.

The art critics active today represent a more or less homogeneous group in respect to their opinions on art. As there are no principal differences between Lyrical and Geometrical Abstractionism and Conceptualism (both allow a great deal of freedom to the artist and in both the professional requirements toward artists are lacking), there is also no difference between the attitudes of the "new" critics – those who began their activity in the second half of the 1960s and in the 1970s and who constitute the majority in the population under study – and those of the critics who started their activity in the earlier period. The few differences that do exist between the two styles, and especially, the fact of the critics' belonging to two different camps explain those differences in attitudes which exist despite their basic similarity.[2]

It is remarkable that the critics are acutely aware of the relativity of the definitions of art and of their being society-dependent. They are exposed to Marxist and certain Structuralist views concerning the society–culture relationship and quite often base their requirements toward art on sociologistic views of this kind. Cognizant of the tight connection between society and culture in every period, they are conspicuously unable to define art of our period and society, as if the society-dependent definitions of art were the exclusive privilege of past societies. The definition produced in the end is a contextual definition, namely, a definition of the object by the circumstances in which it is found. The professional criteria characteristic of the plastic arts before the modern period which allowed to distinguish unequivocally between art and non-art are rejected in most cases. They reflected other periods and are not relevant now. A number of critics still need them because of the lack of any criterion to be put in their place, but they do not know in most cases how to define them clearly. The only criterion for the evaluation of contemporary art which was mentioned by these critics is innovation in itself and, it seems, for itself, for they demand art that must not serve any function for society or individuals in it. It owes nothing to anything but itself, it exists for its own sake. The spectator is the one who must adjust to art, not the other way around.

The role of the critic in this framework is parallel to the role of the artist. The critic does not have any duties towards the public; his sole duty is

towards the art. He must build aesthetic theory. The aesthetic theory is derived from the works of art themselves and is intimately connected to them. However, it is also supposed to draw from other sources (such as philosophy and literature). Its final goal is to be a work of art in its own right. The critic explicitly sees himself as a creator. This is the opinion of all the critics, without exception, even of the small minority who view themselves as public servants to some extent (these belong to the older generation of critics).

The creativity of the critic is the only justification for his activity, by analogy to the creativity of the artist, which (in the opinion of the critics) is the only justification of the artist's activity, specific professional skills being insufficient and even hindering factors.

This creativity takes the place of the conventional function of the critic as a judge who, from the heights of his knowledge and understanding, aids the public to distinguish between good and bad, between what is worthy of being exhibited and what is not worthy. In other words, critics do not fulfill the function of the "gatekeepers" ascribed to them by the system. The critic is not capable of judgment and in most cases is completely aware of his inability. He claims that this is not at all important and transfers the function of judgment to other agents in the system, such as curators and artists themselves.

"Art is everything which is placed in artistic context (in galleries, museums or is executed by artists recognized as artists," claims the Jerusalemite critic of the *Maariv* newspaper. In his opinion, professional criteria and skills such as an ability to draw, to build a composition, to paint, have no importance whatsoever. More than that, because of the irrelevancy of these criteria he, a museum curator in the past and a lecturer in the Art Academy with Master's degree in art history, has difficulties in defining these criteria and skills. Requested to explain the meaning of all these (good composition, good drawing, etc.) he answers:

Correct construction of composition – when I have a feeling, that the organization of elements on the canvas is a meaningful organization, when it seems that if you'll change this organization, this will change the message of the painting. Good drawing – it is awfully difficult to define it. I cannot define it. I do not speak about good drawing. I cannot apply specific criteria. Masterly virtuoso line – this may be called good drawing. Application of color which shows the command of the skill? You must have a great deal of experience to see it. It is awfully difficult to express in words, but one sees it. This is only a matter of experience. A quantity of paint and the matter of applying – this is a professional matter. Purely professional criterion, which, I think, painters can see better than critics, this is more a matter of painters.

"Technique is not important," he adds, "in contemporary art (since the

Surrealism of André Masson's kind) it is possible to dissociate the element of art from that of craft completely. There is . . . a theory which requires lack of technique" (namely professional estimable skills – which it is possible to evaluate). More than that, sometimes these skills are even damaging. They were already used in the past. They do not increase the quantity of information conveyed by the work of art, while "good art must be innovative, it must convey the information not yet delivered. I don't think that an artist today can make good Impressionism. Art is a function of the conception of space, reality, world, which must be adequate to the time in which it is created." These opinions are echoed in different ways in the opinions of this critic's colleagues from other newspapers. "I do not have a definition of what is art," says an important Tel-Avivian critic, "it does not concern me at all because I live today. If somebody presents before me something as art, I don't mind viewing it as art. The question of the borderline [between art and what is not art] is a question of no importance in my view." Professional skills do not play any role in the framework of this attitude. "There are a number of things – formalities," she says, "when you refer to a work of art, you discuss them, elementary questions, of no importance in defining criteria of judgment of the work of art in general – because they are too elementary. One refers to them always. These abstract values – today one refers to them intuitively. I do not ask myself the questions of composition, unless the work is explicitly engaged in this matter. In fact, this is an almost instinctive flair, recognition at a glance, which says: stands or fails." To the question: "what is a composition?" she answers:

These are totally unimportant questions, this is important only as a frame of reference . . . this is judged according to the work of art, in most cases, a number of works. There is some such thing – a kind of idea of what is a good composition. This is society-dependent. [What is this in our society?] There are many bad painters who can make composition, there are plenty of kinds. It is difficult. I don't think, it is possible to define it. [It is] rather clear, that these are things that do not have to be an *a priori* definition, this is necessitated by the fact that for two thousand years people have created new works of art. If this matter were definable, this would not be so stimulating. This would be an acquired trick, like "What red does to green" or "center as against background" – in every picture the application is different.

For her the only criterion to distinguish between good and bad works of art is innovation.

I shall define it from the point of view of a good spectator – the one who reacts to visual experiences, who has a good system of associations, who can derive from himself and from the work of art things most people miss – who can be one of those well

acquainted with the field, who know what's going on, but, in my opinion, this is not enough. This is very rigid and not open to surprises. An open personality – this is awfully, awfully important for contemporary art. This is almost a central test, you yourself take the step over the known and learned. If a work of art succeeds in showing such a spectator a new approach interesting to him, which changes his scales of preferences or intellectual constructs, existing in his mind as a result of general experience, and which also has implications for his aesthetic outlook or his world view or his ability of understanding phenomena – that is a very good work of art.

Only a spectator of the kind characterized above can evaluate a good work of art; its quality, in fact, is measured by him. It follows that a work's being unintelligible, unaccepted, that is, unsuccessful, may depend upon the spectator's inability to evaluate it. It is the public's fault if certain works of art do not achieve success. "You must understand," says an influential critic, "there are no good artists and bad artists." In her newspaper her critical reviews are sometimes rejected "because the editor does not like modern art. He thinks that all this is one big fraud. He is primitive." Her definition of art represents a wonderful example of the influence social sciences have outside universities. She says:

I don't know what is art, since from the moment Duchamp discovered that everything an artist does is art, he widened the definition too much, so that it became closed. One of the possible definitions can be made in terms of Structuralism. This is a process in which an object passes from the category of nature to the category of culture. There is no argument about what is art, but about what is good or bad art. Since I am for the pluralism of the jargon, for a sociologist the criterion is a number of people who agree to have a picture at home and who enjoy it. From the point of view of the History of Art, the criterion is the opposite – because there art is created for the elite. A very limited product for a very limited circle. If you're an aesthetician – every harmonious object possessing equilibrium, balance, values of beauty of certain culture – is art. To a physician, psychiatrist, etc. – the criterion of good art is convulsion of the stomach. In the Structuralist definition the quality does not matter, the definition is more elegant because the criteria are irrelevant. It is taken for granted, that if an object is considered art, irrespective of what is the criteria the society chooses for art – this is a sign that the object is needed and this is the criterion. If a society names something "art," it means that it consumes it as art and I am content with it. Criteria are additional ramifications and very personal ones.

The criteria are irrelevant first of all because they are lacking. The critic finds himself in an embarrassing situation. He does not know what he is, in fact, talking about. In the words of the *Haaretz* critic, from the interview with whom a number of quotations above were taken: "Let us say, we take art as a language, a means of communication. We do not say that English is more beautiful than Hebrew. Before the Abstract, art really was a language, or to

be more exact, a meta-language in the sense that what in a language is a sign, is more than that in art. Until today people viewed art as a means of communication and I don't know if this is a language or pseudo-language. Art ceased to function as a language. It has a new function and we don't know what it is. Were art a language – what criterion would you apply to a language? If it is a pseudo-language, if we do not know what it is, how can I know the criteria of this thing at all?" According to her, specific criticism depends upon "a million and one factors: on which side I got out of bed; maybe the given painter did not greet me once, as he should . . ." But besides this "when you are a critic you see so many works of art that you develop the knowledge of 'good.'" (She adds: "This is the most mystical sentence I could say.") In this developing knowledge two things are clear: "new, original – this is the criterion of good today"; and the professional criteria of painting are totally irrelevant to the judgment. "It is important . . . whether one is an artist or a painter [art is a product of artists] – a painter copies, imitates correctly, works according to the Renaissance conception, while an artist creates." She herself does not "take into account technical criteria, because they do not say much . . . without these criteria – composition, etc. – there can be a good work of art. There are plenty of such." In distinction, the professional, learned element, is a drawback. For example, this critic is "suspicious of photography – there is always something which makes it not art."

Another influential critic, a frequent representative of the Israeli Art Establishment abroad, refers to intra-artistic problems, such as composition, as "all this nonsense" and claims that their place is justifiably taken by contemporary art forms. He does not have criteria. "In words of Duchamp," he says, "everyone who proclaims oneself an artist is an artist and every work proclaimed by the one who made it as art – is art. I most emphatically oppose the establishment of borders or the rejection of any artifact." He shares with his colleagues the belief in the importance of innovation and justifies the demand for it in the following way: "Art created now cannot resemble art created in the past, in another society . . . I expect a contemporary artist to react to the fact that he lives in a consumer, technological, permissive, democratic society, a society the distress of which, economic and political, is its main characteristic. For example: if there appeared a young artist painting like Rembrandt, I would not accept his works as relevant art, even if the historical Rembrandt had never existed."

There is another group of critics, most of whom either began their activity in the earlier period and long ago lost their influence, or are writing in less important newspapers, or if in important ones, are responsible for the

coverage of provincial exhibitions. Critics in this peripheral group hesitate to claim that innovation is the only criterion of judgment of art, they do not feel comfortable with this claim and clutch at the straw of talking about traditional professional skills. A senior critic from Jerusalem claims that "the main criterion of contemporary art is a false criterion, it is innovation for the sake of innovation." An ex-critic says that "there is a problem with art experts (artists, critics, curators, and historians of art), they are the first to become tired and bored by art: they see so much. They always search for new things, something original, and it becomes a primary component in their considerations, while the whole question of quality becomes a question of secondary importance for them . . . Of course, there can be an excellent painting which is not too original, but I know, the professionals, most of them, will not accept my opinion." Such critics talk about professional painting: "A professional painter is defined by the quality of his work. A person in whose work there is knowledge of the craft which is based on learning. A person who has a personal style, technical knowledge, and spiritual message. Technical knowledge means that he knows what a line is, what color is, what a composition is, a mastery of the medium of painting." "A work of art has to include something which may be called 'an original order' or 'new order': sincerity, professional dexterity (although not in the first or second place), emotional and/or intellectual depth . . ." "I throw out things that, according to my opinion, lack visual value. Even if there is a conceptual value, whether important or not (in most cases it is not important) in it, but no visual value – this does not belong to the discipline . . . I want the painting to be done as it should be; whoever doesn't know how to draw – glues (I mean here those things that don't require any professional level)."

However, these critics do not present an alternative position to those who scorn professionalism and glorify undefinable art, because, as a matter of fact, they lack any position. They feel the lack of definite criteria, but the whole history of Modern Art compels them to question their own judgment. They lose their self-confidence and follow the advice of those who have authority. Even for them there are some things with which nobody argues: a need for openness, respect for the creativity or innovation, relativity of every judgment and of art itself (its duty is to reflect the time). "How I decide what is good and what is not good," says one of the interviewed, "I don't know. Art has to appeal to my aesthetic, intellectual senses. Even the scientific–professional sense of painting – drawing, materials, vision. But there can be a good artist without any technique. The main thing is that something will flame up inside me – sometimes it will happen exactly

because it does not enter into any existing category. A good work of art –
something which inflames me."

What is art for me, in general? This is a very difficult question. I always try to avoid
this. I perceive every work of art as a sort of reorganization of the world; it can be a
subjective experience, it can be external description, or engagement in the basic laws
of artistic creativity, even in a scientific sense, governing an artist or a work of art.
This order or this organization must be (even to a small extent) an organization which
did not exist before. This is so mainly for the creative artist, this is a point of view of
the artist. The point of view of the spectator – for him all this matter of "new" or
"original" is not so important, not so necessary . . . But if there is some clear
originality (according to the evaluation of those for whom it is important) all other
required characteristics are not important.

Says another critic in this group:

It is very difficult to define what art is, where is the borderline between art and not
art. We live in a period in which all these criteria have been turned upside down.
Once there were laws of aesthetics. I go to an exhibition, look at things. It makes
sense to me, means something to me. I try to understand, what is it, what this person
wanted to say . . . There is a need for technical criteria. But it is very heterogeneous,
all this is very broad because of the form in which art is revealed in recent times. It is
difficult to say how one should judge in this case . . . When I go to an exhibition, I
pray sometimes: let it say to me exactly what it is. If it does not say anything, I try to
avoid it and not to write about it.

Along with this, she claims: "An artist who works in classical tradition today
is not a serious artist. One must create by contemporary means, creation is a
function of the time. An artist is not free to decide in which technique to
work. There are many techniques today, but they are techniques of our
time." "I can not define art," says another critic, "although I am acquainted
with most of the definitions . . . The criterion is . . . personal satisfaction
. . . When I try to explain to myself why I enjoyed it – I rationalize."

The cognitive embarrassment in which these critics find themselves, the
sense of the unconvincing character of the opinions dominating the artistic
circles and inability to oppose to them something more clear and unequivo-
cal than general phrases, such as "the only criteria of all plastic art are always
color, form, composition," frequently lead them to contradict themselves
not so much out of the logical faultiness of their propositions, but because of
the discomfort caused by the lack of complete agreement with opinions
which are shared by so many.

"Innovative art also has criteria of form, color, and composition," a
senior critic tries to find a way out of this morass, "but certain artists deny it

. . . [for them] the main thing is communication, transmission of a certain message. These are the principles of advertisement, not of art. In contemporary art an element of draftsmanship certainly exists, but not enough. There is a very interesting effort in contemporary art of a total liberation of form and of color . . . Abstract sculpture opened for sculpture very important possibilities – because now it is possible to work from within and not in order to render a human image."

Such hesitant expressions in which it is impossible to discern a clear position, are frequently followed by an explicit demand for the lack of a stand. "A critic should be an adherent of pluralism, not to prefer any specific trend." They, too, in the end, define art as "everything which appeals to me," claim that it is only possible to distinguish good from bad in Modern Art by searching for innovation, and vigorously deny the lack of enthusiasm in their acceptance of avant-garde art: "It is impossible to define me as anti-avant-gardist, I love Abstract art!" In concrete cases they are incapable of reacting to works of contemporary trends with patience and sympathy – or openness – which they would like to demonstrate. They claim that many works of contemporary art (sometimes Conceptualism in general) or art innovative for the sake of innovation "do not belong to the discipline." But these opinions lack substantiation; these critics are unable to support them and to convince others or even themselves of their validity.

There is a consensus that there are no intra-artistic criteria (qualities of a work of art *qua* work of art) which would make it possible to distinguish between art and not-art and between good and bad works of art. In spite of that, critics constantly face the necessity to make such distinctions. As a solution, they resort to a highly articulated contextual definition. Contextual definition is a definition of an object by other objects that surround it. Not the object itself, but its context enables critics to refer to it as a work of art and justifies such an attitude on their part. In Israel, this attitude finds its best expression in a book by an influential art critic, Dr. G. Efrat, *The Definition of Art*.[3] "Let us define a thing called 'art'," writes Dr. Efrat, "by a word-thing definition after an analysis of the socio-psychological circumstances as a result of which we apply the term 'art' to objects." He asks himself a question: why are certain objects named "art"? and gives an answer "in Wittgensteinian spirit": "Things are designated 'art' in consequence of a language praxis." We, as our fathers and the fathers of our fathers, learned that certain things are designated "art." This happened, however, not because there were characteristics common to these things and distinguishing them from other things. According to Dr. Efrat,

Things are designated "art" independently of the qualities of a work and, in fact, in an absolutely arbitrary fashion. The decisive question is: is the artistic quality a value intrinsic to an object, or is it a quality attributed to it because of some or other external circumstances? The second possibility is the right one . . . The connection between the circumstances and the application of the word "art" is a most arbitrary one. In my opinion, the term "art" does not refer to any quality intrinsic to an object. Its source is in an attitude, in a certain approach to the object, which we shall call "the artistic approach." This approach depends upon the circumstances in which an object designated "art" appears. These circumstances which behave according to certain laws we shall name "the circumstances of artistic intention." In this interpretation I see the only possible answer to the situation in modern art during the last decades, when we witness the rejection of all absolute laws . . . the abolition of a border between what is art and what is not art. We say: let us apply the term "art" to everything placed in the circumstances of artistic intention, meaning something which necessitates artistic treatment.[4]

The circumstances of artistic intention are defined as "exactly those circumstances in which an object named 'art' appears – a museum, a gallery, a collection." "A pair of pants," says Dr. Efrat, "will turn into art from the moment it is presented as art, because it is the circumstances and nothing else that allow for the application of this title." The circumstances of artistic intention also include museum directors (curators), gallery owners, collectors, experts and catalogues. "These are the circumstances in which we are told by the artist himself, or by a catalogue to an exhibition, or by a collector or 'expert' (the one we decided to consider an expert), that an object x is art – that is, a certain person in a casual way applied the word 'art' to a thing pointed at, directly or indirectly, by people whom we consider connoisseurs. And who are these 'connoisseurs'? First of all, the artist himself. We shall call a person 'an artist,' if we indeed know him to be an artist (or others know him to be an artist), namely if his works have already appeared or are appearing in the circumstances of artistic intention . . ."[5]

The author continues that since the idea which lies at the basis of his approach is that no "inherent quality" exists, which would enable us to classify anything as art, there are no grounds for preferring any one thing over another (for example, a painting by Rembrandt over a typewriter by Oldenburg) on the basis of such an inherent quality. At the same time, he says, it is known that every museum director (or gallery owner, or collector) has an artistic theory of his own and a definition of his own. Therefore, the word "art" can designate different things for each one of them. The facts, contrary to this expectation, show that it designates more or less the same thing.

The question is how is it that the word "art" does not turn into a homonym? There are museum directors who will restrict themselves within the limits of their personal definition, but the more liberal among them will rise above their definitions, consciously or unconsciously, and will consider certain things to be works of art, if these things sufficiently resemble other things, already recognized in the past as works of art, or if these things were offered to them by people known to them as artists (those whose works appeared in the past in the circumstances of artistic intention). In other words: we shall require from a liberal museum director knowledge of history of art and connections with artists, rather than an adequate answer to the question of application of the term "art." The truth is that in most cases we do not know what the personal definition of the museum director is, and we, the public, take his understanding for granted and apply the term "art" to the things he presents in his museum and/or catalogue.[6]

According to Dr. Efrat, one must distinguish between the question "What is art?" and a different one, "What is good art?," because, of course, not all art is good art. This important question, "What is good art?," has to be addressed, according to him, to museum directors. And indeed, museum directors are supposed to present good art and not art in general – which is to say, they must have criteria by means of which they would distinguish between good art and art that is not good. It is not easy, in Efrat's opinion, to make such a distinction. However, for the purpose of discussion, he assumes that the answer is a matter of a certain theory which a person adopts, namely that there is no objectively good art. "This means: the museum director x has a certain theory as to what is good art. All that he should do is apply this theory to the things brought before him and placed in the circumstances of artistic intention; if the thing stands up to the test of the theory – it will be exhibited." Such a view, says Dr. Efrat, necessitates a great deal of trust in artists, museum directors and other experts, because there is apparently a possibility of a fraudulent museum director (or other expert), "for whom it will suffice to exhibit a group of objects in one of the halls in his museum to turn them into art." This problem is solved in the following way:

The existence of a fraudulent museum director is impossible. Even if it were possible, we must remember that the possibility of a fraudulent director will exist also even if we adopt traditional definitions of art. On the other hand, how can a fraudulent director exist in the framework of the definition proposed here? If everything a director presents as works of art necessarily turns into art, it is not possible for him to exhibit something as art without its being art. That is, a fraudulent museum director is not possible by our definition.

Dr. Efrat refers also to the problems of a possible opposition to the judgment of the expert:

There will always be people who do not accept the verdict of the museum director, of

the catalogue, the collector, the expert. But history has already proved on numerous occasions that this opposition does not change the fact of the addition of new artistic manifestations to the widening realm of the concept of art. In the end, the term "art" is applied to those works which were not recognized by the minority [sic] in the beginning. This opposition is only temporary. An example is the opposition of the directors of the Academy in Paris to Impressionism, which looks ridiculous or worse to us today.[7]

The critics do not want to be ridiculous. They are not "primitive," as certain newspaper editors are, but open. At the same time the situation of the lack of criteria is an embarrassing situation and one in light of which the critics' activity seems totally irrational. In order to solve this problem the critics release themselves from the necessity of defining art and transfer the responsibility for this to those whose activities cannot be checked or changed: artists, curators, etc. Critics themselves assume a passive position and become exposed to "fraud" on the part of these agents. However, they solve this problem also, claiming that such a fraud is impossible, by definition: everything exhibited in a museum is art; everything the society consumes as art is art. From the logical point of view one is left with the question he began with (these propositions are tautologies of the kind well known in sociology), while from the sociological point of view, the curators' and artists' ways of judgment and other "circumstances of artistic intention" assume ever greater importance.

In the light of the complete inability of the critics to judge (and thus help the public in judging), what is their function, in their opinion, why do they write and to whom do they appeal?

The function of the critic might be to draw the public's attention to works of art of social–moral significance, to expose the public to social values and foster these values. But without any exception, the critics are of an opinion that art should have no concern for any extra-artistic values. More than that, it must not appeal to society. "Art is elitist. Any attempt to talk about the connection between art created today and the wide public is wrong. Art is made by individuals belonging to the art circles, influenced by them, creating first and foremost for them. Art circles consist of artists, art critics, museum curators, collectors, gallery owners, students of art, but not all of them, only those concerned, those who know what's going on." At the same time the attitude of the critics to the public is not absolutely homogeneous. The critics of the second generation consider themselves obliged, among other things, to serve the public, to appeal to it, to draw its attention to works of art and to explain or share with it their subjective feelings about art. Even for these critics, service to the public is only a part of their function as

critics. More important are their duties toward art. But the main duty of a critic is his duty toward himself. Criticism is a kind of creative work, a critic has to create, this is the ultimate end and justification of his activity. A senior critic from Haifa views criticism as "an aid given to the reader in his relation to a work of art," and at the same time believes that "the criticism must also be an independent work of art which frequently does not suit the taste of the public." "I do not know whom I address," says the critic, "I am interested in being read by as many readers as possible, but I shall not mourn, if it will not be read . . . The function of the critic – is to be honest professionally, disinterested and objective in his judgment. But relating to the artist's work of art the critic too must create a work of art of his own, express himself, his 'ego'." Another critic, writing for an English language newspaper, says:

I always go on the borderline. On the two sides of the border there are two camps: on the one hand, the general public – the readers of the paper, on the other hand the professional public: gallery owners, artists, collectors, and people who are greatly interested in art. When I write I must appeal to both of them as a matter of fact. What happens is that criticism which is too professional cannot be written. Because of the wider public I use the language acceptable in both camps.

For him also, "a part of the critic's function is to find, to find new in art, to do something to advance the profession." A Tel-Aviv critic with thirty-five years of experience behind her thinks that she helps "people to see things, which, maybe, they would not be able to see without me." "I appeal to the public," she says, "I try very hard to write in a simple and exact manner, so that they understand exactly what I mean." According to her, "The writing about exhibitions is an art in itself." In the opinion of yet another critic from Tel-Aviv, the critic's duties toward the public are also explicitly merged with his duty toward himself: "My function is to root out corns," he says. He would like "museums to exhibit different things – I appeal to artists, curators, establishments . . ." But "I write for myself," he confesses, "maybe it is supposed to persuade people in the rightness of my approach and falsity of others. When I ask myself why I write all this – it helps me to define myself . . ."

This moderate opinion is well summarized by a Jerusalemite critic, the oldest in the country: "A critic must first of all try to discover talents, to be the first who writes about a talented novice, not the second or the third . . . A critic must serve the artist, the public too to some extent, but first of all the artist."

The critics of the third generation – those who started in the mid 1960s and in the 1970s, who write in the central newspapers and cover central artistic

events – have a less ambivalent position. For them, the question of relation to the public does not exist at all, they do not serve but art, and the matter of the critic's independent creation is more strongly emphasized among them.

"I do not know for whom I write," says a critic from Jerusalem, "I think that a critic must be an interpreter of art . . . My responsibility is toward the work of art and not toward the public. A critic is certainly a creator." Another critic justifies the critic's activity by the function criticism fulfills personally for the critic, in this case for her:

No criticism written for the press can be constructive, for the moment you say, "You are an idiot," – you offend someone and it does not build up the painter, it builds up the critic. I perceive the work of the critic as a creative work. To bring to a communication between the public and the artist – is not my ideal. To show everyone how smart I am – is one. I want to understand things. It is an ego trip . . .

"A critic is a theorist who acts out of a drive to publish his thoughts," says another critic, "and, indeed, art criticism is art in itself, the materials of which are, on the one hand, contemporary art history, and on the other hand, works of art and the connections the critic finds between art and social life." The critic's creativity is expressed in the construction of an aesthetic theory, which is supposed to play an independent role in the development of art. By means of constructing a theory, the critic takes up a place equal in importance to the place of the artist.

The attitude of the critics toward the status of theory in art, and their own status, is clear – they perceive themselves as creators who greatly influence the development of art. However, the relationship between the theory and artists' production is logically ambiguous. Theory derives from works of art, but it also conditions them. Art, these critics believe, is everything presented in the artistic context. "Within this context," claims a well-known critic, "the body of aesthetic theory is important, the key to which it is possible to find in the analysis of works of art. The greater the extent to which an artist fulfills the requirements of the theory – the better artist he is." However,

theory must be a coherent system. I must derive theory from the works of art. It must be connected, indeed, to the works themselves, but it also must be connected to other cultural systems (literature, philosophy). The theory is usually constructed by an intellectual elite, by arbiters of culture, who take upon themselves the responsibility to build a theory. There is a certain investment on their part, an investment of their personality. If just anyone creates a theory, it will have no importance. The theory must be created by the artistic context, and the artistic context from the start has a certain intellectual prestige.

The critic works by the side of the artist and is directly involved in his work:

This is the concept of an art critic – a person involved in artistic life, a person who not only comes to examine the final product, but who really knows the work of the artists he is interested in, engages in conversations, etc. – and is involved in the construction of a theory for art in general, and for those artists he has specific interest in, in particular. The theory stems from art, the raw material of the theory is works of art, that is, what is already produced. What influences the art critic is all the theory that exists in the period of his activity, his cognitive and psychic inclinations towards some of the theories. As a result, a preference for and curiosity develop towards the work of one or another artist in the vicinity; as a result the critic creates a new theory which expresses his creativity – the process of the critic's thought is parallel to the process of the artist's creation.

The relationship between artists and critics is presented here in a conspicuous and clear fashion: "An artist works on something, he has a certain feeling. I come, I talk to him, say to him: 'That is that; that is this.' He says: 'Listen, exactly so!' An artist uses the theory to define his message. An artist acts on the basis of feelings, the art theory provides verbal definitions to these feelings."

According to another critic, "The relevant aesthetic theory appeals only to artistic circles and to circles that deal with culture – writers and so on. No doubt, the need to engage in art theory is a creative need *par excellence*, a person does so for himself, and there is also a need to influence and a belief in inculcating art relevant for him in the artistic world."

In spite of the mutual aid between artists and critics, the critics' activity is egocentric. Thus an important critic describes her work: "I work on a semantic problem, try to create a new language, a new jargon. It is not possible to reach the thing itself [art], since were it possible to explain the whole painting verbally, it would not have the right to exist as plastic art . . . I try to talk about art without using the jargon of art itself, I use all the languages I can, interdisciplinary comparisons . . ."

What is all this done for? The critics wish to create. Creation is the only justification for their existence. Therefore they must rise above the artists. They want to dictate to artists and art in which direction to develop. But they cannot dictate, because they do not know what to demand. They lack criteria, definitions. As a result, they have to submit to artists. They construct their theories on the basis of works of art created in the framework of latest trends. Even so they find themselves in an awkward and uncomfortable position. They want to create, not to describe – they do not perceive themselves as obliged to transmit the message of the works of art to the public; besides that, they would not be able to do so even if they wanted.

Because of the lack of criteria they also cannot approach the artistic production as interpreters and judges. In fact, except for the mastery of information about what exactly is going on in the centers of art today, nothing links them to art. They try to connect this information to philosophical theories, and primarily to a certain kind of Wittgensteinianism and certain popular interpretations of Marxism and Structuralism. This activity is best defined as the construction of a new jargon using all these social philosophical trends hovering today in the air and the information about the currents in the art world. It becomes a kind of versification – exercises according to a more or less clear model which it is possible to perform with greater or lesser degree of virtuosity; an art of theoretization or art criticism for the sake of theoretization or criticism. (The conventional concept of "criticism" is not suitable here, of course, as that is something which is absolutely impossible in the context of the critics' actual role.)

The attitudes of the Israeli critics are not unique. They seem to share them with their counterparts elsewhere,[8] which makes the social implications of these attitudes particularly worthy of serious consideration.

The newly interpreted profession of the critic which is expressed, among other things, in these critics' style of writing, emerged as a result of their affiliation with Abstract styles (mainly, but not exclusively Conceptualism). These critics fight the war of progressive art (against what *was* the art establishment a long time ago). This war is their *raison d'être* and it guarantees them a respectable and special position in life. For that reason the critics must be the spokesmen of this art which, because of its nature, turns this mission into an impossible one. The critics of non-abstract styles expressed in words and analyzed by means of logical concepts what the painter expressed by means of painting. In this they perceived their creative work. Without the assumption that painting expresses something which has an objective meaning this activity becomes impossible. The lack of such meaning also does not allow for any judgment, with the exception of one based on "social reality."

The principles of Conceptual art (and to some extent of all kinds of Abstraction) necessarily lead to the contextual definition of art. This contextualism which is the corner-stone of the critics' philosophy in this group does not allow them to fulfill the formal function of criticism, namely, to distinguish between the works of art and to judge them individually.

In this sense these critics cannot be "gatekeepers." They become "gatekeepers" in another sense, as ideologists (in retrospect) of a certain group. Their function is to defend a certain school of art and fend off the alternatives – organizational rather than those advocating different values and ideas – of the group to which they are related. The quotations show that the

reconciliation of the formal function of criticism – the judgment of works of art – with the role of the critics in given circumstances is, in fact, problematic for them and there is a high degree of inconsistency in their efforts to formulate a professional ideology and to define their function. There is, though, a ready solution to this problem: the critics simply accept the evaluation and the directions of the group. The critics turn from public servants into the servants of their professional community; their writings are addressed to artistic circles. For this reason these circles gain in importance for this research; they represent the audience for which the production of both the artists and the critics is destined and, in the absence of internal standards of quality, they are the sole source of such standards.

5 The "gatekeepers" – curators

The group of curators consists of museum directors or head curators and of curators of Israeli art. Museum directors or head curators are appointed by boards of directors consisting of different public figures with the partici- pation of Ministry of Education officials and representatives of Municipal Cultural Departments. It is museum directors and head curators who ap- point curators of Israeli art, though, this is also done with the approval of boards of directors. These positions are central administrative positions in the system in question.

The group includes people who began their career with an occasional appointment in a museum (usually a clerical position) in the period when the first museums in Israel appeared, and advanced to important positions in them, as well as relatively young people. These were appointed to their positions directly, as a result of an announced vacancy, or were personally invited by boards of directors or directors themselves; they filled these positions since the 1970s, when the founding curators had to retire and more general offices were split. The members of the former group in most cases either lack formal education altogether or have some education which is not related to the field of their activity; the latter are graduates of Art History or Museology departments in Israel and abroad, who have some experience as art critics, or as museum curators outside Israel. In any case, the two groups ascended to their positions of influence simultaneously with the rise of Conceptualism. This fact is particularly significant in the cases of the Israel Museum and the Tel-Aviv Museum, in which there are no exceptions to this rule and which set the tone in the Israeli art world.

The responsibilities of curators can be described thus: they are in charge of the museum collection, they have to extend and to supplement it (to purchase new works of art and replace works in the permanent exhibition with other works from the collection). Another responsibility is the orga- nization of temporary exhibitions such as one-man shows or group exhi- bitions imported from abroad. In the case of local artists it is usually curators themselves who initiate the exhibition, though on rare occasions curators

respond to the request of an artist to organize an exhibition of his works. In order to organize an exhibition curators contact artists, gallery owners and collectors. Every exhibition is supplemented by a catalogue edited by curators and published by the museum. Some of the curators are commissioned to write books about Israeli artists, also published by the museum press.

Does the behavior of the curators justify the expectations of the art critics, are they capable to bear the responsibility which the critics place on their shoulders as a result of their own inability to bear it? The answer is "no."

Similarly to the critics, the curators believe that theirs is a creative activity – it is the expression of creativity and not the ability to discriminate, to judge and to preserve criteria created before them, which is the purpose and the justification of the curators' positions. They find it difficult to define art and have no criteria to judge it by except "relevancy" and "innovation," "authenticity" of the work of art or its being an expression of "creative personality" – characteristics which by their very nature make it impossible to construct criteria and require, instead, their constant destruction. The lack of criteria which would allow them to choose among works of art embarrasses the curators, they take refuge in talking about intuition, experience, make every effort to gain a foothold and find a justification for their judgment. Yet this justification itself always represents a part of what must be justified. One of the side-effects of these unsuccessful attempts is the sense of diffidence expressed in the craving for a group which would agree with them, in rejection of those who do not agree and in reliance upon experts abroad.

The public to which museums appeal directly is a professional public in the narrow sense of the term: curators regard themselves as obliged to serve the artists–creators in the first place. Their duty, as they see it, is not to satisfy aesthetic needs of the general public within which they act, but instead to create new needs according to their judgment. Furthermore, art, the supreme expression of creativity, in their opinion, is unrelated to its social context, and whoever serves this lofty ideal is released from commitments toward extra-artistic values of the state and society in which he lives.

In fact, their sense of diffidence is also expressed in the curators' belief in the creative character of their role, and in their worship of "creativity" and art. The curators view creativity as the holy of holies. Since it is most purely manifested in art, this conception leads to a sense of obligation to reflect everything which happens in art, not to be late, not to miss, to be the first to accept every new development (every new expression of creativity) with sympathy. There is no end to declarations such as: "Certainly the function of

a museum is to expose what happens in the world of art as part of all this great story, which is called art and culture; while doing this we must be aware that a museum must take upon itself a responsibility for decisions about things which it is difficult to judge, to help criteria to emerge and not only to reinforce the criteria which were created in the past and other places"; "It is the duty of a museum to show the public the latest development"; "For me it is most important to say things in time, to say things relevant to society, to the time, and to the place"; "The duty of a museum is to try its best to expose things before the public – irrespective of whether what is exposed is good or not . . ."

The greatest danger for the curators is to find themselves among the latecomers.[1] (This is most conspicuously expressed in the efforts the curators in Haifa, the least daring of all, make to justify their tendency to exhibit not only the newest but also "simply good" works of art, while they emphasize the taken for granted inconsistency between these two qualities.) Correspondingly, the greatest satisfaction is to succeed to be among the first, to forestall everybody, to exhibit something nobody exhibited before. The direct involvement of the museum in the contemporary developments enhances the curator's sense of self-importance: "the development which happens together with me." The success of a curator "is judged by his ability to build something (namely, to create from scratch) – which will be good according to one or another criterion."

The structure and the content of the last quotation (taken from the interview with a person whose influence on the development of Israeli art during the last fifteen years was, probably, the greatest) is very characteristic and well expresses the attitude of the curators towards their work. The main thing is to "create", meaning "to do something which was not done before"; only after this the question arises: what is it they want to create? But this is a question to which the curators–creators, in fact, have no answer. Of course, it must be good, but "good" does not exist apart from some definite criteria. In the case of the curators in this study there are no such criteria. A thing must "be good according to one or another criterion" which means that it may be good according to one criterion and bad according to another, while next time it may be good according to this other criterion, while it is bad according to the one which made it legitimate in the previous case. No choice is made among systems of criteria prior to the judgment, it is also impossible in the moment of judgment to keep in mind all the alternative systems, and, certainly, there is nothing which cannot be justified according to something. It follows, that virtually everything is justified and that justifying criteria are brought into account retroactively. This is so indeed. With no exceptions,

curators, who are the most important "gatekeepers" on the way to success in this system, lack criteria of judgment. One of them says:

Art has no borders. I think that it is impossible to define art, because it is impossible to define the framework of human thought and creativity. Any framework, which is the framework of creation, that is to say, in which things are done is acceptable . . . and it is impossible to define these things but in the framework of art (I doubt, whether the created thing must be an object, but let us say, it must) . . . any object which can be given a certain meaning or which is not explicitly non-artistic, as in science, may be included in the framework called "art." The problem with definition is that the more it was extended to include things that were done in the 60–70 last years, the more it was extended to include things which previously were considered not to belong to art . . . Actually, the essence of art contains something which makes it impossible to reach the edge of the realm belonging to this framework. Even with the assistance of a computer it is impossible to describe the frontier of the artist's liberty, his possibilities in creating an object capable to convey some meaning to others . . .

Another important curator says: "I do not ask myself what form the thing [work of art] is to take. I am willing to accept everything which is material culture and is interesting. It is impossible to define art – all the definitions are temporary definitions related to certain societies. We do not have a definition. We must be exposed and open to the developments in the realm of creation without restricting ourselves by a concept, because concepts are restrictive and not broadening . . . Everyone has the right to think that what he does is art." The curator of the largest museum in the country, an art critic in the past, agrees: "If somebody offers me something as art, I don't mind to regard it as art. The question of the borderline is unimportant."

However, there is something which, in the opinion of Israeli curators, definitely cannot represent a criterion for the judgment of art works and for determining whether something at all belongs to the framework of art: these are the professional artistic criteria. These "anachronisms" are treated with the greatest respect in Haifa. However, even there these criteria are used quite reluctantly and the impossibility to define them clearly is emphasized. "I would look for the expression of objective artistic criteria in a work of art," says a curator from Haifa, "a line, color, form, composition – all these together must form one uniform piece. These criteria must not always be something I like. I don't think, there is a way to define these criteria: what is a line, what is a classic composition. But when you see a painting, you see where these criteria exist. There is no ready definition. What is art? Anything an artist views as art."

The curators, therefore, find themselves in an even more difficult situation than the critics, because the curators are those who decide what will be

accepted or rejected and by their decisions determine the context in which the critics act. A sense of embarrassment prevails among them. On the one hand, there is nothing more gratifying than to discover something completely new, to participate in the creative act by its exposition and in so doing to create. On the other hand, as one of the curators says, "it is embarrassing to come across a work of art which is not similar to anything done before."[2] In this case the curator is in danger, he has to take upon himself the responsibility for the inclusion of something in the framework of art, which can expose him to criticism and ridicule of future generations (he knows of such cases in history), if, God forbid, he would make a mistake. "No curator," says an important curator in Jerusalem, "will take upon himself a responsibility [for defining a certain thing as art] and commit himself by saying that it is forever, or for a hundred years. I do not pretend, that everything I exhibit will be defined as art in the next hundred years."

Curators are aware of the fact, that they work with "the risk of high probability of mistake, for the news of today will look as yesterday's news tomorrow." "From a certain point of view," says a curator from Tel-Aviv, "the museum sets the taste, but it is not the final judge in this. The museum does its best to function as a forum. It is the history which determines." The responsibility in such a situation definitely does not seem agreeable to curators. However, they understand, that the two things – the destruction of the old and the intense desire to build new values, to "create" for the sake of the creative process, on the one hand, and the responsibility for what is created as a result, on the other – necessarily walk hand in hand.

What – in the absence of criteria – can help them to bear this responsibility? They talk about experience in work, intuition. "What I thought, fundamentally, was that in the absence of criteria to evaluate the place of an artist in the historical perspective, the person who makes the decision must rely on his intuition and belief." "What is art – I don't know, I do not have a definition. Much of what is done in the museums, I suppose, is done according to intuition, although I don't want to use this word. This intuition is acquired in practice with time. The taste may be developed, enriched in the everyday practice." "There is a possibility, that I will not understand, but after all, there are years of experience and intuition behind me."

Much less frequently the ability to bear the heavy responsibility the curators unwillingly take upon themselves is argued to be based on professional education: "It is the person with the education in the field, who has the greatest right to judge." However, drawing self-confidence from education is the privilege of few relatively young people (those who entered their positions five to seven years ago).

The reliance on intuition and education does not convince the relying

curators themselves and they search for more general grounds – objective ones which it is possible to describe and which can be shared with others. Art is not science, they say, but it is almost science, the judgment in it can, after all, be tested. Such an objective test is made possible, first of all, by the information. Most of the curators master the information about the developments in the great centers of art, as well as the history of modern art. This information protects them from mistaking imitations for originals, and gives them an immediate possibility to identify innovation. Furthermore, on their own testimony, it helps them to understand the work of art. "There is a problem," says one of the Jerusalemite curators, "called a problem of information. In every artist there are recognizable elements that are shared by many and that represent cumulative knowledge. For art in the process of becoming, this information is outside the work of art itself. Usually there is a framework – this framework is the information outside the work of art. According to this the degree of belonging, of authenticity is evaluated."According to another curator from Jerusalem:

People who work or engage in this have large experience and know the field through, they recognize the different and the significant, if it happens. This is something which one can recognize. In our institution, if ten works were brought to us, and nine of them were plagiarisms, the one different work would be recognized. It is hard to say, whether this work would be important or not, because usually you need more information – more than one work and more than one period in the life of the artist.

As previously noted, such a command of information helps to identify innovation, and therefore, innovation is the most explicitly formulated requirement toward works of art. This requirement is related to the demand for "authenticity" or "personality" of the work as well as the one for "creativity." "What I personally admire in the work of an artist is his being personal," says a curator from Haifa. "Every artist who does not imitate, does not repeat the works of others, but has something to say (whether in terms of form or of contents) and what he says is interesting and significant, and has a personal stamp, deserves to participate (in museum exhibitions)," is the opinion of another curator. "There is no clear tendency, but I would expect from a beginning artist some innovation, I wouldn't like him to repeat what was already done, even if he would do it well. But I don't search for innovation for its sake, rather for some special personal approach." These are the words of a curator from Haifa, while a colleague from Jerusalem always searches "for the element of a kind of a leap into the indefinite realm which can be defined as creative, this is what distinguishes between an imitator and a great artist."

The demand for "authenticity" and the use of information have another meaning which contradicts the requirement for innovation and identification of innovations, namely the emphasis on the embeddedness of a certain work of art in a more or less broad artistic framework. For a certain curator the decision whether to exhibit an artist in the museum or not depends upon "how it [the artist's work] fits in the framework of things that engage the artistic community today." According to him, in the process of judgment a choice is never made between two frameworks, but the degree of embeddedness of an artist in some framework facilitates the judgment of the quality of his work. The same curator also tells that he would accept or reject works of art according to his attempt "to understand what is the language of the artist, and to which extent he is capable to express it." The criterion in modern art, according to him, "can be an attempt to express itself correctly in the spirit of a certain period of time." Another curator searches for "the degree of correspondence between what the artist says he does and what he actually does . . . First of all you must grasp the philosophical idea . . . " In her words, "the criteria for established artists are not problematic: you try to select the best from the path of the artist's work according to his own values. In regard to contemporary artists, you are alone in the field and you try to use the criteria you have, and talk to the artist himself and listen to his ideas. You are in the situation of the creation of a language, language in the process of becoming; you determine the degree of authenticity of what he says." Another curator claims, that art has no definition, and therefore there are no prior criteria for the judgment of art. However, "art is the result of the works of art that have been created" and this, of course, creates a framework and certain requirements towards new works of art willing to be included in it.

These are two contradictory approaches: (a) the definition of "authenticity" of a work of art as innovation, namely, by its difference from anything that was created before, and (b) the definition of "authenticity" as a high degree of correspondence to some framework existing outside the work of art (whether the language of the artist, against the background of which a certain phrase is evaluated, or "things that engage the artistic community today," or works of art which were created earlier). In the former case the information is used to identify the different, while in the latter case it is used to perceive the similar. Yet these two contradictory approaches lead to the same result. The search for and the praise of innovation for the sake of innovation with no demands formulated in advance as to what this innovation is to convey, in what and how it is to be expressed, results in the criteria for the judgment of a work of art being created after the judgment itself is already made. Similarly, the requirement for the framework without

the preceding choice of a framework and criteria of correspondence to it makes it possible to find a framework for everything which has already been judged and accepted – for "art is the result of the works of art that were created and not the other way round." Both approaches camouflage the actual inability to judge, and in no way make the difficult situation of the curators easier. This inability necessarily leads to the transfer of responsibility and dependence upon other agents.

This dependence is expressed, first of all, in the attitude toward the artist as well as toward colleagues and other authorities in the field. "The artist is the one who determines the framework of the definition," says an important curator in Jerusalem. And who can be an artist? According to the same curator, this is also "determined, first and foremost, by the artist himself." His colleague in Tel-Aviv says, that sometimes she is "assisted by conversations with artists – it can help me to see, because it is new things that are in question, and sometimes the man is already experienced in them, while I am not." Another curator says, that "with contemporary artists one has to enter the world of the artist himself and to attempt to participate in everything which preoccupies him" in order to understand and to judge his works.

Curators also rely on and find confidence in the consensus among the experts. "Evaluation of art is not subjective," says a curator from Haifa, "I deny it. It is absolutely scientific. It is difficult to define it, but it is not subjective and there is a degree of professionalism, which makes it possible to make almost no mistakes. There is always a certain consensus in respect to what is art and what is not art. This unformulated consensus gives a backing, some sense that after all I do understand." A curator from Tel-Aviv finds support in that "there is a general agreement among the museums in respect to who are the good Israeli artists, there is a rather widely shared consensus." She would like more than that, though: "in other countries," according to her,

there are all sorts of mediating institutions (small museums, contemporary art galleries); we have too few of these and not so vital. All these are works of art which will not be bought, one must have a very special personality to make people think that there is some value in them and that the purchase is economically worthwhile. From my personal point of view, I am glad that the museum is involved in all these matters from the height of its prestige. From the point of view of the museum, it does not help at all that it has no backing, because the museum appeals to the public and shows it things we believe in. These things have cumulative influence, if they see them only in the Tel-Aviv Museum, it is worse than if it were possible to find their likes in galleries and in Petah-Tikva [a provincial town] – otherwise it may look like a whim and not like a consensus of the professionals.

This dependence upon consensus determines the type of public to which

the curators turn in their activity and is an expression of their yearning toward the *Bund*, the community which would share with them their belief. Curators divide the public necessarily confronted by the museums into two types: passive public and active public. The vast majority of the public belongs, in their opinion, to the former category. This is, in the words of a curator, "a public which does not visit the museum in order to answer very definite expectations, a public that does not look at the work of art actively." According to the same curator,

almost every exhibition – if the curator is at all aware that the exhibition is intended for somebody – appeals to some potential of an active public. Something that was particularly interesting, especially creative exhibitions from the point of view of the museum were exactly the avant-gardist exhibitions or exhibitions of young artists which were intended for the active public. I view this public in such a way: this is a public characterized by patterns of reacting which are not dependent upon a system of prejudices leading people or dictating to them what to see and closing before them everything else. In part this public consists of young people, but not exclusively. Every artist, in fact, has a certain circle, from the family framework and friends to people who work in the same spirit with him. You can meet among them Bezalel students and even university students and all those people who acquired a habit of coming to the openings.

His colleague from Tel-Aviv says: "Today I try to exhibit artists about whom I know that the young people are interested in the problems these artists raise – I mean the appeal to the relevant artistic questions . . . " And a curator from Jerusalem claims that "the principle in organizing an exhibition must be that on some plane the exhibition should be intelligible to all, but on the artistic plane there is a specific public which understands what the wide public does not understand. This is the artistic family – artists, and hopefully the critics also."

The main characteristic of this specific public (besides its factual membership in the world of art in the narrow sense of the term) is its "openness or the eagerness and ability to accept whatever the museum offers it as art," namely (as we have learned from the curators) anything at all. This public should not approach the exhibition with definite principles and values, apart from the principles by which the curators themselves are lead: search for innovation, belief in the holiness of creative art which can be defined only as the production of a person whose main occupation is to "create." This public must react to the work of art and this reaction, according to our impression, must have the character of the willing acceptance of all sorts of shocking stimuli. A good work of art, in the opinion of curators, must arouse reactions. A Jerusalemite curator says: "Good art must stimulate to something – if it leaves a person totally cold, it is not a creation. It must create some

reaction." A curator from Haifa claims that "art must have an impact on the spectator, even to make him feel disgusted." Although they talk, as it may seem, about any reaction, they never mean such positive sensations as touching emotions, which many genre painters in the 19th century strove to arouse and which are aroused now by certain popular posters, unanimously despised by the circles in question and representing the world of art in homes of people belonging to less enlightened strata. Stimulation of positive civic feelings is also out of the question, as a Tel-Avivian curator makes clear: "The curators in the central museums in Israel do not place Israeli patriotism before art." She thinks that "were there people considering patriotism or identification with local values as one of the criteria for the judgment of art – there would be an abyss [between these people and herself]." Usually, when curators are asked to specify, what sort of reactions should a good work of art arouse among the spectators, the answer is "even a feeling of disgust" and although they almost always start with "even," an impression is created that this is, actually, the only reaction they expect.

Unfortunately, the data does not make it possible to substantiate this impression further and it well may be that the evidence presented here is not sufficiently convincing. However, it is supported by two following observations: the insistence of the curators on the distinction between art and extra-artistic values on the one hand and the exclusion of the concept of *beauty* from the realm of artistic values on the other. (As may have been inferred from the last chapters this concept does not have any importance for the critics and the curators, and as we shall see, the situation is not different in respect to the artists affiliated with them.) These factors, together with the abstention of the curators from specifying the reactions they expect and their disregard of positive reactions of whatever kind, make it possible to view this impression as correct and to claim, that an ability to shock the spectator is definitely the distinguishing characteristic of the good work of art. However, usually the spectator is not supposed to protest against it, what is meant is only a slight repugnance which is not expected to result in expressions of protest, but must be accepted as a mark of the high quality of the work of art. The shock is caused by the innovation. In the words of a certain curator, in whose opinion, a work of art must arouse "some reaction," pornography which arouses reaction "is not art, because there is no innovation in it, no creation, there is no significant creative change." The envisaged spectator, therefore, must be educated enough to recognize an innovation and to react to it, and "open" enough to accept it with sympathy because of its very nature.

The quality of the work of art, thus, is determined by its ability to arouse a

reaction of this special kind among this special public, while the public is defined by its ability to react in this specific fashion to a work of art of the kind defined above, namely, defined by the reaction it is capable to arouse among this public. If the work of art arouses a different reaction, or if the public does not react as it is supposed to, it is possible to say, that the work simply addresses the wrong public.

This public, willing to accept shocks with sympathy and joy is the source of solace and support to curators exhibiting works of art, the only definite characteristic of which is, indeed, their potential ability to shock the public (as other criteria according to which it would be possible to select works of art are lacking). Such a public gives the curators a sense of belonging, of sharing in belief and in responsibility, and justifies their activity. And this is necessary. An important Jerusalemite curator says, that he is "moved by a desire to be together – in a common belief. The greatest reward for me is to find people who share with me the belief." A Tel-Avivian curator claims that she is rewarded "only by our artistic world – all of us participate in something which was never finally accepted, except by this tiny group."

As the rewards come from this active public, which in its greatest part consists of people belonging or close to the artistic circles, the curators perceive their main function as the service of this group, particularly of its kernel – the artists. Thus says a curator from Tel-Aviv: "A museum should not cater to the general public, instead as a public institution it has to be committed to the original art and creativity." A curator from Haifa agrees: "A museum has the duty to spread contemporary art of the artists which live and create today, and in this complex of the purchase of paintings and organizing exhibitions there is not only encouragement but a certain help to the artist." Another curator says that this activity of the museum "certainly emphasizes Israeli art – we have an intention to support the creative culture. As a framework of this kind we exhibit experimental shows – to accentuate the creative aspect." "A museum in Israel," claims a curator from Haifa, "must support local art." Her colleague from Jerusalem defines her goal as "the encouragement of the artists."[3]

The service of this small group actively involved in the creation of art is the only function of the curators and all their activity is oriented towards this group. They also view the activity of other people in their small world in this light. Speaking about critics, a curator in Jerusalem says: "The main duty of a critic is to be open to what is happening, to create communication among all those involved in the creation of culture: artists, galleries, museums, collectors, institutions which give the money, in order to create an atmosphere as creative as possible and to explain what is going on. [To explain to

whom?] – To everybody, mainly to the Ministry of Culture which does not give enough money to artists."

The passive public which includes most of the society, most of the museum visitors (in distinction to those invited to the openings) is left aside. It cannot be said, that the curators do not consider it at all, they are necessarily in contact with this public and are indirectly dependent on it. However, their attitude is very reserved and even cold and haughty. The curators explicitly do not regard themselves as public servants. One very important curator thinks, that "the society itself . . . does not need art. Art is supplied to society by museums, media and so forth – as they usually supply to society needs in whatever it consumes." The society also does not understand art. In the words of another curator: "The important processes, while they still continue, are not accepted by the general public. They are problematic for it and in conflict with its upbringing. The public must be educated by the very things it does not know yet, namely does not yet like." In other words, one has to adapt the public to the works of art. A curator of the Haifa Museum, in which there are still some remnants of the archaic opinions in regard to the relation of a museum to the general public, says: "Of course, the museum has an educational function of the utmost importance – I mean education of the general public with no distinctions of origin, social affiliation or age. Any exhibition has an educational function, not only an artistic one. Not the education for art, but the education through art." He immediately adds, though: "First of all we exhibit art – something which has an artistic value, without consideration of its implications. As to the implications of the show, things surrounding it – we do not pay attention to the scolds and shocks of the public." Art is the highest value, instead of serving by means of it other values, which was normal for everybody until the emergence of the modern art, every means must be used to serve art itself. And "the taste of the general public," – as a curator from Jerusalem claims, anyway "drags behind the doings of artists."

This estranged attitude toward the public in general finds an expression in the relation to the Israeli public, to Israel, in particular. Since the curators do not consider their duty to consist in the service of any extra-artistic values, they do not make an exception for the Israeli society and do not regard its values with any difference. On the contrary, Israel seems to have the distinction of being an object of an emphasized disrespect in comparison to other countries – cultural centers of the Western World, because, although the curators receive most of their rewards from the Israeli artistic community, their high position within this community reduces the value of these rewards and makes it possible to take them for granted. Since this com-

munity is a group closed in itself, there are no rewards the curators may be able to achieve in the Israeli society outside the artistic community. One of the important needs in the situation of the absence of criteria combined with the necessity to judge and to make decisions for which the decision-makers have to assume a heavy responsibility, is the need in a possibility to rely upon someone else in the process of judgment. The curators, in fact, represent the highest authority of judgment in Israel. They have no one to rely upon there, for everybody relies upon the curators themselves. They turn for help to artists whose works they are supposed to judge, but artists, as far as curators are concerned, belong to a totally different species because of their immediate relation to the creativity; turning to them for help resembles approaching the deity, a form of spiritualism rather than conferring with equals.

Therefore, foreign climes are relatively highly regarded, while Israel is slighted. A Jerusalemite curator mentions an "aesthetically significant exposition." When he is asked, what does it mean, he answers without hesitation, that it is an exposition which is modeled upon "the modern European taste." Without exception, curators talk about their respect for and eagerness to belong to a foreign framework. Israel is considered a periphery, namely not an independent unit, but a relatively unimportant part of something else. A Jerusalemite curator recalls:

The main task was to act within the community I live in. At the same time I wanted to complement this community with things from abroad. The museum [in which he works] is one of the rare ones in the periphery which has an activity of this kind. I always tried to evaluate myself in comparison to the center and to belong to the center in some way. I wanted Israel to be somehow a part of the right system, but at the same time I had a clear vision of where we belong and what are our limitations.

Table 30. *Independence of judgment in public institutions of different prestige (in %)*

Painters who exhibited in museums	Type 1	Type 2	Type 3	Type 4	Type 5
Before exhibiting abroad	26.0	31.0	45.0	33.0	46.0
After exhibiting abroad	74.0	69.0	55.0	67.0	54.0
Before prize	48.0	56.0	64.0	59.0	67.5
After prize	52.0	44.0	36.0	40.0	32.5
Before galleries	44.0	37.5	32.0	37.0	49.0
After galleries	56.0	62.5	68.0	63.0	51.0
Before everything	11.0	12.5	9.0	15.0	46.0

N = 312*
*Only 72% of all the artists exhibited in museums

A Tel-Avivian curator hopes, that "Israel can develop into one of the small centers which in the limitations of its size would be capable to contribute something original to what is going on around." Another Tel-Avivian curator says, that although the judgment is made, first of all, here and there are no actual relationships with foreign colleagues, "they give us a good feeling that we are on the right way."

Day after day the selection is made between what is worthy of being shown in these museums and what is not worthy. Systematically, artists working in some styles exhibit there, while artists working in other styles are rejected (see chapter 3). The professional ideology of the curators, their attitudes to and assumptions about art, do not provide a consistent basis for such selection. According to these assumptions all styles have equal chances to be accepted as good art, because there are no limits to the possible forms of innovation (including the forms of figurative art which relate to extra-artistic values) and "authenticity" is not necessarily a privilege of art which uses the means of Conceptual Abstraction. The professional ideology of the curators requires them to be open. Their actual activity attests to closeness and stylistic dogmatism. Only their peculiar affiliation with Conceptualism can explain this paradox.

These observations combine to create a picture of public officers in whose jurisdiction their society places valuable resources (see the chapter on publics in regard to the officials of the Ministry of Education), who use these resources without an ability to justify either the way they use them, or their activity in general. This activity which serves but a tiny group offers no criteria with which to evaluate it and resembles groping in the dark. It creates a sense of insecurity among the curators and leads to attempts to transfer the authority of judgment to, and to share the responsibility with, somebody else.

It is significant, that the independence of the curators' judgment diminishes with the rise of a museum in prestige, the curators of less-important museums make more independent decisions, than the curators of the more important museums (see table 30).

These findings are especially interesting if related to the fact that more artists exhibit in prestigious museums (particularly, in the central museums), than in museums of lower prestige.[4] Therefore, it is not possible to interpret this table as an expression of differences in the permissivity of criteria in the less prestigious museums, in contrast to those of the more prestigious ones. Instead, it must be interpreted as pointing to the connection between the declining independence of judgment and the prestige of the museum. It is also interesting to compare this table with the equivalent one (table 31) pertaining to private galleries and showing the opposite situation.

It follows, that curators, who are supposed to function as "gatekeepers" on the way to success in this system, cannot fulfill this function and actually avoid it (although nominally they, of course, fulfill it). The avoidance of fulfilling the function of the "gatekeepers" is most pronounced precisely in those institutions where its fulfillment is most vital.

The curators are completely aware of the importance of their position and the responsibility connected with it. However, similarly to the critics, they find themselves in circumstances which complicate the fulfillment of their function and, like the critics, resort to the contextual definition of art. The affiliation of these curators with the Conceptual artists and their acceptance of the philosophy of creativity and innovation make it impossible for them to use their individual judgment in relation to works of art. They are able to recognize what is not an innovation and, therefore, do come up with rational reasons for the rejection of certain works. In respect to the positive judgment curators have no choice other than to rely upon narrow "social reality" or context determined for them by artists, experts in avant-garde art abroad and active public. Their actual behavior, therefore, contradicts their professional ideology on two points: (a) although this ideology demands absolute openness in relation to different styles, curators lack stylistic flexibility: they are connected to a certain style-group and are unable to loosen this connection; (b) although this ideology demands initiative, construction of new systems of criteria on the basis of which it would be possible to select innovations in art, curators lack initiative, they accept only that which has been already approved by the group.

6 The "gatekeepers" – gallery owners

In the system which supports figurative painters the function of the "gate-keepers" is supposed to be fulfilled by the owners of the private galleries. They enable painters to exhibit their works and reach the public, they buy these works themselves and help in selling them to others. In many cases well-established galleries aid a painter to get a show in private galleries and museums abroad and in different ways contribute to his gaining publicity.

Between 1979 and 1980 the Israeli Association of Gallery Owners listed sixty-four galleries. This number represents the result of a very rapid growth in this sector during the preceding twenty years. In the 1940s there were only seven galleries in Israel and they did not exist simultaneously. Fifteen galleries were active in the 1950s, forty-eight in the 1960s and 128 in the 1970s. It is the overall number of the galleries active in a given decade which is taken into account here, not only those which existed simultaneously: some were closed during the period, others opened, still others continued their existence which started in an earlier decade.[1]

The galleries, at a glance, can be divided into three categories: galleries with unambivalently figurative preferences, which represent the decisive majority of all private galleries; galleries with unambivalently avant-gardist preferences; and galleries with ambivalent preferences, which can be characterized as semi-avant-gardist. Avant-gardist and semi-avant-gardist galleries are but a small minority in the overall population.

As was shown in chapter 3 the galleries were classified according to prestige on the basis of several criteria. Most of the avant-gardist galleries belong to the most prestigious category. The owners of such galleries differ from owners of galleries with figurative preferences in that they – without exception – are people of ample means, and the money in their possession, which is unrelated to the profits of the gallery, enables them to finance its activity irrespective of its commercial success. As to education, age and all other background characteristics, there are no differences.

Figurative galleries act in different ways. Consignment is the most frequent form of transaction: a gallery accepts works of art, exhibits them as a

part of its collection and receives a certain percentage (usually, a third) of the price when the work is sold. Certain galleries, more respectable and well-established, purchase the artist's production and sell it afterwards as their own property. Most galleries which own a collection out of which they exhibit and sell works most of the time, sometimes organize special exhibitions. Established galleries do so more frequently than less-established ones. Beginning artists bring their works to a dealer – a gallery owner and ask to exhibit them. If a dealer is impressed by the works, he can visit an artist in his home studio in order to see more of them. Catalogues of exhibitions held in private galleries in the majority of cases include a *curriculum vitae* of the artist – no doubt, the gallery owner is interested in knowing about it and takes it into account while making an acquaintance with the artist. On the basis of such acquaintance with the artist and his works a gallery owner decides whether to reject or accept him. And if to accept, in what way: to organize an exhibition, to purchase some works or to take them on consignment. In some cases the dealer (gallery owner) signs a contract with an artist, according to which he pays him something like a monthly salary, advertises him, promotes him by means the gallery can afford and receives all his production in return. Usually in the beginning the gallery exhibits a few of the artist's works in its collection and determines their initial price (the price is determined on the basis of the dealer's considerations in consultation with the artist). If the works are well received by the public and are sold, the price rises and in certain cases the artist is granted an exhibition.

Prices of works by painters who are already known are usually similar in all the galleries.[2] These prices are determined on the basis of the prices similar works by the same artist received at the auction held every half year by one of the established galleries in Tel-Aviv. It auctions works by well-known painters which are received from gallery owners, collectors and private persons. The auction arouses a great deal of interest in the local artistic community.

Prices of paintings are different in galleries of different prestige.[3] In 1980 they moved between $50 and $1,000 in small galleries, and between $750 and $20,000 in prestigious galleries.

Another form of business is leasing a place to artists for a period of two to three weeks in exchange for a certain predetermined payment. A gallery owner selects an artist he is willing to exhibit and guarantees himself a profit through the rent payment he receives from the artist; the artist receives all the profits from the sales of the paintings. Sometimes, on very rare occasions, a gallery owner himself invites an artist (in such cases not a novice) to exhibit in his gallery. In all the cases gallery owners announce the opening

date of the exhibition and send invitations to the public of permanent clients of the gallery.

This public includes all those who visit the gallery regularly and also those who eventually purchase a work of art in it. In case the invited person does not appear for a number of times in succession (the number is different for different galleries) this person is dropped out of the list and does not receive invitations any more.

Most of the galleries (and every established gallery) have a circle of more or less permanent clients. In part they are friends and acquaintances of the gallery owner, the majority is acquired in the process of the gallery's activity. Established galleries guarantee to take back any work of art purchased in them in case the client is no more interested in his purchase. Owners of such galleries say that their public trusts their opinions. Indeed not once was it possible to see a spectator who was interested in purchasing a painting who did not hesitate between several alternatives, asking for the opinion of the dealer, inquiring which of the paintings the dealer considered the best and in the end purchasing the painting suggested by the dealer. However, with the exception of such consultations it is difficult to point to any form of per-suasion on the part of gallery owners. Only in rare cases of a close relation-ship and mutual trust between a dealer and his client would a dealer insist on a purchase, and then only jokingly. Thus, an owner of a very prestigious gallery told an old client: "If you will not buy this painting, I shall never again invite you to my exhibitions." However, the relationships are per-fectly symmetrical. The clients whom the dealers try to persuade in such a way, are the ones whose opinions they especially consider, the ones whom they would ask about their attitude to a beginning artist, a few of whose works were recently added to the collection of the gallery, and whom they would consult regarding various decisions in their work.

Usually the clients are collectors, but, of course, there are among them people whose interest in art has no foundation in a long-term commitment and is of an accidental nature. Gallery owners do not force their opinion upon the public, the opposite is true; it seems that they make every possible effort to know what are the preferences of the public. As a result, the importance of the gallery owners as "gatekeepers" for painters increases for they serve as a reliable barometer of the public's disposition and opinion. At the same time it is not possible to claim that they mold the taste of the public and determine the success of the artist, as it is done by curators and critics. Gallery owners do perform the role of opinion leaders for their public or clientele, but the relationship between them seems to be analogous to that between a dog and its master in an old saying. Namely, while being excep-tionally sensitive to where the wind blows among the public, gallery owners

are always found half a step ahead of the public and, apparently, lead it. In fact, though, they go in the direction desired and chosen by the public itself.

In contrast to curators and critics who have to function as "gatekeepers" in the system affiliated with public art institutions, owners of figurative galleries do not engage in construction of theories and – not being public officers – are not obliged to provide for the public any reasons for the decisions they make by nature of their trade. Therefore, they do not excel in formulation of definitions. Indeed, in answering a question "What is art?" they do not claim that "there is no definition" or "it's impossible to define it," but frequently answer: "I never thought of it" or "I don't know, I don't understand, I am not a professor."

At the same time, within this undefined realm the dealers have a clear scale of preferences, established taste and permanent criteria which help them to distinguish "good" from "bad." Gallery owners lack sympathy toward avant-garde styles, Conceptual and Abstract, and unequivocally express this. This lack of sympathy has several reasons. First, art of this kind does not suit their taste; they simply don't like it. "I wouldn't be able to live with avant-garde in my living-room," says an owner of a gallery in Tel-Aviv. "Conceptual art is nothing for me," says another one and: "Abstract does not fascinate me." They explain this by their upbringing ("I grew up with figurative art"), say that they do not understand and do not pretend to be "great connoisseurs" of avant-garde art. At the same time they do not hesitate to express their most negative views of this art. "90 percent of the Abstract is a lie" says the owner of one of the oldest galleries in Israel. "There is much cheating in it," claims the owner of another gallery. In the opinion of the owner of a relatively new gallery: "This is too easy a solution, to make avant-garde art. Someone will bring me a scribbling and say that this is avant-garde – it has no proof."

They do not like easy solutions and demand art in which "it is impossible to cheat." "Art has to be made well," they say and this, in their opinion, is a result of learning. An artist must know how to draw (human body and so on)," demands one of the dealers. "The quality of art is a function of artist's studies and work. A talented artist who did not study and has no learning – you see this, some dimension is lacking in a painting." "Professional knowledge is what is important for me," says one owner, for another one "the criterion [for selecting works for exhibitions and sales] is the quality of art from the technical point of view. When a person does not do it like a dilettante, but has learned, and knows to draw well – this is art." Her colleague has "a great belief in Russian painters, because they know the ABC of painting."

The meaning is also important, and it must be intelligible to the spectator

and represent for him "a sensual or intellectual experience." "An artist must have a message to people," claims one of the subjects; they ask for an explanation behind the details of a painting. As an owner of one of the most prestigious galleries in Tel-Aviv puts this: "If a painter has an explanation for everything; if he is a philosopher – this is good."

The message has to be expressed in a defined subject and provide the spectator with the possibility of interpreting it. "Classic art, Naive art – these do appeal to my heart. Or Fantastic Realism," says the owner of one of the luxurious and important galleries in the gallery quarter of Tel-Aviv, "you hang a painting – you see what it is. This is art."

Clearly, it is figurative styles which are the favorites of this group. However, here it is possible to notice a certain inconsistency. Among the styles, now existing in Israel, Surrealism more than any other style answers the requirements of the members of this group. However, Impressionism is preferred to it by a significant number of dealers. An owner of a successful gallery, focusing on Surrealism, says: "Surrealism is so polished. I prefer styles with an element of sketchiness in them. Otherwise, it is possible to buy a poster." (In fact, this preference is inconsistent with the requirements this group has towards works of art. Among the figurative styles Impressionism indeed provides the best possibilities of "cheating." This inconsistency is an expression of the fact that the aura of success around Impressionism and the post-mortem isolation of those who rejected it succeeded in converting this style into something to be admired by every cultured person. The ideology of creativity with its anti-mechanistic connotations facilitates the willing acceptance of this style. A creative person is the opposite of the machine. Machines, among other things, make artifacts without mistakes and erasures, smoothly and perfectly. In hand-made articles there can be errors and erasures; in fact, they'd better be there – otherwise how would one distinguish between hand-made and machine-made objects? The result: love for sketchiness. The preference for Impressionism walks hand in hand with the inability to explain this preference. Without an explanation its internal inconsistency is not exposed and does not disturb.)

In any case, figurative styles of every kind are what gallery owners like, and they do not need to justify their taste; it exists and the fact of its existence perfectly satisfies them. When these dealers have to decide between two artists they base their decision first of all upon their personal attitude to the works of these artists. One of the famous dealers says: "My personal taste is the only consideration. I have enough self-confidence to say what I like." She is also better able to offer her clients works she herself likes and understands than something alien to her. In fact, there was no interview in

which at one point or another a dealer did not insist that "the main consideration is my personal – whether I like it or not." One of the subjects explained: "The gallery is my own. I do not pretend to be a connoisseur or a great understander of art. But because the gallery is mine I feel that I must do what I want in it."

However, this is not the only important consideration; the decisions of gallery owners are to a great degree based upon commercial considerations. Usually, they emphasize this point: "A gallery is a store in which people buy and sell. I think that a painting above a certain price has to be also evaluated by the investment potential concealed in it. A realistic person standing with both his feet on the ground would not behave wisely without taking into account the investment value of an artist." This statement is taken from an interview with an owner of a successful figurative gallery. She views the gallery as "a good business enterprise" and does not "exhibit works which will not sell." Usually, the two considerations coexist. "The considerations: that I like it and a commercial consideration: I am not a philanthropic institution," says one dealer; according to another one: "This is commercial art; we present here paintings that may be beautiful, but the main thing is that they must sell." According to another subject: "The main consideration is that I like it. However, matters of investment are important matters. Cheap things are bought mostly because people like them, expensive works more as an investment." At the same time he exhibits "only art which I hundred percent believe in." His colleague from a neighboring street keeps in the gallery "usually only what I love." When asked if there is no risk, in her opinion, in relying solely on her own taste, she says, "there is risk; but there is risk even in the investment in diamonds."

Such a harmony is not everyone's lot; thus, one of the subjects tells that he always accepts "artists on the basis of my personal judgment and the mood of the period. As to myself, I like classical art, perhaps with certain modern implications. But the gallery also works according to commercial considerations. I cannot love everything I exhibit." Another gallery owner says: "I choose works of art at a glance – according to their commercial value. Sometimes I like something, but it is not marketable. As a gallery I am a commercial enterprise, I am not a museum. I establish quality requirements but I also try to find a golden path: something which would not be below a certain level and would also be marketable. Sometimes there are excellent works which have no chance of being sold."

The gap, though, is not wide and in the decisive majority of cases does not exist at all. In fact, a work of art is always perceived by gallery owners first of all as a merchandise the merits of which are most clearly expressed in its

investment potential; their taste, therefore, is an expression of their developed commercial intuition. They like what can (because of various merits) represent a worthwhile investment; only a work which will be bought can be a worthy investment. As a result, marketable art is the art which gallery owners like. Besides there is always at least one thing common to a work of figurative art and a clever investment, a certain immanent value independent of the period and lacking in the non-figurative art. An owner of a famous figurative gallery (who tells about herself among other things: "I always knew very well how to sell things, I have a talent for it. In fact it's a matter of contact with people") explains why she and the public do not like Abstract and Conceptualist art: "Art is a good investment. Good art is always an investment, but not temporary, period-dependent art. Israeli public does not want to invest in seasonal, period-dependent art." Something the value of which, by definition, diminishes with time, can in no case be an investment. Therefore, in the opinion of this group, this is, in fact, not art at all.

Perhaps, it is this founding of their decisions upon commercial considerations which explains the self-confidence of gallery owners: there is no figurative gallery which does not succeed in selling paintings; sales in themselves provide a convincing proof of a correct judgment; besides, in most cases they also reinforce the personal taste of a gallery owner.

Commercial considerations explain several other features characteristic of the attitudes of this group. One of these features is its inward orientation; these dealers orient themselves toward Israel. "The galleries in Israel are concerned with what happens in Israel," says one of the gallery owners. An owner of a neighboring gallery adds: "The public likes Israeli subjects more, it does not like foreign works so much – there is a feeling that ours is better." However, this preference can be explained in a less sentimental fashion. Apart from a number of world art masters, and Israel can boast only of a very limited number, if at all, of their works which are not for sale in galleries, the names of foreign artists whose isolated works can be found now and then in the country do not mean much for the Israeli public. These works are anonymous for it and as such they cannot be an investment. As a result, dealers cannot be interested in promoting a style, however fashionable and successful abroad it may be, before there is a sufficient number of Israeli artists working in it.

Commercial considerations also explain the reserved attitude of the group toward art critics and museums. In the words of one dealer: "We do not care what goes on in the museums. If a museum, organizes a show for a certain artist, it may raise the prices of his paintings, but this does not happen always, only in some cases. Museums do not make an impression on the

buyers." "Museum does not determine quality," says another gallery owner, "that's why we do not consider whether an artist had an exhibition there." According to them, "museum directors are afraid of judging; this is not a way of acting, this is an escape from it." "Museums are worthless, contemptible and unfair. In my opinion, there is a Mafia: do me a favor and I'll do you another in return. If some years ago I could see paintings by rather well-known artists hung in the museum – now they are in the basements. It comes from the wish of these directors to float with this stream – which I don't understand – of avant-garde. They don't exhibit good art, but avant-garde art. The public scorns it." This is not the ideal situation, but apparently members of this group reconcile with it and do not perceive in it a threat to their interests.

The attitude towards art criticism is more ambivalent. One of the dealers admits: "It is important that critical reviews appear, does not matter which, even negative." Criticism is one of the routes to publicity, namely to the promotion of sales. However, critics do not visit figurative galleries. Gallery owners "have very serious complaints in what concerns critics. Most of them deficient in that they are subjective. They think more of themselves than of the painters, they want to look super-in, super-avant-garde so that they will not be accused of conservatism. Therefore, if there is an exhibition of a figurative painter without some terrific gimmick – they simply do not mention it. Critics do not come to the galleries. It is an unbearable heartache. When one is a critic, one must criticize everything, not force one's taste upon the others." "Criticism is a very sore subject. If you don't exhibit an avant-garde show – you have no chance."

On the other hand, in their words, "gossip columns in the press are more important than criticism. Those who read criticism do not buy," "nobody cares for what they write," so that the critics, actually, are not worthy of the headache which they can cause. "Critics are a perverse profession," says an owner of a very successful gallery, "only very rarely it is possible to find a critic who is a real guide. Most of them do not have an artistic education I could rely upon." And according to another subject, also an owner of a successful gallery: "Most of art criticism is commercialized"; in her opinion, most of the critics are simply frustrated unsuccessful artists. "The country is too small for an art critic to be a professional art critic," explains another dealer, "an objective art critic does not have enough income." The prevailing opinion is that criticism is bad and that nobody is influenced by it: in fact, there is no need for criticism. Without exception, gallery owners claim that they do not consider criticism while making their decisions and one of them briefly summarizes: "I don't read newspapers. Don't want them to fool me."

At the same time, commercial considerations necessitate taking into

account the taste of the public. The dealers' regard for it is expressed in a twofold fashion: the composition of the public to which this group appeals, and the sense of deep respect for it. The public of figurative galleries is rather wide. It is described by some of the dealers in the following fashion: "middle-class people, tradesmen, young educated people, industrialists"; "Liberal professionals, ages twenty-five to forty-five, journalists, physicians, lawyers, industrialists, stewardesses, hotel managers, restaurant owners, politicians, entertainers, fashion-designers, a rather young public, beautiful people of Tel-Aviv"; "the public is composed of high-school graduates and up. European origin, also tradesmen, shopkeepers, there are many senior people – pensioners; the majority is liberal professionals, with high education, part of them people with money, many young people, young couples."

Members of this wide public are usually classified according to amounts of money they are able and willing to spend on a painting (including those who do not spend anything, as a rule, but more or less regularly visit exhibitions). But the respect gallery owners feel for their public does not depend upon money – they respect all of their public, irrespective of its purchasing potential. The reason for this respect is different: important collectors able to afford costly paintings are undoubtedly respected for this also; those who can afford to spend but a small sum or those who do not buy at all are respected for their reasoned opinions and aesthetic taste. In general, the public is respected by gallery owners for the independence of its judgment. "People usually know what they want to buy," says an owner of a prestigious gallery, "they don't buy for an empty space on the wall above a piano. Most of those who buy understand what they buy. There are also buyers who in the course of time developed an ability to judge, people with consistent personal taste." An owner of a gallery across the street characterizes her clients in the following way: "educated public, there are exceptionally learned collectors." In the opinion of others the public is "good public, intelligent, sensitive people" or: "a very cultured, educated public," "they regard paintings as an investment, but also want to like them, they can distinguish between water color and gouache, between oil and water colors. They do not explode with knowledge, but they know";[4] "The majority understands. From the moment a person wants to acquire a painting for himself personally, he comes closer to the intellectual class. We are a cultured country" and so on. Because of this feeling of respect for the public, gallery owners mention, among the considerations that guide them in selecting works of art, the consideration whether something "is worthy of being shown to the public."

It is this attitude toward the public which explains why the independence of judgment generally characteristic of the owners of figurative galleries increases with the rise of a gallery in prestige, as can be seen in table 31.

This connection between the independence of judgment of gallery owners and the rise of a gallery in prestige represents an interesting contrast to museums among which the relation is exactly opposite, namely with the rise of a museum in prestige the independence of its judgment decreases.

The greater self-confidence of the owners of prestigious galleries is explained in the following way: the prices in the highly prestigious galleries are much higher than in less-prestigious ones. It means that the clients of more-prestigious galleries expose themselves to serious economic risks. In exposing themselves to these risks they cannot let others decide for them. Namely, the clients of the prestigious galleries are also more independent in their judgment, than those of the less-prestigious galleries. Since gallery owners respect the opinions of their clients – sympathetic attitude of the public towards a new artist (and only after some of the artist's works are sympathetically received, the gallery decides to grant him a one-man show) represents a sufficient ground for a gallery owner in his decision to accept him. On the other hand, from the moment a gallery becomes established and prestigious its activity gains a momentum of its own. An established gallery is a gallery which in the eyes of its public has successfully passed many tests. This success gives it credit which induces the public to trust its independent decisions.

An interesting comparison to the dealers is provided by the owners of avant-gardist and semi-avant-gardist galleries.

These galleries actually lack any definite function in the system of Concep-

Table 31. *Independence of judgment in galleries of different prestige (in %)*

Painters who exhibited in galleries	Type 1	Type 2	Type 3	Type 4
Before exhibiting abroad	45.0	41.0	38.0	46.0
After exhibiting abroad	55.0	59.0	62.0	54.0
Before prizes	73.0	69.0	77.0	73.0
After prizes	27.0	31.0	23.0	27.0
Before museums	53.0	41.0	38.0	38.0
After museums	47.0	59.0	62.0	61.0
Before everything else	47.0	22.0	8.0	23.0

N = 322*
*Only 75% of all the artists exhibited in galleries

tualist art. They act as informal museums, private and not public art institutions. Their owners work in close cooperation with museum curators and exhibit artists who are members of the group affiliated with the museums; frequently they organize collective shows of these artists' works. Some of these galleries (as was shown in chapter 1) promote artists they represent abroad.

In contrast to their figurative colleagues, the owners of nonfigurative galleries do not know what is a good work of art. "It is subjective," says one. They know, though, when it is not good. One gallery did not have a one-man show for seven months, because the owner thought that "there was nothing to show." He thought that what there was was "not creative, not experimental, not educating," he "didn't want . . . to make a Tumarkin or Lavie show once more, it was already done in the 1970s." According to him, art "must be experimental." In the opinion of another gallery owner "it is not possible today to paint like they did a hundred years ago, it is necessary to innovate and to say things all the time." In another gallery the grave and discouraging state of affairs in the field of the Israeli art is described: "After the Six Day War the prosperity led to a situation, when 90 percent of the art which is sold really must be burned. First of all the revival of Surrealism in Israel, Fantastic Realism – it raises artists lacking talent to a level of fantastic prices! No new questions are raised, there is no place for innovation." Without exception, the owners of these galleries say that they reject "painters who do not innovate." What is the innovation to be expressed in? In the subject. "Art must have a message and not represent nature," says the owner of a gallery which she calls "experimental," "it is not important which message, it just must have some message." However, most of the works exhibited in galleries of this kind lack a subject. They are called "A Composition" or "An Object" (or, very often, "Untitled"). This problem has a simple solution: "It happens that the subject is lacking, but even if there is no subject – there is a subject." In contrast, "technique, execution is not important, for me the technical aspect is the least thing," claims one of the gallery owners. Another one agrees with her: "Technical means (composition and so on) are not relevant today. Any academy in Italy can produce painters like Bak [a prominent Surrealist], no academy can create a Conceptualist or a Minimalist." The mastery of technical means (an ability to make exact drawing, representations) is not a merit, it is a shortcoming. This attitude is expressed in relation to figurative styles which require some degree of such mastery. "Surrealism is bad taste," says one of the subjects. "I will never exhibit a Surrealist, even a good one," says another. This phrase repeats itself in every interview.

Any subject is legitimate, even if there is no subject, any message is a message, and the execution is not important. If so, how do the members of this group distinguish between the artist whose works they would be willing to exhibit in a gallery and the one they would reject (if we take into consideration artists who are not Surrealists; clearly Surrealists would be rejected in any case)? What are the considerations of these gallery owners?

In most cases, they also talk about works of art "appealing" to them, creating "initial shock" etc. However, their commitment to their decisions is reserved, somewhat apologetic. How do they recognize a good work of art? "I don't know," says an owner of a respectable gallery, "even critics are sometimes mistaken. This one seems good to me [points to one of the works hung in the gallery], may be, I am mistaken. You must stand the test of time. Sometimes I look at the works done in the 1950s which once seemed excellent to me, they do not appeal to me any more. It did not stand the test of time." They try to secure some backing for the decisions they are about to make and search for information about what is regarded innovative and experimental at the moment. One of the subjects when making a decision compares a given work of art with "a selection of good works" which can be found "in the best galleries of the world." Another one tells about himself that he is "tightly connected with the *Art Magazine* etc., draws from there general information. In this way I know the current trend. A professional must be up to date." He is not sure that works of art he selects are good: "I am neither a genius, nor a prophet, but I live my work, go every couple of years abroad." Foreign countries are an important frame of reference for these people. They evaluate their own activity according to foreign standards. For example, one of the gallery owners says that he does not want "to receive a label of avant-garde gallery – because they do not do it in New York."

This group does not base its decisions on commercial considerations. Its members take pride in this. "My considerations are never commercial," says one gallery owner, "I don't want to be a shop, I am interested in the advancement of art, I do not want to grow rich from the gallery." She is "very much for contemporary, experimental, Conceptualist art." However, hers is only a semi-avant-garde gallery and she holds figurative exhibitions. "The commercial part," she says, "provides the means for the experimental one." Her colleague from the most prestigious gallery in this group claims: "the gallery is relatively not commercial, but there are compromises, those who come and ask for investment are thrown out of here. But if I am in need of money I sometimes sell." Another subject says: "The commercial component is not in the first place for me." Commercial considerations are not

"in the first place," because "the clients buy, but very little. This art does not sell so well." An owner of one of the very few purely avant-gardist galleries tells: "there are few clients. I have very little profit from the gallery, though I reached the condition in which I do not suffer losses because of it any more."

On the other hand these "quality" galleries enjoy the respect of, and frequent visits by, art critics. "Critics come here frequently," says an owner of an avant-garde gallery, "actually there is no exhibition that is not covered by the press. I did not have an exhibition without press coverage yet." "Critics are interested in experimental things," we learn in another gallery, "that's why critics come here." Most of the gallery owners tell that they have no problems with critics, that they come without a single effort on the part of the gallery owners to attract them to the exhibitions. In their turn, gallery owners think that "criticism is important."

They are also satisfied with the activity of the museums. Curators are regular guests in "quality" galleries and gallery owners highly regard their opinions. The respect of critics and museum representatives pleases them: "The small artistic community recognizes me," – proudly says one of the subjects. "I am very glad that somebody loves my exhibitions," says another one, "museums, institutions buy these things on the basis of my evaluation." The manager of still another gallery takes pride in that "the gallery receives many critical reviews, it answers the requirements of Art."

In fact the approbation of critics, curators and artists affiliated with the galleries of this kind is the only source of gratification for their owners. The public they appeal to is very restricted while the wider public, the public of those who have interest in visual art in Israel is treated by them with contempt. This public is not worthy of respect, in their opinion, because the people it is composed of do not know and/or understand anything, are at every moment exposed to influences and do everything only to impress the neighbors. An ordinary person, according to the owner of a semi-avant-gardist gallery, is not concerned with anything but "what will his neighbor say, how will he explain the painting to his neighbor. People pay God-knows-what prices for no matter what painting, authentic or not authentic, poster and so on. They do not know what they buy. Five percent of the Israelis can appreciate a good work. Eighty percent of the purchases – very mediocre paintings, colorful, figurative, something which catches one's eye at a glance. People need decorations in the house, they avoid thinking too much. Those 5 percent who understand include those who study art." "Good art is bought by one or one and a half percent of the population of the art purchasers," says an owner of another gallery. An owner of an avant-gardist gallery says that "the public should be educated, its taste should be

improved. The taste of the public never develops in pure art directions – this is the law of nature. We strive to direct it as much as possible so that it will receive some conceptual, valuative level. They are always confused. When they enter they don't know what words to use to ask, they are unable to ask for what they want. Those who have money lack an opinion. Most of those who buy do not understand anything." An owner of another avant-garde gallery claims that "the taste is usually very low."

In contrast to such a general public, galleries of this kind "work with a specific public – an artistic elite, not the *nouveaux riches*. They look exactly for what is sold here. There is a circle of initiated – they have enough means to judge; few dozens of those who are interested in art for a long period of time." Another subject tells that her public "is limited, loves art; no *nouveaux riches*, many are artists themselves, architects, intellectuals (university professors), museums, Ministry of Education and Culture – these are the clients." A manager of an avant-gardist gallery says that "the gallery appeals only to intellectuals; artists usually visit it." With such a public, actually, the commercial considerations are irrelevant: "Intellectuals do not buy at all," we are told in one of the galleries, "they are not possessive. They come to see."

This attitude towards the public also makes the sympathy of these gallery owners toward "experimental" styles understandable. Artists working in these styles also treat the public in a similar way. One of the gallery owners explains, why she liked an exhibition which made some noise in Israeli artistic circles: "the show – 'Boots' (see p. 36) is good, because it leads to something, gives the society what it deserves, makes the public feel inferior."

These two groups, namely, the owners of figurative galleries and the owners of avant-gardist and semi-avant-gardist galleries, are supposed to fulfill the function of "gatekeepers" in the two subsystems of the Israeli art world, the system affiliated with the private market and the system affiliated with public art institutions. The first group – owners of figurative galleries – is the only group of "gatekeepers" in the system it belongs to. It may be characterized as self-confident, possessing definite taste and clear criteria for selection and evaluation of works of art. Since this is a group which earns a livelihood by selling art, the behavior of its members constantly undergoes a concrete and immediate test. The test is the commercial success of a gallery, and thereby of the artists it selects, among a certain public. Because of its dependence upon the public this group respects it and feels responsible in relation to it.

It follows, that the owners of figurative galleries, the dealers, want and

must function as a group of "gatekeepers" and that they actually do so. Their behavior and attitudes help to explain the patterns of success and career routes of the painters affiliated with them and supported by the private market.

Commercial success represents an important consideration in the work of the galleries, therefore, an artist advancing with their help must constantly answer the existing demand of the market. The demand is a demand for works of art which have more or less definite character. The success of the artist, in this framework, it follows, is based upon a certain achievement and not upon an ascriptive basis as such a basis does not make him (his work) marketable. Since the intersecting point of supply and demand is not static, the artist must constantly stand the test anew.

The second group – the owners of "quality" galleries – is only one of several groups which are supposed to function as "gatekeepers" in a system it belongs to. Like the groups of curators and critics it lacks confidence, ability to formulate clear criteria and respect for the wide public. It doesn't have to stand any tests, except the test of history.

In contrast to the owners of figurative galleries for whom the gallery is a source of income, avant-gardist galleries apparently fulfill a very different function for their owners. As was already mentioned, these gallery owners do not depend on the profits of their galleries. However, through their support of different avant-gardist groups they – similarly to curators and critics – gain a valued title of the promoters of art as well as importance among the people affiliated with museums, mass media and a public of a certain kind of intellectuals (about which we shall speak later). It is not coincidental that no figurative gallery achieved the distinction of entering the written history of Israeli Art, although figurative galleries constitute 90 percent of all the galleries in Israel. In contrast, a significant number out of a handful of avant-gardist galleries found its place in this history (and a place in history may be a very important and gratifying reward). It is also not surprising that avant-gardist galleries are called "quality galleries" by the press. The main reward for this group is its approbation by other agents in the system. However, its situation is more comfortable than theirs because the responsibility for decisions, which is in any case lighter in the case of this group because of its private character, can be transferred to the shoulders of others. Gallery owners are not the main judges. Because of this possibility to transfer responsibility, the owners of avant-gardist galleries do not try as hard as the two other groups to come up with reasons, grounds and formulations for their approach. Their expressions are more simplistic and they do not reach the impasse of "everything goes." They know that something

certainly does not go. It is Surrealism. Why this is so – they don't explain, but they feel that it is bad taste. For this group Surrealism becomes a symbol of negative identification. When the solidarity of the group represents the only justification of the form and the very fact of its activity, symbols of positive as well as negative identification (namely, those uniting the members of the group and distinguishing them from other groups) rise in importance and acquire a kind of ritual significance. The owners of avant-gardist galleries explicitly regard Surrealism as an "impure" style and this attitude on their part makes its rejection by the system affiliated with the free styles more understandable.

7 The artists – attitudes of Conceptualists and Lyrical Abstractionists

The interviews with art critics and museum curators show that in the art system to which they belong, artists, more than any other group, determine the criteria for the judgment of their art. In the end, the judged fulfill the role of the judges. Theoretically, the situation is not as absurd as it may, perhaps, seem. The artistic community may be capable of determining the criteria or norms of behavior for its members, prevent the acceptance of those who do not answer its requirements and guarantee thereby a high level of performance on the part of those who succeed in being accepted into it. This is the way of guaranteeing quality (which provides the basis for success) in different professional groups, this was the way to guarantee it in various craft guilds during the Middle Ages. Art also offers numerous examples of norms dictated by artistic communities to individual artists as well as to their clients (including art critics, museums, etc.). In certain cases such norms were no more than norms, namely, specific rules of behavior (Impressionism represents a remarkable example of such a case), in other cases they expressed important social values and explicitly demanded reference to them. The history of Israeli art provides us with such examples. In its beginning Israeli art existed without criticism and without museums – however, the artistic community itself clearly defined the functions of art in society and possessed professional standards which served as criteria for the judgment of the works produced by the members of this community (see pp. 9–12; 14–15). The definite criteria existing within the artistic community provided efficient means for acceptance or rejection of artists and their works even in the absence of critics or other "gatekeepers."

In the system promoting Abstract artists (mainly Conceptualists) the critics and curators, in fact, do not function as "gatekeepers" and the ultimate agency of judgment is represented by artists. It is they who have the decisive opinion in establishing the consensus prevailing in the system that includes besides them the "gatekeepers" and the active public.

It is therefore necessary to examine how these artists themselves establish criteria for the evaluation and judgment of art, and what is a good painting,

126

good work of art, in their opinion. However, it is apparent that in this case the artists are also unable to fulfill this vital function.

The interviews with these artists present an image of art as an activity expressing solely the experience and the ideas of an artist, which is not subject to any professional rules or extra-artistic values.[1] Art is perceived as an ultimate value, as sacred; and the artists, because they are calling themselves artists, perceive themselves as individual manifestations of this divinity on earth.

Everyone belonging to this group is firmly convinced that the artist is, by definition, a spiritual leader and that the importance of art for society is immense. There is no argument about it. A Conceptualist painter "considered the most outstanding young artist in Jerusalem during the last decade" who is also seen by some people in New York as one of the prophets of what is called "the Conceptual Abstractionism" and who "feels . . . in the Israel Museum as a king in his own house and defines it as his private territory"[2] says: "According to McLuhan, the artist is the antenna of society, he develops aesthetic senses and they are relevant to the period he lives in from political, sociological points of view. The artists are among special guardians of the individual. Brecht once said that an artist is somewhat similar to a prostitute and his function in society is similar: he can tell the truth to all those people above." According to another artist, one of the first Conceptualists in Israel and an outstanding leader of the Tel-Aviv group of Conceptualists that was active in the 1960s: "Artists are simply more sensitive and develop faster than ordinary people," while "art is the essence of life"; when he looks at art, he feels "that life is justified." According to yet another distinguished Conceptualist, art liberates human spirit, and an Abstract artist, one of the most successful men even in the 1970s (when Conceptualism replaced the Abstract in the system affiliated with public institutions) claims: "Art enriches society. Art influences every form of man's life, his house, the form of the house, the street, his clothing, way of life. Many times people see the view only after they saw it painted, art opens their eyes." "Always because of the perceptual sensitivity of the artist," says a young Conceptualist artist, "he will be sensitive to the things of which others will not be aware." As to art, in general, he says: "True art is the art which irritates, asks questions, it is, in fact, a system of things which are oriented toward a general feeling ultimately connected to man."

However, in order to express the uniqueness of the artist and make the importance of art for society manifest there is no need for an intelligible message, and the content of the work of art has no significance. One of the artists says: "art certainly is a communication, but not of the kind of a

telephone. The communication in art is like the communication which results from my sitting near a girl in a bus, when our legs are pressed together simply because I am fat, while she starts to think all sorts of thoughts and understands it differently. I am, in fact, an option of communication. Of course, I am interested in initiating a communication, but it does not matter how will it be understood." For another artist, the chairman of the Art Department in Bezalel Academy, what is important is "elementary painting, a language and not contents," when "lack of content – is content." An Abstract painter claims that "the art of painting is something which cannot be defined. Art is created by an unknown which cannot be defined. For me art is color, and as well as colors, there are colorful forms which create among them a certain relationship and a certain structure which results in a certain tension which is, in fact, the work of art; and this tension is the creation of an artist. It does not matter whether it is figurative or not. Of course, if the figurative only tells the story, if it is only narrative – then it is worthless."

There is also no need in technical knowledge or in the mastery of the media. "In art," says an important Jerusalemite Conceptualist, "craftsmanship has no place. By the word 'craft' society wants to derogate, to humiliate the artist." In the catalogue devoted to Pinchas Cohen-Gan, "one of the artists who helped to form the image of Israeli art in the 1970s," the curator of Israeli art in the Tel-Aviv museum writes:

The flight from Mona Lisa brought about the artistic work which placed the idea behind the artistic act in its center and perceived the "materialism of the work of art," its visual embodiment, aesthetic treatment as side-effects which are not always necessary. Such a conception of the artistic act led to almost complete abandonment of painting because of the aesthetic history with which it was loaded and from which they wanted to escape. The flight was to those means and forms of expression which seemed useful for emphasizing the idea, the verbal phrase, the formula, laws of logic, the research, the voyage, the life itself . . . The contempt for the individual *chef d'œuvre*, for virtuosity for its own sake, and the craving for the idea behind the work of art produced in the 1970s the image of the "thinking artist" – creator of the Conceptual movement, who abandoned the use of painting as one of the creative resources, among other reasons in order to establish the claim that an artist is a person who has something to say and not the one who knows how to draw. The accentuation of the idea brought in most cases about the drastic restriction of any possibility of sensual admiration of works of art.[3]

The artist, thus, is the person who has something to say, but there are no rules for how will he say what he says, as we saw earlier, and the meaning of the work has no importance. (The definition of the artist as a philosopher, paradoxically, does not imply that he must be evaluated *qua* philosopher.

He is nevertheless called an artist and judged as an artist.) Is then everyone who says something an artist? No. In general an artist has to express, reflect or document his epoch, his art must correspond to the path of technological development. This must not necessarily find its expression in the contents of the artistic work, but can be restricted to the media. "The function of an artist," declares a successful artist of this group, "is to document the environment." Her colleague, one of the important Conceptualists, writes: "The basic feeling of insecurity deriving from the abundance of components in reality, of different levels of understanding co-existing at one and the same time, of the surplus of information. The work must reflect all this, so that it will give a frame to our reality."[4] Or, elsewhere he claims: "like medieval philosophers who tried to reconcile the God of the Mishna with the God of Science, the God of Israel with the Creator of Earth and Heavens – so are the scientists of Israel and its innovative artists who bridge the gap between the idea and the technological reality."[5] (Such identification with science and the use of scientific and philosophical concepts are characteristic of these artists who see themselves as first of all thinkers and men of letters.)

However, the most important and, in fact, the only indicator (from the operational point of view) of the ability "to say something" is innovation. According to one of the artists, "aesthetic senses have a tendency to sink in sentiments and nostalgia and it is the function of an artist to renovate these senses, for example, to view the scenery not by the eyes of Cezanne or Van Gogh but by the eyes of artists working today." And: "a good work of art, which is involved in all the matters painting is concerned with, must be innovative." His colleague claims: "Art is the opposite of institutionalization or the opposite of 'to find'; when you find, you must quit; it is the search, and aspiration to reach the unknown."

According to another artist, "it is difficult to say what is art," yet he can "come rather close to what is not art. What I already like today is not art – it is a phenomenon, and there are *chronicles* of art which had already succeeded, and that is the history of art." Another interviewee thinks that "a good work of art is what changes the perceptual – semantic conception either from the perceptual narrative aspect or from that actually connected to the senses." Another Conceptualist, a Bezalel professor, says: "There are artists who work in the framework of conventions which may be most progressive conventions. In distinction to them there are artists who succeed in breaking conventions and creating new ones. Of course, the importance of the latter is greater, than that of the former, because they succeed, through artistic activity, to dictate new ideas and new artistic ideologies."

As there are no restrictions of either content or form, that could provide a

ground for the comparison of different innovations and for the evalu-
n of these innovations, an impression can be created that any innovation
(namely, anything which was not done before), is defined as a work of art.
This is indeed so, with one qualification: the innovator must be an artist.
"Pinchas Cohen-Gan became a conspicuous figure on the Israeli art scene
since his 1974 exhibition," says the Tel-Aviv Museum catalogue, "one year
after the Yom-Kippur War. Then he was still engaged, naturally for the
period, in socio-political problems. The show exhibited a series of 'activities'
and voyages of Cohen-Gan and avoided presentation of drawings in order to
keep the Conceptual character of the activities pure."[6] Among these activi-
ties were: "The voyage to Alaska," "Reconciliation with Asia," "A voyage
to the Nepal and China border," and others. When Cohen-Gan was asked,
why does he define these voyages as art, he answered without hesitation,
"My activities are art, because I am an artist, everything I do is art."
Another Abstract artist agrees: "Actually any work is a work of art if the one
who created it is an artist." "Art," says one of the interviewed Conceptual-
ists, "is a social convention. It means, that there is a certain activity and
certain things are produced which the society decides to regard as art. At
first, this is an agreement of a small number, which grows, widens into the
consensus of the Establishment." The decision-making agency is art itself.
Says a Conceptual artist, with fifteen years of teaching in most important art
schools behind him: "One should not intervene in the reality of art which, in
fact, must be the main leader."

Art means artists. If so, the main question is: who has the right to be called
"an artist," who decides, who is an artist? "There are a number of people
who can determine it," claims one of the Abstract artists, "people who are
engaged in the profession," and "artists are the ones who make an artist."
However, according to some opinions, virtually anyone can be an artist. The
chairman of the Art Department in Bezalel says: "I teach that everyone has
a basic artistic trauma – some traumatic problem with reality. The talent is
not important, only neurosis can turn a person into an artist; those who can
make their neurosis a symbolic game – which is art – succeed. The main thing
is to find the basic trauma of a person, his art will be derived from there.
From the moment a person is able to turn his eccentricity into a code – he is
an artist." And the Director of the Academy, also a Conceptualist artist,
declares: "It is necessary, in my opinion, to increase the number of students
in this institution, particularly in the Art Department. I believe in large
numbers and in the spirit of 'non-elite'."

There is no possibility to define an artist by his characteristics or by
characteristics of his activity, for there are no rules for converting the

eccentricity which, according to the interview above, is concealed in everyone into the code which turns a person into an artist. If in the end, according to the artists themselves, everyone can be an artist, we arrive at the absolute abandonment of any criteria – whether explicit or implicit, for the judgment of works of art in this stylistic framework.

The definition of art as what artists do, combined with the claim that anybody can be an artist, from the start eliminates the possibility of independent criteria and leaves the judgment in the hands of "artists" appointing themselves to this office. Such a situation can lead either to an absolute anarchy in a given realm or to an absolute authoritarianism in it, bordering on tyranny. And, if it is possible to judge by the ideas these artists have of the artist's function and duties toward society – mankind, Israeli people, the public these artists address – the result is authoritarianism.

Although these artists say sometimes things like "art is a social matter," they firmly believe that the artist does not have any duties towards society, except the duty to create. "An artist must create," says one of the Abstract artists, "if he will not create, there will be no art." This sums up the duties of the artist toward mankind. Artists' attitudes toward Israeli society are more elaborate. Art must be cosmopolitan and any relation of duty between the artist and the society or people he lives within is out of the question. Ran Shchori, an important Conceptualist artist, an ex-art critic and Director of Bezalel Academy, says:

I have problems neither with my Hebrewness nor with my destiny – in its national context, of course, – it is not possible in the end of the 20th century to return to the age-old problematics. The world is open and the problems we confront are universal. I view nationalism as a phenomenon which was very important and necessary, but I don't see it as something holy, and if I dream, I dream about the supra-national world. So far as it cannot exist, I am a part of a certain national framework which has certain uniqueness from the point of view of language and culture, and as a *Sabra* I live here and that's it! . . . An attempt to find roots in the artistic plastic existence of the Jewish people is dubious . . . the Israeli art is a part of what happens in the world art and this is the way it should be. Any attempt to create a new spiritual ghetto, to turn one's back to the world and say: "long live us," is a disaster; it is either an expression of regression or an expression of pathology.[7]

Another Conceptualist artist says: "those who talked about Israeli art are immigrants, you must keep it in mind, Zionists. They have this problem: I am an Israeli, essence, identity, etc. A person comes here, drives out Arabs and feels uncomfortable – so he must justify it. I and my children don't have this problem." According to another artist: "The function of the artist is to document the environment. If a person wants to declare himself an artist, he

has to take into consideration the whole of his environment, to be cosmo-politan, in fact." In the Tel-Aviv Museum catalogue, dedicated to Pinchas Cohen-Gan's exhibition we find the following passage:

The activities [of Cohen-Gan] raised questions dealing, among other things, with the relationship of an artist to every environment and place he happens to be in; the significance of the place, geographical and physical places (East and West), the relative weight of personal and geographical determinants in a work of art in every place. Also were raised the questions of the meaning of art in relation to concrete human conditions . . . Among the conclusions that were inferred, one must be mentioned, which says that the sole center of art is the artist and that the place is a relatively changing fact . . . (notwithstanding) his decentralistic ideas, Cohen-Gan, as a civilised artist, understood that the place where he must express his views is New York.[8]

He himself says:

I am not an Israeli artist. I live in Israel, but first of all I am an artist. It is not cosmopolitan, but it is art, it is human and supranational . . . My political opinions now are sophisticated philosophical opinions. I cannot express them now; to say whether I want territories or don't want territories, this is not important, and if I chose to express them at all, I would like to talk to many people, not one million, to fifteen art lovers who live between Metula and Eilat; it is not worth the time

He also writes: "The claim that contemporary art is not Jewish and not Israeli because it is universal – is faulty, for philosophers of all religions said that the perfect God is one and equal for anyone who reaches the knowledge of Him. Not the haughty artistic isolation and not the retarded paganism will lead Israeli artists. The artistic idiocy and bad taste are not the exclusive prerogative of the Jew."[9]

Whom do these artists address and for whom do they create their works? The answer is clear: for art, for their fellow artists and in the final analysis for themselves. Thus one of them expresses this point: "The public I envisage is the public willing to enjoy that change of coordinates [which the artist offers in his work]. There is such a public, but its members are numbered, it consists of people whose main occupation or background are close to it: colleagues – artists and people around – art administrators." Another artist: "I don't do what I do for the public, but for artists, I talk to artists. My public is anonymous, as a matter of fact I hate it, I never received anything from the public."

An outstanding example of this approach is Joshua Neustein; he expresses his views clearly and is considered a philosopher of art among his colleagues; long and very sympathetic articles are devoted to his activity. "A good artist," says Neustein, "is an ambitious artist who wants to do something

great, who feels that his is a historic mission, who has vitality – creative power, ideas tied to the development of art, and whose own development is systematic . . . A good artist has to influence the public in such a way as to bring it to change its attitude towards the artist. I. T. is a good artist from the sociological point of view, because he is a fighter – in that way he changes the attitude of the society to the artist, and this is his mission." Dr. Efrat, a close friend of Neustein, writes about him:

Neustein lives within the supra-temporary, within the history of art . . . his historical consciousness is acute, sensitive . . . he wishes to participate in a dialogue with the "spirits of the ancestors" and not coincidentally he forced himself in the beginning of the 1970s to create a series of works devoted to the masters of modern art. He formally notified them that their *chefs d'œuvres* were created earlier by himself . . . He made himself photographed walking on the path in his garden in Abu-Tor, a branch in his hand, imitating a well known pose from the self-portrait of an artist, the founder of Naturalism, Courbet, "Bonjour, Monsieur Courbet." "Good morning Mr. Neustein" the Jerusalemite artist called his picture. The same self-portrait which had stormed the French public opinion by its megalomania and narcissism, fascinates Neustein. He, like Courbet, turns into a hero, a prophet with a mythological crook, into a storming figure, into an artist in great Romantic terms . . . Inside his "Neustein's wisdom" you will find a mapping of modern artistic developments and his relation to them . . . as one who is constantly aware of his historical place and acts accordingly.[10]

"A professional artist," says Neustein, "is an artist, for whom the aim of society, of a civilization is to develop a perfect artist" and "an artist must influence the society so that it will change in such a way as to be able to serve the goals of an artist."

As to society, these artists have a lot of complaints. First of all "the more cultured a society is, the more respect it has towards the artist."[11] The society must be trained to value art whatever form it takes; as one of the first and outstanding Conceptualists in the country says: "It is necessary to teach public to love art, not this or that art, but art in general." And this is so, in the words of another artist working in Abstract style, "because art enriches society, not always society recognizes it, not always it is aware of that it has a need in this."

Israel, in particular, lacks sufficient respect for art, in the opinion of these artists. "The state does not understand, what is the function of art," says one Conceptualist, "the institution of art must be administered by people who love art and not by politicians.' In Dr. Efrat's article Neustein says: "What interests me is the ethical problems which must be discussed. Morals play an honorable role in Israeli art . . . In our days art is devoted to decoration, subjected to bureaucratic decisions, it serves as a political means and plays a

role of servile, picturesque clown; it is entertainment. The art of wooden camels is the desired art because it corresponds to the expectations of American Jews and other donors who consider us Puerto Ricans in a Disneyland . . ."[12] "And because of that," summarizes this passage the author of the article – "The portrait of Neustein," "to obtain a studio from the Jerusalem Foundation, according to Neustein, is a part of society's duty towards the artist."[13] Pinchas Cohen-Gan writes: "The vitality of culture and art in Israel is a true constituent of our life; the Ministry of Education and Culture is the one who must find a modern operative pattern of acceptance for the new expression of reality; this expression is a natural and integral part in the system of our art."[14]

The artists are the kernel of the system to which, beside them, belong the museum curators, the art critics, and the owners of the "quality galleries." The account of their attitudes complements the analysis of the ways in which this system functions and adds to the explanation of the patterns of success and career routes described earlier.

The curators and critics do not consider themselves obliged to render an account to the public, they are not public servants but the servants of art. At the same time, they have no coherent requirements towards art and do not possess criteria for the evaluation of the products of the artists' work. Naturally, they turn for help to artists, and to those artists for whom also art does not serve but itself. The artists too, in their turn, lack criteria with the aid of which they could determine who is an artist and even to substantiate their own right to be defined as artists. In the absence of criteria, the only reason for such a definition is its acceptance by the cohesive in-group.

The location of the judgmental authority within this small in-group which bases its judgment not on a system of criteria but on its solidarity, on mutual dependence of its members and on the consensus existing among them, which derives from this dependence, explains the patterns and the sequences of exhibitions in the careers of these artists, as well as other characteristics of their success.

These artists, working in Conceptualist and Abstract styles, represent an elite of a complete social system. On their way to their place in it there are no "gatekeepers," because those who are supposed to judge their works transfer the task of judgment to the artists themselves. The artists in their turn, are not able to form criteria, because their activity is not oriented toward a common goal, if we do not consider as such the personal aspirations or personal advancement of each of the members of this group.

Their success is based on no discernible criteria. It is determined, judging from biographies of the artists in this group, by an ability of the artist to be

accepted by other artists in the group and by critics and curators close to it. After he is admitted by the group, an artist is almost automatically rewarded. Everything he does is defined as art, for the group considers it an expression of a creative person. At the same time – and this strengthens the above conclusions – these artists have no difficulty in distinguishing between those who belong to the group and those who do not belong to it.

Their network of communication is very dense and rigidly defined. In most cases the best friends of these artists are also artists working in the same style. In the interviews the painters were asked to list twenty names of Israeli artists whose works the interviewee liked most and who, in his or her view, have contributed to the Israeli art. The lists obtained from painters quoted in this chapter are very similar. In most cases they include the same names: in the Conceptualists' lists these are the names of other Conceptualists and in the lists of artists working in Abstract (but not Conceptualist) style beside the names of Conceptualists there are also names of their fellow Abstractionists.[15] The majority of artists included in these lists participated together with the interviewed artist in various artistic groups and in numerous collective exhibitions. Others listed were the interviewee's students or teachers at one or another stage in his or her career. This involvement of the artists included in the lists in the careers of the interviewees, doubtless, influenced their inclusion. The interviewed artist's conception of these artists as important and significantly contributing to the art in Israel, strengthened his or her self-definition as an artist.

The ascent of the Abstract and especially of the Conceptualist schools[16] was followed by the acceptance of an approach which rejected the possibility of, and the necessity for, shared artistic values and criteria, and demanded absolute freedom for the artist to determine what is art. This freedom was actually granted only to the members of the school's "in-group." No such liberality, nor even a shade of tolerance, is manifested in relation to artists who do not belong to it, and their art is indiscriminately rejected. The insistence on normative openness central to the ideology of the Conceptualists, which is accepted today by most of the curators and critics, turns into an institutionalized intolerance with regard to other schools (with the possible exception of Naive artists). One may ask, how can such a dogmatic approach, which rejects most of the painting existing in the country, succeed in sustaining itself in the center of the Israeli art. We shall deal with this question in a chapter devoted to the publics of different styles.

8 The artists – attitudes of figurative painters

Painters affiliated with the private market provide a fascinating comparison to the artists promoted by the museums.

The fact that immediately attracts the attention of a sociologist is that the structures of the two groups are very different. As the previous chapter has shown Conceptualists (and other Abstract artists) can be defined as an ideological group in Shils' terms[1] despite the absolute normative anarchy in the framework of which they act. In contrast, the visual characteristics of all the Figurative styles presuppose a clear and consistent system of values. (See pp. 9–12; 14–15; 18; 32; 38.) The interviewed artists in this group had no difficulty in formulating their professional ideology in an intelligible way. Yet, they do not constitute a cohesive group which is aware of the importance of its solidarity and cultivates it with the help of certain symbols forming a uniform artistic platform. The borders of this group are not defined and the network of communication of figurative painters is sparse – if it is at all possible to speak about a network of communication common to these artists. Each one of the artists who were interviewed is linked by ties of friendship to different people, known (among his colleagues) to him alone and important for him only – people of different professions, who are connected to art solely by these personal ties. These figurative artists also found it difficult to make a list of twenty painters whose talent and contribution to Israeli art they considered significant. They mentioned hesitantly two or three names (different in most cases for every interviewee): sometimes these were names of painters working in the style of the interviewee; more frequently painters working in different styles were mentioned, and in most cases these were classics of Israeli and even non-Israeli art.

In fact, in distinction to the Conceptualists and Lyrical Abstractionists the figurative style-groups do not represent real groups but are, actually, categories of classification. As was pointed out earlier, the artists were grouped into stylistic categories on the basis of visual–technical similarity of their works and their place on the continuum of the rigidity of professional requirements versus the individual freedom of the artist. Therefore, pain-

ters belonging to different styles can share similar attitudes, while in every style it is possible to find several ideological approaches. Thus, for example, among the Surrealists there are Jewish Surrealists, and Fantastic Realists who stress more universal values. I shall, therefore, consider all the approaches without an attempt to attribute them to the styles and refer sometimes in this chapter to a certain figurative painter as an adherent of an ideological approach and not as a representative of one or another style.

An adequate representation of artistic attitudes characteristic of the figurative painters in general must take into account the differences between particular ideological approaches prevailing among them. The consideration of all these approaches may help to distinguish what is common to them all and to accentuate what distinguishes them from the aesthetic position of Abstract artists. This was the reason for the choice of the sample for this chapter, which did not focus upon the Surrealists, as the preceding chapter focused upon the Conceptualists; instead, an attempt was made to bring in important painters considered main representatives of Surrealism, Expressionism, Realism and the Free Figurative style. The Naive artists were not included in the sample due to the ambivalent character of this style and the difficulty to decide whether they belong to the group of styles that stress professional requirements or to styles that allow for a great degree of individual freedom of the artist, and also because they are equally accepted in both systems of promotion. The consideration of these artists in any of the two groups would only blur the differences existing between them.[2]

Two elements unite the approaches characteristic of figurative painters and oppose them to the aesthetic position of artists working in Abstract styles. The first element is the accentuation of the quality of performance and adherence to the professional technical criteria. This emphasis on the professional–technical aspect of the work of art does not imply that its spiritual significance is considered any less important. On the contrary, in the opinion of figurative painters, only through the perfect execution can the spiritual aspect be expressed. Thus a Surrealist painter answers the question, "What must an artist do in society?": "I think, that it is necessary to draw well . . . A good work of art is determined by the absolute mastery of the technique and by the best solution of certain technical problems. First of all, the absolute mastery of the medium . . ." It is not possible to separate the emphasis on the professional–technical skill from the stress on the intelligible message of the work of art (namely, a message intelligible to the spectator). As a certain Expressionist states this position: "I want to tell the spectator clear things, interesting things, of course, very intellectual things, but in such a way that he would know what I wanted to tell him. Some

message about the reality is, of course, necessary – this is how the greatness of an artist is measured." The connection between these two emphases is clear: the accentuation of the technical skill cannot exist without a parallel requirement for a possibility to put this technical skill to a test, and it can be tested only against the background of an intelligible message.

It is possible to claim that the figurative character of these styles derives from this element in the professional ideology of the painters, because figurative painting requires an ability to represent on canvas or paper visual impressions in which spectators can usually participate. However, this demand for an intelligible message and for adherence to professional criteria of performance is a result of a more fundamental characteristic common to all painters working in figurative styles which is the second element uniting them. This fundamental characteristic is the belief that art must transcend itself and possess general moral significance. In fact, the requirement for professionalism and for the high level of execution is always brought in within a more general context of the demand to express certain moral values. It is these values that are worth, and demand, the effort. The main thing, as one of the Expressionists puts it, is the confrontation with "metaphysical reality," involvement in it and an ability to embody it in visual form, in which "the means should fit the end." A Free Figurative artist, who agrees with this point, aspires to achieve "the unity between ethics and aesthetics" in his art.

Two main types can be distinguished within the transcendental definition of art characteristic of all the figurative painters: (a) a collectivistic type of transcendentalism, namely, reference to the values of a certain collectivity and a desire to implement them through art; and (b) an individualistic type expressed in the conception of art as a means for the embodiment of values, the focus of which is an isolated individual. There are variations in each one of these types. The collectivities the values of which the painters with collectivistic orientations try to express are three, and it is, therefore, possible to classify these artists according to three approaches which are: the universalistic approach, the local-Israeli approach, and the national Jewish approach.

The roots of the universalistic approach, for which the relevant collectivity is the whole of mankind, can be found in Martin Buber's conception of art. According to Buber, the purpose of the Jewish art was the creation of a cultural, aesthetic education, a means for self-knowledge, and a cultural avant-garde for the nation and the world. The Zionist movement, thought Buber, was a movement of revitalization, it used the capabilities of the people – as individuals and as a collectivity – and liberated them. In Palestine

the suppressed longing of the Jewish people for beauty and nature might blossom and express itself in works of art. Buber required unity between the artists and the ideology of the people, but not a "tendentious art." His intention was different: art, according to him, was the ideal way to bring the nation to itself, to self-consciousness. Art was important for Zionism as a means of education for beauty, cultivation of feelings, in short, development of the characteristics the Jewish people was allegedly lacking. Only a complete nation (namely the one that possessed all the lofty human characteristics and did not differ from other nations because it lacked these or other features) was worthy of salvation. There was nothing better than art to express truth – the Jewish art would express the nation's Zionist, Jewish, and human essence.

The painters whose ideological approach today resembles Buber's conception also want art to educate people to universal values.

One of the adherents of this approach, a Free Figurative artist says:

In addition to everything else art is a means of communication; great art has an influence similar to other great deeds with roots, with power – such a thing can influence not as a political program but in a human, philosophical way, as a vision of true life . . . art must not make revolutions . . . but it can educate, make us more aware of our neighbors . . . An artist must be good. Without being a good man it is not possible to be a good artist.

"I appeal to the human side of humans," says an Expressionist painter.

The attitude of these artists to themselves and to the role of art in society is not pretentious. An Expressionist painter says: "Art is an expression of a person involved in a situation which confronts him at the given moment. In this I am like any shoemaker, any other human being, there is nothing special in it." He expresses his moral attitude to the world through art "simply because art for me is an activity I like, it mobilizes my intellectual and my emotional potential." According to his colleague, a figurative artist, art is also not "the most important thing in the world. One must not romanticize it in this way. It is exactly like sociology, or chemistry, or literature. Maybe, without the pinch of salt contributed by art life would be more difficult, but you may find this salt in music also . . ." Their view of modern trends of "art for art's sake" in which an artist is "the hub of the Universe," in which everything he does, he does for himself, is unequivocal: this is pathology, "a clinical fact" as one of them phrases it, or at most "an intellectual–technical game."

The local-Israeli approach was the approach of "the Rebels against Bezalel" – the founders of the Land of Israel style. Their art nursed on the

geographical uniqueness of the Jewish settlement. They conceived of their work as "possessing mystic quality saturated in the visions of return and generation"[3] and saw themselves as obliged to make local art which would mirror social ideals, demanding in this framework to turn away from the period of the Diaspora and to identify with the Ancient–Biblical past and with features characteristic of the geographical location and ethnic composition of Palestine. An artist had to be connected to the society and express in visual form the values of the settlement. The adherents of the local-Israeli approach today think that art must educate to general humanistic values and develop sensitivity and ability to experience beauty and harmony. However in addition to it, they emphasize the need to refer to the values of the Israeli State and society and create art rooted in this society.

One of the members of The Group of 10 – a group which in the middle of the 1950s opposed the cosmopolitan art of the New Horizons and demanded to create Israeli art, a painter who began as a Free Figurative one and works now in Surrealist style, a very successful artist, says:

Among the elements composing art there are also the elements of political idea and of conscientious – moral aesthetics. It has to do with justice, with the search after the perfection of justice. This search must exist, without it one loses the ground, the moment you think, it is not possible to attain it – you are lost. All kinds of sages come and say that there are ugly things in life too, that's right, but should you bring it into art? Art must educate, it must raise the morale of a person, emphasize the conscientious and moral chord and prove to man that life can be beautiful. Art is a matter of enjoyment, of aesthetics, you must live with it.

But he adds:

The group of Ten was a reaction to the Diaspora painting . . . We wanted to be pioneers of the Israeli painting . . . In my painting there was a chord of a search for the identity of the people and the State and the region. It was not Zionist fanaticism, but it was Zionism. I wanted to create new aesthetics related to the fact of living in Israel as a young and developing state. It is ridiculous to talk about abstraction in the immigration camp. The country needed something which had to be built anew. The Abstract grew on the European social soil, and was not of any use to us. I make every effort to relate to my environment. An artist cannot be cosmopolitan.

Alongside these two approaches: the universalistic one, educating to all-human values which indeed have unique meaning for the Jewish people for so long isolated from them before the return to its country, and the local approach, evaluating the artistic significance of different trends according to their correspondence to the Israeli reality, there exists another approach which places national–Jewish values at the top of its scale of preferences.

This approach for the first time was expressed by the founder of Bezalel, Boris Shatz. A couple of months after the institution was founded he wrote:

here . . . we feel . . . all the bitterness of the Exile and of the slavery mixed with the hope in our wonderful future on this very land; here, where on their school bench our pupils will learn art according to wonderful Jewish symbols under the skies of our Motherland, while in our ears a charming sound of the Hebrew language will resound with the national songs and melodies – here our pupils are obliged to talk in their paintings about our national aspirations and hopes.[4]

Painters among whom the national approach prevails today emphasize what is common to the Jewish tradition of all the generations and what distinguishes it from other traditions, they share certain elements of the local-Israeli approach, because, in their opinion, Israel is the most natural place for the development of Jewish art and rejuvenation of Jewish culture. More than that, for the artists–adherents of the national approach, art is necessarily concerned with the universal human values and has to educate people to these values. One of the outstanding National painters, a well known Expressionist, says: "Through their creative power artists want to express themselves and thereby to present the spectator with an experience which will excite his feelings so that he will be able to identify and to rise together with the work of art itself . . . art is a divine creation of a mortal, a creation which is linked to deep levels in the traditions of life. Certainly, art must express the most lofty values. An artist wants to influence in the direction of educating to certain values." However, in the conditions we live in, it is not enough: "If art is a universal–global matter," says this painter, "I cannot connect it with the fact that we here build this country . . . I see myself as an artist who stands at the cradle of a culture. I have nothing in common with all this talk of the world-wide ideology of art – I must grow here." Or as another artist, also an Expressionist, recalls about the beginning of his career: "I wanted to make simple painting, so that people would be able to understand – I wanted to participate."

The participation of these artists in the building of a new culture in Israel is the participation of Jews in the Jewish cultural revival. One of the artists says: "I began to define myself as a Jew and started to believe that here, in this country, one must make different painting than anywhere in the world . . . because of the fact that we want to talk and understand each other and we can do it only as Jews. And as Jews we can be respected by the neighboring peoples only when we shall be enlightened Jews. But the stress is on Jews." Another painter expresses this point in a most lucid fashion: "The Bible, the works of Jewish religious art and folklore, and Jerusalem as a

symbol and as a city, are something I truly love. I do not just translate them into the language of painting, they are painted from within me. I don't study Jewish folklore. The Bible and all that is connected to the Jewish faith are a source of inspiration one cannot be ashamed of. This spiritual world is not yet destroyed for me, it still nourishes and gives life." Or: "Among us the artistic tradition is linked to few things connected to Judaism itself. A contemporary Jewish artist wants to build a new culture, to continue the dynasty of art which has deep roots and not to create art which will compete with other arts. True art is nursed by spiritual values – it must not be competitive." Reflecting upon the Jewish tradition this painter feels that "here I have an art of my own, Jewish art . . ." and through the connection with it he "closes the gap of 2,000 years." Another artist says that in his art he reminds "them [the spectators] that they are Jews and I am not ashamed of it."

The conception these artists have of their art, as art that is first and foremost national, is connected to their explicit and articulated definition of the role of the artist, and therefore their own, which they view as that of spiritual leadership, a view which does not exist among other groups which are discussed in this chapter. One of the artists views himself as "a man who contributed his small part to the culture evolving here" and as "a small flame." Another artist says: "Artists are certainly people who can be counted on fingers, for when they are many, they are a herd and they do the work of a herd. Artists are high priests – guardians of culture, creativity, they nurse on much deeper sources, have deeper roots. I wouldn't use the word 'leadership,' but the true art is created by people who unconsciously want to influence." And more: "An artist is the conscience of the human mass, for he searches for the expression of a power hidden in the soul of a man, he wants to touch the upper level of human wisdom to share the process of creation with God, to help Him." As to himself, the artist quoted above hopes: "If I shall persist on this way of mine – I shall be able to determine something here."

These statements can create an impression not different from the one created by the claims of Conceptualist artists. However, the general context in which they are placed gives them a totally different meaning. An artist is a spiritual leader, in the opinion of these painters, not because art is sacred in itself, but because it serves important human and national values which transcend it, it can emphasize these values, bring them out to light and in so doing provide people with a compass. (This conception may, perhaps, remind one of Durkheim's view of sociology capable to discover the concealed values of society for this latter's use.) Thus, in this case, an artist

occupies a special position as a public servant, not as a tyrant, and this is an important difference.

One thing unites the three artistic ideological approaches: there is not a shade of the "art for art's sake" spirit in them, all three view artists as an avant-garde in an ideological struggle assisting in the common effort of the collectivity (conceived differently in the framework of each one of the approaches) and as spiritual leadership capable of articulating the values of the collectivity. Given this goal – art, according to each of these approaches, must be intelligible to the public, and as a result the elementary bases of professional painting attain great importance and it is necessary to use clear criteria for the judgment of works of art.

The approach of the individualist painters is different from these collectivistic approaches. Individualist artists engage in art, on their own testimony, because of a certain internal drive which they cannot control. According to these painters, art is first of all functional for the artist himself and it is not its duty to embody values and to refer to the subjects important for a collectivity. One of the prominent Surrealists says: "subjects are not important for me. The subject is only an excuse for painting. The function of art (for an artist) is to eternalize his genius. From the artist's point of view, the function is to defy death by an actual elevation of dead matter to the sphere of the spiritual. When I create I try to convert matter into spirit and thereby to fight destruction, death and dilapidation of myself. I eternalize my personality as an artist." Says a Realist painter: "What I do in art, I do for myself. If a gallery is willing to exhibit and people are willing to buy – all the better. Fortunately, it pays, but for me it could as well not pay." This is also pointed out by her colleague, to whom we have already referred above: "I am faithful to my searches as an artist and I do not take into account anything else. When the public is allowed to look at the work of art – it is granted a favor in fact . . ." Regarding the gallery which successfully sells his works this painter says: "This does not at all count for me." Before his fantastic commercial success he worked as a grave digger, a guard and had numerous other jobs – this did not prevent him from painting.

Art for these painters is individualistic activity gratifying in itself. Therefore, they address the public only indirectly and do not demand any respect from society. It is possible to interpret this as a contempt for the public and placing painting or in any case personal values of an artist above everything. However, in contrast to Abstract artists, this attitude is not connected to the demands for support from the despised public. More than that, even for the individualist artists, art can fulfill an important function for society. As a Surrealist painter says: "I don't think that an artist can somehow influence

society, but art has a great function – mainly, humanitarian one." According to another Surrealist:

Art is not an expression of what surrounds me as it is. I perceive art as a means man can use to reach psychic and social homeostasis, that is if there are things in life which disturb him, art can correct the situation and to some extent provide an equilibrium, bring to some spiritual balance . . . By creating a painting in such a way that it calms the spectator as well as the artist, it brings them aesthetic enjoyment and causes a recuperation of a previously disturbed state created by an unpleasant reality . . . Art also must open the eyes of the beholder, teach him to see.

This approach is similar to the approach of a painter whose works in most cases organize geometrical forms. His success is affiliated with a respectable commercial gallery but it is difficult to identify him with some definite style-group. He says:

My art is an expression of my attitude toward the world. I try to represent in my art ideal states of order, harmony, lawfulness, and these are exactly those states which I do not find in everyday life. I truly feel that when I achieve a perfect and good painting – it has a model of the world in it. I mean that every organization is basically a model of a larger organization . . . I think that I need this reminder of an order and harmony, and I think that I am not the only one who needs it. If there is something where an order appears in its perfection – it is art; in reality it does not exist. The possibility of order and harmony keeps me alive. It is really important for me. I perceive my art as an important social value actually, although I do not engage in social problems and anything like that. The problem is that very few people under-stand this kind of art. My art is very alien in this country, it is not connected to anything here. I think that in the eyes of an Israeli my painting is too cold . . .

The attitudes of these painters form a basis for clear criteria for the judgment of their works and the works of other artists. These criteria represent a combination of certain ideological requirements with require-ments of performance which has to fit the values and express them in the best possible way. In the case of individualist painters, the majority of whom are Surrealists, although this is not necessarily so, the element of performance is particularly emphasized. However, even among them the performance remains a means and does not take the place of an end. Even for them, art has to satisfy certain needs or serve some other entity. The difference between the adherents of this approach and those of the three other ones is that the values which the painters with some kind of collectivistic orientation want to embody are the values of a certain collectivity, while the value scale of the individualist painters is crowned by the consideration for an isolated person and his individual problems without any reference to the collectivity

to which he belongs. All the figurative artists stress the general humanistic function of art and its ability to develop the experience of beauty among men.[5]

The painters discussed in this chapter represent an elite of a certain social system too. However, unlike their colleagues in the system affiliated with the public art institutions, these painters, the painters advancing in the private art market, act within the framework of clear requirements both in terms of values and in terms of performance and enable the public to judge and put to test their activity.

The professional attitudes of artists add an important dimension to the description of the bifurcated world of Israeli art. To complete the picture we need one last element. It will help us to answer the question why *must* the figurative artists and the dealers act on the basis of definite standards and principles (which we know they have), and how *can* the avant-garde artists and their "gatekeepers" – curators, critics and owners of "quality" galleries – function without more or less clear and articulated criteria (which we know they lack). Since, in the final analysis, both the artists and the "gatekeepers" depend on the public, and the public has to be convinced that they act in a reasonable fashion and according to the principles it can accept, this answer is to be sought in the characteristics of the public, its attitudes toward and expectations from artists and "gatekeepers."

9 The publics

The discussion of the case so far might have already made clear, that the Israeli public is divided into two parts which correspond to the division of styles into figurative and Abstract and belong to the two subsystems of the Israeli art world. The division of the public is so conspicuous that one actually has to talk about two distinct publics.

According to the interviews,[1] extracts from which will be quoted below, the main characteristic of the figurative art public is its self-confidence. This public has clear and rather well-founded personal preferences. Its members understand what they like and why. They approve or disapprove of paintings according to whether they answer their requirements or not. These requirements protect the public of figurative painting and help its members to explain why they prefer certain works of art or styles to the others. Since its judgment is based upon rational considerations, there is no intolerance towards the existence of those styles which this public does not accept. It does not perceive any threat in the existence of these styles and can allow itself to show patience towards them.

Although among this public there are persons who prefer "not quite Abstract and not quite Realistic" art, "real, but hinted, not finished things," namely works of Impressionistic or Post-Impressionistic character, they, in any case, demand from the painter a demonstration of technical skill. In accordance with this, even paintings of this kind have to be "with some sense, not mere daubs." The general tendency is toward styles as exact in representation as possible. (According to a certain gallery owner, "Surrealism sells as fresh muffins today.") Execution, accurate rendition of objects of painting are very important in the opinion of this public, and the reason for this is twofold. First of all, this public wants to understand what it is looking at. Secondly, accuracy in painting enables it to estimate how much work and learning was invested in a work of art, while hard work and education behind it are seen as a justification for the high prices on the art market.

"I like good art," says one spectator. "Everything except the exper-

146

imental. What I require from a work of art is technical knowledge plus spirit, plus education, preferably academic, a great deal of learning on the part of the painter." Another spectator demands: "It must be good from the technical point of view; it must be neat." "I like Realists," says a spectator at a Surrealist exhibition, "that is the reason why Surrealism does not disturb me so much; you see, it is executed in a Realistic technique, the very opposite of the Abstract which I don't like, because it does not appeal to me. One must understand what was the intention of the painter. Surrealism too, for the same reason, appeals to me less. I am excited about her [the artist's] way of painting nails, an apple which it is possible to eat. These are not scribblings, although you have to cudgel your brain over her ideas." "I like figurative art," says another spectator. "I like art that expresses something clear, images . . ." In another gallery an interviewee explains: "We like Realism. It is difficult to understand Modernism: Conceptual and Abstract art. We look at it, but don't understand it. I need something I can understand!" "We don't like undefined things, we prefer Realist art. Maybe, even less than Realist. But not entirely Abstract things, works that are subjective, but more real, because in Abstract art you have to be a genius to guess what the artist wanted to say. And if he allows me to say what I want, I can as well do it myself without his help." He also says: "What I like here [at the exhibition where the interview took place] is the effort he [the artist] invested in his works." "We like Realists because we understand them better. We want to see, not to guess," we are told in another place, and: "I like Realist paintings. I enjoy clear things. If I don't understand, it does not do me any good. I want to see a painting and enjoy it and not to be given some scribbling and to be told that this is art."

The absence of the required characteristics in Conceptual and Abstract art is the reason for the figurative public's lack of sympathy towards these styles. "I do not have any criteria to evaluate Conceptual art by," says one of the spectators at a figurative exhibition. "I don't understand it. It does not appeal to me." Notwithstanding this general lack of sympathy, only one interview can be interpreted as militant rejection of these styles. A visitor, invited by the artist to an exhibition which, it seemed, was an unpleasant surprise to him, expressed his opinion thus: "I don't like Conceptualism! This is disgusting! I couldn't have imagined that they would exhibit such an abomination!" Usually the attitude is very tolerant and at most tepid. "Contemporary art seems questionable to me," says one of the interviewed spectators. "I think that what they do, I can do myself." "Abstraction?" says another, "I am afraid that no world is hiding behind such a painting." Another spectator has "an impression that Abstract artists are cheating me,

they despise those who accept their art; they think that the public would accept anything." Another one says: "I don't like things that pretend to reveal more than can be seen. Abstraction looks like it's cheek (*hutzpa*)." However, she adds immediately: "I don't reach the level of all this; it does not speak to my heart." And this is the usual situation: These spectators do not claim that Conceptualist and Abstract styles are not "good art," but they do not meet their personal requirements, do not suit them, are not understandable to them personally. "Avant-garde does not say much to me," says one of the interviewed, "I do not understand it. It says nothing to me. In my opinion, they have the right to be called artists. There was time when I thought that they are cheating the public. But if I don't understand, it does not give me the right to claim that this is not art." Another interviewee stated: "I like clear figurative views, because it seems, my sense of abstraction is restricted and I like to enjoy without having to imagine things which transcend what I see." "My preferences in art are everything, except abstraction," we are told in yet another interview, "I simply do not understand it, and I don't try to understand, because I lack the necessary knowledge."

Abstract styles are certainly not among what this public likes. But, as we were reminded by one of its members, "opinions differ." These styles are irrelevant to the spectators constituting public of figurative art, and because of that, this public does not deny them the right to exist. In the opinion of these spectators, this art has its place, if somebody, not them, wants to enjoy it.

Another consideration enters the judgment of the members of this public. As it is in its largest part a public of buyers and as the prices of paintings are very high, the profitability of investment plays an important role in their choice and provides another reason for their preference for figurative styles and rejection of "modern" art. The professionalism of painting is a guarantee that it will retain at least a certain value in future. The economic risk in this case is small in comparison with investment in "contemporary" art, the value of which (its contemporaneity) is, by definition, temporary. Not once among the members of this public do we meet with such expressions: "We don't like Conceptualist art; it is a matter of period. Serious art is for generations and generations," or: "What is going on in the Israel Museum is a scandal. You need not be a great sage in art in order to understand that. Somebody spills yellow paint in front of the museum and afterwards the municipality has to clean it." (The implication is: What a waste of municipal funds.)

At the same time, period-bound considerations merge with this requirement for perennial values. According to a large number of spectators, the

price of a painting is a matter of supply and demand, and the reputation of an artist may serve as a justification for high prices. However, they believe that there is always an element of permanent value in figurative painting, which cannot be lost entirely as a result of the fluctuations of fashion that, beyond doubt, affect its market price.

The most salient feature in the attitudes of the figurative art public is the independence of spectators' judgments and their unwillingness to rely upon the opinions of others. "I like to see an exhibition and to understand it," says one of the interviewed spectators, "not to listen to what others tell me about it." Another spectator tries "not to read art criticism," because in her words, "it does not reflect my opinion; I am impressed by what I look at; I don't need art criticism." Another one says that she does not read art criticism "in principle. I have an 'anti' against our critics, because most of them are not professional enough and I don't want to accept their opinion." A couple of spectators at another exhibition say: "We read criticism, but are not extraordinarily excited by it. The critics write in a manner which is too complicated, too bombastic."

The majority of spectators in this public does not read criticism at all, at most they turn over the pages allotted for it in weekend supplements. Those who say that they read, almost without exception, do not remember the names of the critics (which do not change for years and are very few) which attests to the fact that they do not try very hard to focus their attention on it. Yet, their indifference towards art criticism does not imply that they are ignorant of the "spirit of the age." Indeed they are conscious of this spirit, but they allow themselves not to pay attention to it. One of the spectators, who, as he told us, does not like Abstract art, says: "Although it is claimed that one needs an education to understand abstraction, I think that it is not true. There is no need to explain art." Another one says: "I like figurative art. In respect to Conceptualism, I know that it is intellectual and so on, but in my view it is not aesthetic." When they say "I am very conservative in my artistic taste" (and not once was this exactly how they characterized themselves) they say this with pride.

Yet another view, which is also a part of the "spirit of the age," is not accepted by this public: they do not think that an artist as such, is a spiritual leader or a special kind of person who must be treated with respect due to the very fact of his being an artist. Art in itself has nothing to do with leadership, in the opinion of this public, and only overt engagement in people's aspirations can turn a person into a leader. "The shoe maker near my house," says one of the spectators, "may be a spiritual leader. No connection to art. Many people can be spiritual leaders, if they have a capacity for this."

"Spiritual leadership – it is very personal," says another spectator, "not as an artist, but as an individual. The artist is an introvert. How can he be a leader?" Another one decidedly snaps out: "An artist cannot be a spiritual leader; they are self-involved people. Haven't ever heard about an artist who would fulfill a role of social importance. In other professions one does come across such things."

These attitudes, characteristic of the public of figurative galleries, represent a coherent, although not highly articulated, system of preferences, or in other words, an aesthetic taste. This taste provides a basis for independent (that is, existing prior to the contact with a certain work of art) requirements towards art, and therefore, towards artists and dealers who exhibit and sell their works. These independent requirements enable the public to control the activity of both these groups. Such a framework makes the behavior of this public rational[2] and self-reliant, creating in it no need for leaders. Possibly, this is the explanation why this public does not view art as sacred and artists as natural bearers of charisma.

Let us turn now to the public of Conceptualist art. In contrast to the public of figurative galleries, this public is characterized by a lack of self-confidence. Its members abstain as much as possible from expressions of personal opinions about works of art or styles. The words "I like" in relation to something specific do not exist in their vocabulary. The art of which they approve, they accept because "one should accept this." Their judgment is based upon a consensus as to what is appropriate in art, currently existing in a certain group. Any deviation from this consensus threatens their self-confidence. This is the reason for their dogmatic preference of avant-gardist styles and intolerant rejection of figurative styles, which reminds one of sectarian fanaticism.

Art in itself is the most important thing in the world and the artist, by right of his being an artist, is a person who should be worshipped; such is the belief of the non-figurative public. Even if he lacks any concern for the society or the people, and maybe because of the lack of such concern, the artist is a spiritual leader, "because new ideas always belong to a very thin stratum." What interests an artist, irrespective of whether it interests anyone besides him or not, and usually exactly when it does not interest anyone else – must become everybody's concern. Being interesting for the artist himself is a sign of the high quality of a work of art. Artistic innovation, namely having to do with things that were not seen in art before, is its most esteemed characteristic. The lack of this characteristic is a guarantee that the work is worthless.

"It is interesting to know what is done in art now," says one of the interviewed spectators. "The requirements towards art are: it must excite, it

must be interesting, it must be something new." A couple of spectators tell us: "In a gallery we would like to see new artists. Let us call this 'originality.' There must be something new. The new must be supplemented with a background explanation. The general message must be new. If an exhibition is complemented by different happenings around it, this is very good. The criteria: an examination of the context of the work of art – what is its standing in the world of art and in the whole of the artist's creative work." "A good artist is a man, who expresses himself out of his navel, when It comes from within him," claims a visitor at a certain exhibition (what is It? there is no answer). Another visitor at the same exhibition says that figurative art does not arouse her curiosity "because there is no search." She cannot "distinguish between good art and the art that is not good, but can distinguish between interesting and uninteresting art," and the art is interesting when she feels that "what the man is engaged in is really pertinent for him."

However, according to many of the spectators constituting this public, the "interesting art" is most decidedly "good art," "Conceptualism – this is good," they say. The problems arise, when they are asked, why. "Without exactly understanding everything," confesses one of the spectators–adherents of Conceptualism, "it says something to me; it does something to me. This is a form of expression of the artist. Even if I don't understand exactly his language, I accept it." Another spectator tells about a Conceptualist work of art he has at home: "I cannot explain to you what is it exactly that I have. It is acrylic. I love the truth behind the things. I don't know which truth this picture expresses, but this picture expresses truth." He likes another Conceptualist work of art (at the exhibition, where the interview was taken) "because of the spot that talks" to him. At another Conceptualist exhibition a spectator tries to explain why a certain work of art is good, in her opinion. She says: "There is a surprise here. On the one hand a kind of, you know, very . . . emptiness, whiteness, nothingness, grey colorfulness, but suddenly you see this almost dirtiness, such a beautiful sensitivity of lines. Along with it many geometrical drafts. I cannot explain it to you. This work is beautiful; there is something cute about it." She demands "a Conceptual message to be present behind a painting." To the question, what is the Conceptual message behind the aforementioned work, she answers "it must not be philosophical; it can focus on media, aesthetics . . ." A spectator in another gallery answers the question of why does she prefer modern art: "You know, this is a very difficult question . . ."

These hesitant arguments reveal the lack of self-confidence in preferences, which is also expressed in unwillingness to commit oneself, which is

very notable in the interviews with the spectators constituting this public. To the question which kind of art does he prefer, one of the spectators answers: "I like different sorts of things . . . modern art. My attitude to the avant-garde is one of openness, understanding, but there is always a danger in contemporary art that you may lack a perspective." At another exhibition we are told: "We like everything in art, from prehistory till now," but in a list of favorite artists only artists of the past twenty years are included. Very frequently they say: "We like everything which is good," with the specification of what is not good immediately following. For example, "I like what is good. The style does not matter, [without intermission] cannot stand Surrealism, works displayed in commercial galleries, the taste of an average Israeli bourgeois." Or: "I like everything . . . Surrealism is trash. Avant-garde – this is good." This conspicuous, unreasoned hostility which, in fact, contradicts everything these people say about themselves (a person who "likes everything" cannot reject 99 percent of existing styles, if he really likes everything) is, apparently, a result of the lack of self-confidence in their artistic judgment.

This hypothesis is supported by the willingness to rely on authorities of all sorts, expressed in the attitudes of this public towards foreign countries, critics and policy-makers in art. "I would like to see what is going on in New York now," says one of the interviewed. "We are the public which demands innovations and import." "Criticism must help the spectator, show him how to look at things," says another one.[3] At another exhibition the interviewed spectator, a student of the history of art, complains that at his department at Tel-Aviv University "they don't teach how at all you must look at things." There was one very moderate statement of such an attitude, made by a woman, whose husband was an ardent adherent of Conceptualism. She apologized for her "general preference for the period of Van Gogh and Toulouse-Lautrec" and said: "Avant-garde – I know that one must not reject it, and I try to understand. Usually I rely on people who understand more." The lack of independence in artistic judgment of this public and its unconditional reliance on experts bring to mind certain elements in the sociological definition of "fashion."

The individuals in this public do not expect works of art to satisfy their specific personal needs. Their only wish is to feel that the works they admire are offered to them by prestigious figures, the elite of the artistic community, that is by the group of curators, critics and most highly regarded avant-garde artists. These prestigious figures are the bearers of charisma for the public of the Conceptual art and all the relationships between this public and the elite in-group of the artistic subsystem of which it is a part are the relationships of

adoration of a small group of leaders by a public of followers. This public, indeed, is characterized by a very high degree of awareness of artists' and mediators' personalities and, in contrast to the public of the figurative galleries, in general very well informed about the names of the art critics and curators.

As a result, this public's evaluation of an artist is not based upon the direct judgment of his artistic abilities, but upon external status symbols. The artist's acceptance by the in-group of acclaimed leaders of the Israeli avant-garde guarantees him an immediate success in the eyes of the public of avant-garde art.

We already know that the acceptance by the in-group is not based upon any kind of professional criteria, but upon such circumstances and factors as personal acquaintance, skillful self-advertising, etc. The public does not know of these circumstances and is not interested in knowing about them. Its "artistic" experience depends solely upon the consciousness of being related to what it believes is the progressive, creative art. In this way this public bestows social legitimation upon the success of styles and artists which it, in fact, does not understand.

To summarize, we have here before us two publics which differ in many important ways. The behavior of the first public is based upon individual judgment, for the purpose of which it makes use of more or less clear criteria and of definite requirements towards works of art. The other one is the public whose goal is the identification with a certain group and which, as a result of this goal, lacks requirements towards works of art and is ready to accept any judgment this group may utter. It remains to explain the sociological source of the differences between the patterns of judgment characteristic of these two publics.

The two publics (the public of the figurative art and the public of the Conceptualist and Abstract art) differ from the sociological point of view. This is expressed in the different social structures of these publics, in different functions the respective systems to which these publics belong fulfill for them, and in different roles these publics perform in their respective systems.

The public of the figurative galleries represents a social structure to the extent that the individuals who constitute it have a common interest in a certain kind of social activity, namely in the art of painting. This community of interest does not allow us to define them as an "aggregate."[4] However, the community of interest that unites them into a "public" is not grounded in personal communication. This public is not an organized public, and its

social structure is an amorphous one. This structure can be explained by the fact that the members of this public enjoy works of art individually, and this individual enjoyment of works of art is the need which is satisfied by the system consisting of figurative galleries and artists. This individual enjoyment also explains the function that the members of the public, in their turn, fulfill for this system, which is the economic function. This public is in its greatest part a public of buyers and it is this public which sustains gallery owners and, through them, figurative artists.

In contrast to it, the public of Conceptualist art is an organized public; its social structure is similar to the structure of a "concrete audience"[5] and is based to no small degree upon direct communication among the individuals who compose it. This structure is linked to the goal of these individuals which is not so much the purchase or enjoyment of specific works of art, but rather the affiliation with a certain group, "belonging," participation in "artistic life," and living conspicuously. For that reason, the function this public performs for the system it belongs to is the function of social legitimation of the behavior of the other groups that constitute this system – Conceptual artists, critics and curators. In general, this public is not a public of buyers; the economic function in this system is performed by other agents.

The description of the social differences between the two publics does not explain entirely the difference in the patterns of judgment characteristic of them and, indeed, demands an explanation itself. Why does one public search for individual enjoyment of the works of art, while the other wants to be a part of a group?

There were 400 interviews conducted with spectators, 208 in figurative galleries and the remaining 192 during the opening evenings of Conceptual exhibitions in museums and in avant-gardist galleries. The sample was not chosen according to any accepted method; however, since every effort was made to visit the openings of all the exhibitions in the large cities in the course of one whole season (the year 1979–1980) and only few openings were missed for purely accidental reasons, it is possible to claim that the interviews render a reliable picture of the situation.

Both publics consist of people of European origin (Ashkenasi Jews), aged from twenty-five to fifty, white-collar workers, with at least secondary and in most cases higher education. There is no difference between the publics in the place of the occupations on the socio–economic scale, nor is there a difference in the level of education; however, the nature of occupations and of education differ in a most remarkable way.

The public of figurative art is composed of engineers, physicians, lawyers, industry managers, high-school teachers of different disciplines, economists

– graduates of academic institutions in respective fields and students advancing toward their degrees in these fields. This group can be characterized in short as a group of professionals. The Conceptualist and Abstract art public, in contrast, consists in its main part of students or alumni of Bezalel Academy of Art, history of art departments in different universities, comparative philosophy, sociology or political science departments, as well as those of the history of the theater, cinema and drama (including university professors in these fields), a high percentage of artists, film-makers (directors and actors), theater directors, architects, art teachers and the like. This group may be characterized generally as a group of "intellectuals" (with an over-representation of professions somehow related to visual art and an under-representation of other fields).[6]

The most salient feature distinguishing between educational/occupational characteristics of the two publics is the focused character of the education of the figurative public vs. the relativist nature of the education of the avant-gardist public. A person belonging to the figurative public is educated in and confronts in his occupation a single cognitive system possessing clear rules. For example, in order to become an engineer a person in the course of his training specializes in one specific field, learning certain laws and rules which guarantee efficient and successful work in it. In contrast, a person belonging to the avant-gardist public confronts in the course of his/her education a number of different sets of rules. For example, a person studying in a department of comparative philosophy learns about the simultaneous existence of different sets of rules in the same field and about changes in rules which any one system undergoes in time.

Of course, this in no way implies that all the students of the humanities or "soft" social sciences must be identified with avant-gardist styles and must behave according to the laws of fashion. The avant-garde public is simply recruited from this wider group because the nature of education and/or occupation in this case creates conditions congenial to the development of a relativist attitude to values (though it in no way necessitates such an attitude). In other words, the education and occupation of an avant-gardist public enables it to view every system of values in relativist perspective, if other factors able to neutralize this perspective are lacking; and as a result leaves it no possibility of rational judgment of individual expressions of any one of these value systems.

Unlike the avant-gardist public, the public of figurative styles was able, in the framework of its education and occupation, to develop commitments to specific systems of values. Therefore, it does not abstain from forming commitments toward other value systems in different areas. It views the

formation of such commitments as natural. This applies, among other things, to art. This public does not abstain from judging works of art because its members are not threatened, as the avant-gardist public is, by a prospect that tomorrow the criteria of judgment will change and one's today's choice will look ridiculous.

A person whose world is organized in terms of values does not need a group in order to know how to behave; values dictate the norms to him. For a person whose world lacks such an organization, this function of values has to be performed by an external authority; the group and its leaders become the model and direct him in his actions. In this way the predispositions, deriving from the education and occupations of the two publics, to view values in different perspectives explain their respective needs which are satisfied by art, the functions they perform in the respective systems consisting of artists and "gatekeepers," the different structures of these publics and, therefore, their distinctive patterns of judgment.

Now, the question must be asked: who sustains the system which promotes Conceptualist artists, if, as we know, their public does not perform this function for them? The answer can be found in the fact that this public is but a part of the public affiliated with museums, while the other part consists of high officials of the Ministry of Education and Culture which finances the activities of the public cultural institutions.

The remarkable feature of this group is its absolutely unconditional admiration for art and artists whatever they may be, except for one most intriguing specification, which is already familiar to us from this study: the sole requirement is that art and artists exist for the sake of art and artists only.

In the framework of the Ministry of Education and Culture there is a body called Department of Culture which consists of two sections: Section of Adult Education and Art Section. The administrators of the department are government officials. The Art Section of the department is an agency distributing money in the volume of millions of dollars a year to museums. It is also connected to art schools and to the Artists' Association. Alongside the department there exists a Public Committee for Art and Culture which is composed of public figures; and in it there is a Sub-committee for Plastic Arts. The head of the department is also the head of the public committee. Heads of the sub-committees within the committee, like the officials of the ministerial department, are employees and receive salaries from the state. Appointments to these positions are made by the Minister of Education. The candidates for less important offices in the Sub-committee for Plastic Arts are proposed by the head of the sub-committee and the officials are

appointed for three years, also with the approval of the minister. Today the personnel of the sub-committee includes art historians, museum officials, artists, art critics. The committee is supposed to advise the Minister of Education in regard to the formation of cultural policy and establishment of criteria for the allocation of governmental funds. Besides this, the sub-committee has at its disposal an independent budget which serves as a fund for scholarships for individual artists and for the purpose of financing artistic projects initiated by the sub-committee itself, or proposed to it by other artistic organizations.

In the framework of this research, the key figures of both bodies (the Ministerial Department and the Public Committee) were interviewed.

As concerns this group, there is no argument about the artist's elevated status. In the words of one of the officials, "The artist took upon himself the role of a prophet, a man of vision, the seer of the future." "There is a conservative approach," claims another, "which views painting as the central art. Painting today raises questions and wrestles with the world and the environment." "Art in a country makes life there better," is the opinion of still another official.

However, not every kind of art is treated in this way. "What the government should do," says one of the interviewed, "is create such a situation, in which those who understand, experts in matters of art (and these are men of art themselves) will come as much as possible from different schools, different (artistic) languages, different age groups and will be represented in different bodies. This is the democratization of art." But the curators of exhibitions sent abroad (exhibitions representing Israel in international shows) whom the Sub-committee for Plastic Arts appoints always manifest avant-gardist preferences. "Anyone who has some standing in art must be an adherent of contemporary art," says one official. "The truth is," he continues, "that there is no justification for someone else. They don't paint like Rembrandt today." Another key-position official who also thinks that various styles must be represented everywhere says: "I am affiliated with Israeli artists. I am very avant-gardist, and therefore there is some preference caused by my personal taste."

"What is the reason for the allocation of funds to plastic art?" was one of the questions asked in the interviews. One of the interviewed answered: "It is crazy to begin to answer such questions." Other answers made it clear that art broadens the horizons of ordinary people and forces them to use their creative potential. "Good art," it was said, "brings man to think about something; something happens to him when he looks at such art . . . artists can influence openness in general by their works. When man is exposed to

such culture, he views life differently." One of the officials explained that "the mission of art education is to update people. Man must be updated in his life. The average person doesn't live his times; he is in a certain anachronism. The artist opens before him the possibilities; he is at the head of development of his society and environment." "The function of the artist in society," in the opinion of this official, "is to throw light upon things from the angle which is not dictated a priori, the personal angle." Another official stated this opinion in the following way: "Artists fulfill a function in the sense that they are always important, but they must not necessarily serve the society. It may be said that when they raise questions and criticize or when they are extreme individualists, they serve their society. Not necessarily do they serve the accepted goals of the society. The society must support them. Society is advancing exactly when socialization, education fail. Those who don't accept social conventions, set in motion things in society. The fact that they don't accept conventions does not diminish their contribution to the advancement of society. In a dialectical fashion the society has to support them. They criticize the existing state of affairs. They are very sensitive; they react to existing conditions; not necessarily do they have to give answers."

Openness and creativity in themselves, in the opinion of the Ministry of Education officials, are extremely important. One of them expresses his discontent with art lessons in Israeli elementary schools: "Already when they give a sheet of paper in school," he says, "by this very action they dictate what is to be drawn and how one should draw. It hinders the development of imagination. A pupil should express it as he wishes."

Besides this, no requirements are made towards the art. In fact, there is no right whatsoever to demand something from it. Art, as the representative of creativity and openness, is an ultimate value, and good art is art for art's sake. "The goal of art is not to educate," claims one of the interviewed, "if it is to a good taste – then please,[7] but not to believe in God or to love your motherland. In this way art becomes an instrument." And this is while "our aims [that is, the aims of the Ministry of Education] are artistic," says one of the high officials, "not social–sociological." To a question, why do they support museums, this official answers: "Because it is an important value in the cultural life of the country. The very fact that there is a museum, that is, that the artist has somewhere to exhibit his works, is a great value."

The society must accept whatever modern art does, it must adapt to this art and serve its goals. "Modern art is preoccupied with the relationships of forms and contents and very abstract subjects. It demands a great deal more than the average. People don't know how to swallow modern art. They think they are being laughed at. Only a very tiny part of the population is able to

confront it." In the opinion of the official who says it, this is the public's problem. These officials do not view their function as one of making sure that art which is financially supported by the public would at least be understandable to this public. In their opinion, "if art is a language, it can be unclear." They are "all the time trying to bring the committee to think in what way it can contribute to the plastic art in this country and not what plastic art should do." "The freedom of artistic expression is above everything," in their opinion. As they say, "The committee does not receive anything in return from the museums. The only condition is that the head of the committee will be on boards of museum directors." One of the officials contentedly tells about Bezalel which "was an art school, became a problem solving school – applied art. And now it reached the level where students create problems themselves." Thereby they achieve the desired result, "art which exists for its own sake and does not serve the society."

The State is retarded in its conception of art. "The political system," according to one of the officials, "does not understand pure art. Its conception is that art is functional." But he believes that "there are limits to the Establishment's drive to influence art. They are very careful not to create an impression of intervention in cultural affairs. There is almost a social norm of freedom of artistic creation similar to academic freedom. What restricts the Establishment is public opinion, the pressure of the artists. They have connections; they form public opinion and they are the group which criticizes the society. Visual art doesn't threaten the Establishment. Political art – we don't have here yet. When it will come, we'll have a problem." Another high official says: "First of all, art gives a personal expression. If Tevet [an artist] comes out against the State, it is his right to do so."

"The Ministry of Education does not have a definition of what is good art," claim the officials of the ministry. According to one of them, "There is no such thing – good art. Good and Just and Beautiful are relative, although they are perceived as absolutes. Good art is the one which has quality irrespective of what you expect from it." There are no demands because, according to one of the officials, "There are no criteria. I don't believe that it is possible to form these because this is purely subjective. What this committee would like, the one which will come after it would not, and it will be like that until the end of all times." The practical decisions of the Ministry of Education and Culture officials, in the absence of criteria, are based upon the reasonings of the men of art (namely of modern, non-figurative art almost exclusively) themselves. "Today there is no criterion for judgment," says one of the high officials, "the one which professionals who studied the language use is better than others and they try to express their opinion on the

quality of works of art." They make an attempt in the Ministry of Education and Culture "not to be commissars. We do not intervene at all in what is done. They appeal to us for the resolution of financial questions because of their financial problems . . . we try not to enter into artistic considerations . . . if you want a museum to be good, you must grant the curator the right to choose according to his taste. Maybe change curators from time to time. It is better to make a mistake than to intervene and disturb a curator in his activity." "As it must never be told to an artist what to create, it cannot be dictated to a curator what to choose." In specific cases, when the ministry officials are confronted by certain choices or decisions, they "ask somebody who knows what is it all about for an opinion: somebody from a small group which can choose from within itself curators or advisors."

Apparently, these officials behave like administrators of science. However, while administrators of science do not intervene in the activity of the scientific community only at the level of the means, while the ultimate value or end of this activity is firmly established and accepted by scientists and by the administrators alike, the officials of the Ministry of Education, the administrators of art, do not intervene in the activity of artists, curators and art critics on any level, including that of the ends. Creativity is elevated by these officials to the status of value of the utmost importance to the society, and as a consequence, deference toward the artistic creation merges, in their view, with the conception of the artist as the locus of highest social authority.

This group, therefore, similarly to the wider public to which Conceptualist and Abstract artists appeal, worships art, lacks an opinion of its own and submits itself with closed eyes to those who, at least according to the definition of the relationship between producers and clients, serve it. In so doing, it also legitimates the success of these artists and the activity of the system which promotes them. At the same time this group fulfills the vital function, which is not fulfilled by the wider public in this system. It sustains it (mostly, but not exclusively, the museums) economically.

This combination of social legitimation bestowed by the public of this system as a whole upon the activity of the artists and the "gatekeepers," and a most significant financial support of them by the Ministry of Education and Culture adds a final point to the explanation of how curators, art critics and avant-gardist gallery owners are able to function without more or less clear and articulated criteria.

The difference between this public and the public of the figurative artists helps us to understand the remarkable difference between the behavior of the "gatekeepers" in the system affiliated with museums and that of the owners of figurative galleries and, as a result, the difference between patterns of success and activity of artists belonging to the two systems.

10 Conclusion

As was stated in the introduction, the aim of this work was to describe and to understand the way the social system of Israeli painting functions, the factors which participate in the determination of the artists' success and the patterns of judgment characteristic of this system. In addition to being a study of one particular case, this work was intended to provide a basis of a more general theoretical framework for the sociology of artistic careers and mechanisms of taste-formation, and, perhaps, some insights for the sociology of culture in general.

The findings show that it is possible to classify painters according to a number of profiles of success, with a distinctive career route corresponding to every profile (see chapter 3). In this classification there were several important dimensions: the advancement in the framework of the private market by means of commercial galleries versus the advancement in the framework of the public art institutions, namely, museums; self-employment and earning a livelihood mainly by selling paintings versus having an employee status and living on a salary received from some public institution for holding an office in one or another way related to art; the high probability of being chosen to represent Israeli art in international exhibitions versus lack of such probability or low probability; intense exhibition activity versus less intense one (relative frequency of exhibitions); the relative preference of collective shows over one-man shows versus the opposite preference; the sequence of types of exhibitions: collective shows preceding one-man shows, local exhibitions preceding exhibitions abroad, exhibitions abroad preceding other exhibitions versus different sequence; the orientation toward foreign public versus orientation toward Israel; short route to success versus a long one; and last but not least, the exposure to criticism in the press, and through it, to a wider public versus the lack of press coverage.

It was not possible to explain the differences in the profiles of success and in career routes by the demographic differences among the painters. In contrast, a close relation was found between the former and painting style,

and there were in fact two distinctive types of career, the one characteristic of the figurative painters and the other prevailing among Abstract artists.

It was found that painters working in figurative styles advance in the framework of the private market, usually earn their living solely by painting, do not exhibit in international shows, manifest relative preference for one-man shows and exhibit relatively infrequently. Their career is usually primed by a one-man exhibition. They are very likely to go abroad first, in order to gather acclaim and, only after having gained prestige, come back to exhibit their work in Israel where they turn to the Israeli public as the public for which their product is meant. They usually attain success relatively late and are, on the whole, ignored by the art critics. In contrast to them, artists working in Abstract styles advance in the framework of public art institutions. They earn their living as employees, such as teachers in various art schools or officials in art institutions. They participate in the international exhibitions. They exhibit relatively frequently and prefer collective exhibitions which were the take-off point for many of them. They usually begin with a local show and then go to exhibit abroad where many of them participate in exhibitions organized by groups of Israeli artists. Their way to success is relatively short and their exhibitions have good chances of being covered by the press.

These differences are rendered most visible by two groups which attain the greatest success in the two systems today: Conceptualists, the most successful artists in the system of public art institutions, and Surrealists, the group most successful in the framework of the private market. The differences between these two styles represent the paradigm of the differences in patterns of success in the two systems. The success of the Surrealists can be described, in short, as a commercial success, while the reward characterizing the success of the Conceptualist artists is mainly social honor and prestige. The success of a Surrealist is an individual achievement, regulated mainly by the interrelation between supply and demand, a dynamic interrelation which compels the painters to constantly reassess themselves, or in fact, to succeed anew all the time. In distinction, the route to success of Conceptualist artists is a political one, i.e. a Conceptualist succeeds on behalf of a group of which he is a member. The very fact of being accepted in the group is the most important individual achievement in a Conceptualist's career, once this goal has been attained, a belonging artist is no longer required to prove his worth. His works are exhibited in the most prestigious forums and are never lost from the sight of the art critics. His status is almost unshakable.

The differences in the patterns of success of painters working in different stylistic frameworks can be explained by the split in the Israeli art world,

which towards the end of the 1960s led to the emergence of two systems of promotion different in respect to rewards as well as and, much more importantly, patterns of judgment in them.

Until the 1950s stylistic changes which occurred in Israel were of a sociologically homogeneous pattern. A new style would appear for ideological reasons deriving from social and cultural changes in the Jewish Settlement.

Usually these were demands for the embodiment of new social values. Such was the basis of the Bezalel style, the Land of Israel style, the Canaanic style, the German Expressionism and later – after the tendency which led to the split in the Israeli art world already manifested itself – of the style adopted by The Group of Ten, the National style and the Jewish Surrealism. Other figurative styles which appeared in Israel, such as French Expressionism or Fantastic Realism, the kind of Surrealism which lacks emphasis on national values, did not found their professional ideologies upon social values. These were instances of "art for the sake of art" in the original, Romantic sense of the term, understood as an attempt to embody the value of *beauty* without consideration for the conditions of time and place. However, in these cases also there was a public which regarded *beauty* as an important value and which was, therefore, willing to release art from its duty to express other values and to serve social ends.

These styles emerging, or rather appearing in Israel one after the other, secured their existence by forming connections with social frameworks which would support them. Yet, although every style addressed a new social framework – different curators, critics, etc., the pattern of support did not change and all these frameworks belonged to the same social system. The difference among them was an ideological one and was expressed in the disagreements between the gallery owners, curators of the few public institutions and the critics, most of whom were "critics by accident," about the value deserving to be expressed in visual art. The meaning of the judgment of the works of art in all these styles was the assessment of the degree to which a work succeeded in achieving this goal according to the principles of professional painting.

At the end of the 1940s – to be precise, in 1948 – immediately after the declaration of independence, this sociological pattern of stylistic innovations was changed. A group of artists not united by any style appeared: New Horizons. The purpose of the organization of this group was to gain new resources – the possibilities of exhibiting and acquiring publicity – by means of public pressure. When already organized, the group chose Lyrical Abstractionism as its banner and symbol of identification and claimed that art should reflect its time and that Abstractionism was the style fitting the

modern times better than any other. Apart from this, art should devote its efforts to itself and to the solution of its internal problems. This group met with support from the then Director of the Tel-Aviv Museum, Dr. Kolb, who, after certain hesitation, also decided that Abstractionism is the direction in which future art would develop.[1] The existing pattern of judgment, suitable for figurative styles, was not applicable in Abstractionism because the artistic goal of correspondence to the changing times did not imply any criterion which one could use in judgment. As a result, the fact of belonging to the New Horizons began to serve as the basis for the judgment of the production of the artists who belonged to it. No split, however, has yet occurred between different figurative painters and Abstract artists in regard to the rewards they receive.

Starting with the second half of the 1950s, the tendency toward the split of the Israeli art world into two different systems of promotion clearly manifested itself. One of the factors in this process was the entrance of younger critics into the ranks of art criticism. They were Israeli-born or educated and, unlike the critics belonging to the older generation, professional.

In contrast to the older generation of critics who were physicians, professors and so on and engaged in art criticism as a side-occupation, the new critics usually were not involved in other fields of activity. Visual art was their main occupation and in some form represented a source of income for them. This condition facilitated the formation of a connection between them and the New Horizons. It is safe to say that the interests of these critics were identical to the interests of artists belonging to this group. They were a new group striving to gain control over the realm of art criticism and, therefore, willing to promote a style regarded at this time as lacking supporters among the established art critics. The stylistic innovation and the need to defend it created an excellent opportunity for the advancement of the new critics. Very soon they became a majority and, actually, replaced the older generation. The concurrence of the two events: the appearance of the new generation of critics, different because art was their sole preoccupation and in most cases they lacked other social commitments and interests, in the period when innovation in art became identified with Abstractionism, resulted in that already in the 1960s the frameworks in which figurative and Abstract artists were promoted, were not equivalent in respect to their rewards. While the representatives of both style-groups still exhibited in the few existing galleries as well as in the museums (not always in the same galleries and museums, indeed, but in galleries and museums of the same importance and prestige), the attention of the critics was increasingly becoming the exclusive privilege of the Abstract artists. As was already pointed out, because of the differing nature of the styles themselves the

grounds of judgment were also different in the two frameworks. This difference was expressed in the style and contents of art criticism which had changed dramatically in the period between the beginning of the 1950s and the beginning of the 1960s.

Starting with the second half of the 1960s, the tendency toward the split was strengthened as a result of several simultaneously occurring developments which created two totally different systems of promotion in the late 1970s (in regard to rewards as well as the bases of judgment), coexisting in the Israeli art world with almost no communication between them and promoting different styles.

The developments were the following. In the middle of the 1960s, Conceptualism replaced Lyrical Abstractionism as the carrier of innovation. The principles of the Abstract styles that allowed for the greatest possible freedom of an individual artist and lacked professional requirements toward works of art, were expressed in the former style with maximum clarity. The claim of Conceptualism was Duchamp's claim, that art is everything done by the artist, while an artist is, for all intents and purposes, anyone who declares himself to be one. In spite of the adoption of this ideology by Conceptualism, the stylistic innovation in this case, similarly to the case of Lyrical Abstractionism and in contrast to all the innovations in figurative styles, was related neither to new ideological trends, nor to those already existing in the wider society. Nor did this innovation come to embody explicit artistic values. This innovation was a result of an organizational–political need of a group of artists who found themselves deprived of the possibilities of exhibiting in the Tel-Aviv Museum, the director of which in this period, Dr. Haim Gamzu, did not belong to the ardent adherents of Abstract art. Conceptualists were disciples of the New Horizons. A number of new people, who entered the ranks of the critics in the same period, undertook the task of promoting Conceptualists in the press for reasons similar to those which were the basis for the association between the critics of the late 1950s generation and the Lyrical Abstractionists. Conceptualism did not oppose Lyrical Abstractionism and the new critics did not oppose its supporters for, after all, they fought for the same principles. New Horizons simply ceased to exist; their critics already belonged to yesterday's art and soon lost their importance.

In May 1965 the Israel Museum was opened. In the beginning of the 1970s, important changes took place in the management of the Tel-Aviv Museum. The curators of the two most important museums in Israel were specialized professionals. Art was their only interest and they lacked ideological or other involvement in wider social concerns. They were learned in the avant-gardist ideologies which carried the banner of innovation abroad.

Eager to gain a place on the map of world art for Israel and for themselves, these curators yoked their institutions to the progressive art, that is, to Conceptualism and thereby completed the construction of a totally new social system, the cornerstone of which had been laid twenty years earlier. This system consists of public art institutions and the art critics in the press; critics and curators are supposed to fulfill the function of "gatekeepers" in it. It provides a framework of advancement for the Abstract (Conceptualists in the 1970s) artists only, is militantly hostile towards figurative art with the exception of the Naive painting (for reasons stated above, p. 74) and is closed to figurative painters.

Simultaneously, but independently of these developments, there occurred changes in the private art market. The increased prosperity of certain sectors of the population after the Six Days War caused a dramatic increase in the number of private galleries in the late 1960s and the 1970s. The decisive majority of the gallery owners were interested in the profitable trade in art works while a small number of them, like museum curators and critics, aspired to participate in the collective effort of the advancement of art. This small minority joined the system affiliated with the public institutions while the private market, consisting of the commercial galleries, represented the second half of the Israeli art world. This was the system which secured the existence and commercial success of the figurative styles.

Since the process leading to the split was completed by the 1970s, the purest examples of the functioning of the two systems are provided by the success of the two styles which rose to prominence in this period: Conceptualism and Surrealism; one of them Abstract and advancing in the framework affiliated with museums, and the other figurative and advancing within the private market.

The modes of decision-making and patterns of judgment are different in the two systems. The judgment of the "gatekeepers" in the system affiliated with museums is for the most part determined by their ideological commitment to Conceptualism and to the assumptions this style is based upon. This ideological commitment is, on the one hand, supported by the close connection between the "gatekeepers" and artists of this group while, on the other hand, it relies on the close acquaintance of the "gatekeepers" with philosophies of the Avant-garde art stressing above all the relativity of aesthetical values. Critics and curators are well aware of the recurring rises and falls of definitions of art and *beauty* in other countries. These constant changes compel them to refuse to form a definition or find values for contemporary art.

Relative values do not necessarily imply lack of criteria. The relativity of

values can lead to the destruction of existing criteria and establishment of new ones. What does inevitably lead to the lack of criteria is the assumption that art must not and does not fulfill any function for any other entity, but exists for its own sake as the embodiment of human creativity. And, indeed, creativity is a value for these groups. It is the ultimate and indefinite value. This combination of the awareness of the relativity of definitions of art and the conception of art as self-contained and existing only for its own sake brings about the lack of criteria for judgment among these groups and their refusal and inability to perform the role of "gatekeepers." As the definitions are relative to time and place, anything ever defined as art (or "placed in the circumstances of artistic intention" in words of one of the subjects, see p. 87) is defined as art by the members of this group. This means that the definition of art becomes a contextual one. Given the assumption that art exists for and has to express only itself, i.e. human creativity, the use of contextual definition inevitably leads to that in relation to contemporary art, the sole criterion of evaluation becomes innovation, for only in innovation can creativity be expressed: everything which is not new may be copied and learned.

Innovation is an important criterion in many areas. In the fields of creative activity such as science, literature and various arts, its importance is accentuated by the institutionalized opposition to its antithesis, the plagiarism. However, innovation cannot exist as an independent criterion. A tradition and agreed upon auxiliary criteria to assess whether there is actually something new are necessary in order to imbue innovation with meaning. It follows that in order to evaluate innovation by means of which we shall later judge a work of art, we need a number of preliminary stages. First of all, we must examine a work of art against the background of the goal it attempts to achieve, or a function it is supposed to fulfill. It is necessary to know whether it achieves this goal better than other works, in which the innovation in question is lacking. It must be emphasized that the goal has to be common to an innovative work and to many other works, for the creation of a new ultimate goal does not represent an innovation in a given field, but changes its borders and indicates an emergence of a new field. Secondly, a goal is usually closely related to a definite range of means or rules, at least the basic ones, for its achievement. It is not possible to comprehend and evaluate an innovation while disregarding these means and rules, also common to innovating work and many other works. Innovation as a primary concept, innovation which exists outside the functional framework and without the background of certain rules of performance cannot serve as a criterion of judgment and discrimination. The only meaning of an innovation by itself

(absolute innovation) is "something which was not done before" and as such it not only cannot represent an independent criterion, but in addition necessitates constant destruction of other criteria. An innovation of this kind could be a dance or a hard-boiled egg submitted as a doctoral thesis in a nuclear physics department. No one ever submitted such a thing as a thesis in physics; therefore, it is an innovation. This is, of course, absurd. But this is exactly the meaning of the "innovation" alluded to by the critics and curators functioning as "gatekeepers" in the social system, in which Conceptualist artists advance. Thus, the critics' and curators' conception of innovation as the most important value is different from placing any other value, for example, the value of *beauty*, at the top of the aesthetic scale of values. The problem in this case is that innovation as an independent value is not only left undefined in this context, but, as was explained above, cannot be defined even hypothetically. And this is different from other values, including the value of *beauty*, which in each and every period was defined in one way or another. The only solution available to the curators and critics in their complicated situation, while they fiercely struggle with the requirements of their positions, is the contextual solution, namely a solution by means of "social reality."

The situation of the critics in these conditions is more comfortable than that of the curators. Critics turn to curators and accept their decisions in defining certain "innovations" as art because museums represent a natural context for a work of art. For them, as we saw, everything which is accepted in a museum is art and necessarily good art, since there is no possibility to distinguish between good art and art that is not good (see p. 88). Curators, in contrast to them, find themselves in a most awkward situation: they are the ones who decide if a certain thing will be defined as art. The heavy responsibility they have to bear results in the lack of self-confidence among them. That is why the curators accept the judgment of the artists themselves and the judgment of foreign experts and rely upon the consensus existing in the in-group which consists, besides them, of critics and Conceptual artists. This is also the reason for curators' yearning for a broader group to share their belief and to strengthen this consensus.

This contextualization, which represents the only possible solution for the critics and curators, converts their judgment into a group judgment and leaves practically no possibility for the individual judgment. This means that critics and curators are unable to function as "gatekeepers," namely they are incapable of discriminating between works of art and artists, but instead, must accept or reject whole styles in accordance with whether they are accepted or rejected by the group. The transfer of the judgmental authority

to the group compels curators and critics to define their functions in a new way, which does not include the duty of judgment.

Instead of being judges of individual works, critics and curators regard themselves as creators. The function of a critic, according to this new definition, is to write theories of art and the function of a curator is to discover innovations.

As opposed to these two groups of "gatekeepers," the group of "gate-keepers" in the second system (the one affiliated with the private market – a group composed of dealers – the owners of commercial galleries) behaves quite differently. Gallery owners are confident in themselves, possess defi-nite taste and clear criteria for the judgment of art. In most cases these criteria are professional–technical ones, in the broad sense of the term, requirements for an implementation of certain rules of performance. At the same time, gallery owners demand a message from art. Execution must fit the message and render it intelligible for a spectator. In spite of the confi-dence in their ability to distinguish between good works of art and those that are not good and their unhesitant decisions in respect to the works they like or dislike, gallery owners are also unable to define art. This can raise suspicions as to the rationality of their judgment. Their inability to define art, however, derives from the fact that they are inexperienced in articu-lation and precise formulation of propositions. Since their activity is justified by a system of clear criteria, gallery owners do not feel a need for additional justification of this activity. For the same reason, they do not feel threatened by, and tolerate, art of the sort they do not like. The philosophy behind their criteria does not seem relevant to them in so far as they are confident of what they themselves like and succeed in selling. Therefore, they do not waste efforts to formulate it.

The gallery owners' disregard for a higher level of values and their being content with the rules which systematically direct their activity, gain salience against the background of the importance this higher ideological level acquires among the curators and critics. These latter devote numerous efforts to the formulation of articulate justifications for the way they act (including their inability to define art) and sometimes come up with very impressive formulations. Still, their approach does not enable them to express individual opinion about specific works of art and their evaluations are, in the final analysis, group evaluations.

The differences in behavior of these groups of "gatekeepers" are related to the differences in the conditions of their existence. The groups of critics and curators who do not actually function as "gatekeepers" because they lack criteria needed for doing this, are groups of employees. Gallery owners

who indeed fulfill the function of "gatekeepers," while using a system of rather clear criteria, are self-employed. This means that the former receive a salary which has no direct connection with the decisions they make about exhibiting one or another work of art, while the latter either profit or suffer losses as a result of their decisions. At the same time, although this difference might explain the difference in the behavior of the two groups in the short run, it is not sufficient to explain it in the long run. There is indeed a possibility of a profitable gallery the owner of which does not rely on his personal judgment but submits to the order of fashion. Thus, the question arises: Why must gallery owners actually serve as "gatekeepers" possessing definite criteria? Likewise, it is quite difficult to understand how the museum curators and the art critics who are supposed to be experts in matters of artistic taste are able to avoid the performance of this role and adhere to the philosophy of aesthetic nihilism for years.

The answer to these questions lies in the different characters of the publics which the "gatekeepers" and the artists in their systems address. The difference between the two publics is expressed in different patterns of art consumption. The clients of the critics and the curators come from two groups. The first group, the one which actually sustains them, consists of the officials of the Ministry of Education and Culture. Their status makes it possible to regard them as the "spokesmen of the generation." Their attitudes represent a combination of various ideologies prevailing in those elite strata which seem to be the embodiment of the "spirit of the age." The most prominent one of these ideologies is the ideology of openness and creativity with the concomitant worship of art and the elevation of the status of the artist capable of breaking conventions and norms and opposed to the artist enclosed within a system of rules, and a dread of being defined as a "Zdanovist." These attitudes lead to an explicit wish to avoid any judgment and expression of preferences and to the transfer of the judgmental authority to the experts. Another fear related to those ideologies, a fear of being defined as insufficiently progressive, explains the preference of these officials for experts of avant-gardist character. This preference is strengthened by the militancy of the avant-gardist experts, their tendency to proselytize and to express their expertise in a much more unequivocal manner, than do others.

The second group, in its greatest part, is a public of spectators only, that is, a public which consumes art solely by looking at it. This public, therefore, does not run financial risks which are the lot of the public of the gallery owners, which is, in general, a public of buyers. In contrast to the public of spectators, the public of buyers has to rely upon clear criteria for it cannot afford art the value of which is, by definition, limited in time. This difference

can explain the demand for criteria and for the actual fulfillment of the function of the "gatekeepers" from those supposed to fulfill this function on the part of the public of gallery owners or of the figurative artists, as well as the lack of such demand on the part of the public of museum curators and critics, namely, the public of Abstract, and in the 1970s, Conceptualist artists. However, as there are no differences in the economic situation of the two publics, the different patterns of art consumption themselves require an explanation.[2]

The explanation can be found in the different function art fulfills for the two publics. The public of Conceptualist artists searches for charismatic experiences, participation in the life of the group of leaders. Conceptualism with its theatrical element and the dramatization of the artist's personality provides its public with numerous opportunities to have such experiences, to "participate." The figurative art public consists of people, each and every one of whom, wishes to enjoy works of art personally. (There are different forms of enjoyment including the economic enjoyment of profits which a work of art can bring in the course of time.) This explanation is supported by the fact, that the only major difference between the publics is the difference in the nature of their education and occupation, which results in the difference in behavioral predispositions and cognitive perspectives in the two groups.

As was pointed out earlier, the public of Conceptualist art is composed mainly of people educated and/or working in art history, history of the theater, comparative literature, sociology or other "soft" social sciences, history of philosophy, and general history, that is, people who are usually defined as "intellectuals." Among people with such education and occupation there is a significant group of those who adopt a relativist stance toward culture and social reality in general, which makes it difficult for them to pass individual judgment or to make independent decisions in matters involving values. This inability to decide must necessarily be made legitimate. In art, the legitimation together with the emotional peace of mind are supplied to this public by Conceptualist artists regarded by it as charismatic figures symbolizing creativity and openness. Art in this case represents a symbol of identification; its consumption affiliates the spectator with one collectivity (lovers of Conceptualism–creative, open, enlightened people), distinguishes him from others (those who like other styles, especially Surrealism, bourgeois, closed, not creative and not enlightened) and thereby introduces order into his world, an important contribution in the conditions of *anomie* or blurred values characteristic of this public.

The behavior of the avant-gardist public manifests characteristics of

"fashion." As a result, in the case of Conceptualism, the tendency of the artists towards authoritarianism (see pp. 131–134) is complemented by a tendency towards submission to authority on the part of the public. The public is governed by the wish to resemble the creative artists whose status is regarded as highly prestigious. Because of that, it is absolutely passive. This applies to both groups composing this public: the spectators as well as the officials. No one is expected to consider its opinions and it does not represent anything but an object for manipulations by other groups belonging to the same social system or a means for the achievement of their goals. These latter function as "fashion legislators" or "trend setters." And since their public does not want anything but to resemble them, they are not required to behave according to any criteria.[3]

For the reasons we discussed earlier (see pp. 87–89; 102) curators and critics turn to Conceptual artists who become the highest agency of judgment in this system. In this situation no one, except artists themselves, is allowed to determine who is to be considered an artist. In their turn, artists also lack criteria and have no values to rely upon in order to draw a border between artists and those who are not artists. They also cannot explain why anyone of them is defined as an artist. Indeed, they need each other in order to find confidence in this definition. The lack of criteria, which is perpetuated due to the existence of the public behaving according to the laws of "fashion," leads, in its turn, to the elevation of the collectivity to the position of a value and to the transfer of whatever authority of judgment and, therefore, of promotion to the in-group. This explains the patterns of success and the career routes of Conceptual and Abstract artists.

Furthermore, the character of the public and its goals in the consumption of art also explain the two paradoxes in the behavior of the artists and the groups of the "gatekeepers." The first paradox is that the ideology of creativity and openness frequently results in the absence of creativity and the want of openness among the members of these groups. As we saw, the activity of Conceptual artists in many cases may be defined as "launching a fashion." The emphasis in their work is being farther and farther removed from the individual work of art to the organization of happenings. Prominent Conceptualists devote their energies to the reinforcement of their image as "fashion legislators" in art by means of extravagant performances and the invention of gimmicks capable to capture the attention of the public. The ideology of creativity in this case leads to the restriction of an artist to the means which were not used yet, and turns in the end into a factor suppressing the freedom of artistic expression. At the same time, the ideology of openness is converted into prejudice against every value other than

the value of openness, into *nihilism*. Militant tolerance turns into intolerance, expressed in the rejection of every style except the one based upon the constant demolition of every tradition, which represents the only artistic approach accepted by this group.

The second paradox manifests itself in that, in spite of the fact that curators, critics and Conceptual artists actually represent the Art Establishment – museums are supported by the Ministry of Education and Culture, the public is in part composed of the officials of the Ministry, delegations to international exhibitions are supported by government agencies – they, nevertheless, profess strong anti-Establishment ideology. They have complaints towards the Establishment, which apparently explains their leftist inclinations expressed in so many ways (see pp. 47–48). All this is while their conception of the role of art is based upon an elitist ideology, scornful of the public and opposing any relation between art and wider social interests.

This aristocratic–authoritarian self-consciousness faithfully reflects the social reality of this avant-garde group. The role of the artist is defined in it as a role of charismatic leadership, serving as the source of authority, and representing what is the ultimate cultural value in the eyes of the members of the group, art. In contrast, the adoption of the anti-Establishment, leftist ideology, which apparently contradicts the aristocratic self-image, has only symbolic significance. The socialization, as well as the present way of life, of the members of this group tie them to the relatively closed artistic world, and as a result, their political involvement and commitments are limited. They identify with the anti-Establishment ideology because they view it as a symbol of the destruction of the accepted values, innovation, and keeping abreast with the times, and not because the principles of social and economic equality are congenial to them. For the public, the values of anti-Establishment and leftism as well as the values of creativity and openness are just symbols of identification. The public searches for authority and possibilities to identify with it, and what is important for it is that these symbols are used rather than their intrinsic significance. It is for this reason that the Conceptualist artists and the "gatekeepers" in the system that supports them can behave in the paradoxical ways described above.

In contrast to the public of the Conceptual artists, the public of the figurative painters consists of people searching for personal enjoyment of works of art. In most cases, these are also people with high education, though not of the intellectual but instead of the professional type, that is, people who apply their education to specific and practical ends, such as physicians, engineers, managers, high-school teachers or lawyers. Education and occupations of this type do not predispose them to view the world

in a relativistic perspective; they usually have no difficulty in making de-
cisions when they are confronted with alternative values and, therefore, are
able to judge works of art independently. These people have explicit re-
quirements toward art. On the one hand, they view it as an embodiment
of certain values; on the other hand, it represents an investment in their
eyes, and these requirements provide a basis for clear criteria of
judgment.

This public is an active participant in the system which supports figurative
artists. Without answering the requirements of the public, the figurative
galleries would not bring profits to their owners. Gallery owners have to take
the opinions of their clients into account; they make every effort to know
these opinions and actually make the public decide what would be the fate of
one or another artist. In order to succeed in this system, the artists have to
compete among themselves. As it is the works of art which are judged by the
public and the "gatekeepers," the stress in the work of these artists is on the
individual work of art.

In a certain sense, each system, each public, gets the style it deserves. This
statement, which may be regarded as one general conclusion of this study, is,
of course, nothing other than an expression of the principle of elective
affinity between symbolic systems and receiving audiences. Such audiences,
to which producers and manipulators of symbols appeal (and of which art
publics are just one example), provide boundary conditions for the latter's
products and behavior. They doom to failure such ideas, values, and beliefs
– and their expressions in art, intellectual discourse, politics, or religion –
which are incompatible with their own or those they are able to accept, and
ensure the success of others which correspond to their predispositions. In so
doing they may even channel the energies of the producers, thereby encour-
aging and influencing the selection of specific tendencies. Examples of such
"participation" of the audience in the creative process can be found in many
areas. One should only think about the differences in the style of scholarly
discourse which appeals to the general public, on the one hand, and to the
audience of peers, on the other.

The difference between the two subsystems of the Israeli art corresponds
to the difference between two fundamental types of human behavior,
rational and "social." Rational behavior consists of choices among alterna-
tive courses of action, made by individual actors on the basis of their
knowledge. "Social" behavior, in distinction, is based upon compliance with
social influence. The social system formed around figurative art in Israel is,
clearly, an example of rational behavior, the dealers and the members of the
public, as well as the artists in this system, act as individuals. The system

consisting of public art institutions, art critics, and the public of spectators, which supports avant-garde abstract art is a case of "social" behavior. The action in this case is essentially collective, and the only independent actor is the group. This is expressed in the public's deference to, and diffidence in the face of, authorities to which it willingly submits; in the critics' cultivation of the contextual definition of art; in the curators' fear to commit themselves, the fear of responsibility; in the artists' dependence on the other artists to bolster their artistic identity; and, in general, in the extraordinary importance of the consensus in this group, and the corresponding intolerance towards the outsiders.

It seems clear why such radically different social groups would find attractive different styles – or rather, different kinds of art – and why the specific styles discussed here would flourish, one in a social system which tends to behave rationally, and the other where the tendency is towards "social" behavior. Even if we leave aside the fundamentally different ideologies which lie at the basis of the two groups of styles, they still fall into two theoretically meaningful categories: styles which enable artists and publics to perceive a work of art in the same way as expressing some objective meaning, such as figurative styles; and styles where such a possibility does not exist, since the work of art is defined as an expression of a unique experience or idea of a unique personality, which cannot be shared, but only partially reconstructed by others, such as Conceptualism or Abstract Expressionism. The theoretical rationale for the findings of this particular case-study is the following. Rational behavior requires that the objects among which one chooses be of a nature that can be reliably evaluated. This is much easier in figurative than in abstract art (although, of course, abstract art can also have an estimable market value).

Similarly, it is plausible that a system the action of which fits the "social" type should have a preference for Abstract and especially Conceptual art, since that provides a much better opportunity to focus on the creative artist as a personality, and on his creative experience, and is also more likely to involve exposure to group influence (because of the doubts about the interpretation of such art, and the common concern, or identification with the artist). Susceptibility to social influence in the system creates the demand for authority, which in this case meets among artists the supply of personalities believing in and emphasizing their own charisma.

It cannot be expected that the same relationship between the variables will recur everywhere. Social situations are always open systems, and two apparently similar situations will usually differ from each other in some respects. It is easy to imagine situations in which similar publics will have

different (or at least less clear-cut) preferences than in this case. For example, a figurative artist with a charismatic personality and a flair for dramatics could probably attract a public without definite requirements toward art and susceptible to social influences. On the other hand, a "rational" public interested in personal consumption of art and knowing exactly what it wants from it could purchase avant-garde art under circumstances in which such art is considered a good investment.

The reason why in Israel there emerged two such clear-cut, ideal typical cases has been the bifurcation of the system, which has occurred as a result of the virtual monopolization of the public sector by supporters of the avant-garde, and the simultaneous emergence of the private market with clearly figurative preferences. This was a unique concurrence of events. In a system which is not split in the same way, and where both types of art try to and can appeal to the private market as well as public institutions, it will be difficult to discern these relationships between styles and types of social systems which support them. Nevertheless, it seems possible to see them as inherent in the two fundamentally different approaches to art on the part of the artists as well as of their public broadly defined: one an expression of rational, and the other of "social" behavior.

The case of the Israeli art provided an unusual possibility to study the reasons for these different types of behavior and their structural implications in a naturally controlled environment; the two subsystems of the Israeli art world in a way constitute ideal-types. At the same time, there are clearly cases in other fields, to which our considerations about them may be applicable. The behavior of the groups composing the two subsystems in both cases was directly related to the sets of beliefs and values to which they subscribed – ideologies of the artists, and, in the avant-garde system, of "gatekeepers," and less articulated outlooks or perspectives of the publics and, in the case of the market, the dealers. These sets of beliefs and values in the two art worlds were not simply different; they too belonged to essentially different types of values: values that were capable of creating cognitive order, and values that could only lead to its confusion. The common characteristic of the ideology of abstract avant-garde artists and the relativist perspective of their public was that both demanded the absolute freedom of choice between different value-systems and lacked criteria one could use to choose. This lack of internal guide-lines was directly conducive to "social" behavior. In distinction, both artistic ideology and the outlook of the public and the dealers in the other system encouraged commitment to particular sets of values and contained standards of judgment. In this case the internal guide-lines were present and rational behavior was possible. Through these

fundamentally different types of behavior, the ideologies and outlooks, which in our case perfectly corresponded and reinforced each other, created entirely different social structures and affected social relations between different groups in the two systems formed around them. Similar, though perhaps less clear, effects, however, could be expected in less perfectly aligned situations, as well as in cases when the systems of ideas at the bases of social activities, in terms of their ability to provide internal guidance, differ only in degree. One can think, for example, of the effects of the relative definitiveness of criteria in different academic disciplines on the structure of careers in them, or of the opportunities for different types of leadership existing within educated and self-confident, and confused and diffident electorates.

The central point which the analysis of the Israeli art case made clear, in general terms, may be summarized as follows. Ideologies insisting on the absolute openness towards different sets of values and absolute freedom of choice among them result in situations of cognitive confusion, or *anomie*. Yet, their social structural consequence is not anarchy. Instead of leading to this pathological form of democracy, they generate conditions favorable for authoritarian social structure of charismatic authority, in which a self-appointed elite, not accountable to anyone, and certainly not to the non-elite, rules without norms or standards. In the absence of a set of authoritative, guiding values, the group becomes the only source of authority, and within the group guidance is sought among special individuals whom – in terms of available cognitive resources – it is possible to regard as charismatic. The non-elite, rendered pliable by the lack of guiding values, follows the leaders unreflectively (simply because there is no basis for reflection).

In distinction to this, a commitment to one certain set of values diminishes possibilities of social influence. It is the values which are the ultimate source of authority in this case, and the leaders are leaders only so long as they adhere to these values. As a result, an ideology which demands such commitment, though it may be restrictive in itself, creates the conditions for individual rational action, thereby promoting individual freedom.

Thus, two systems of ideas in the same sphere of social life, in the same period and society, may result in two essentially different modes of social existence, one strengthening the individual, the other turning him into a cell of a larger body, incapable of independent action. In art, the choice between them, after all is said, remains a matter of personal preference. In other spheres of social life it may acquire a different significance.

Appendix A
Increase in the number of
forums for exhibitions

(a) *The general increase*

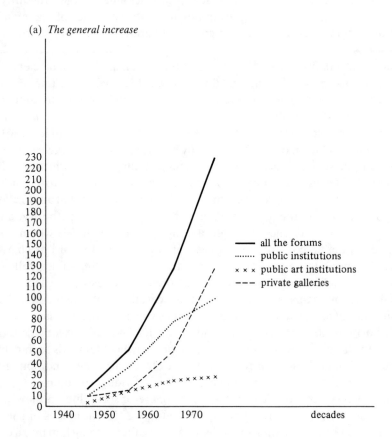

(b) *Increase in the number of public institutions which provide exhibition-forums*

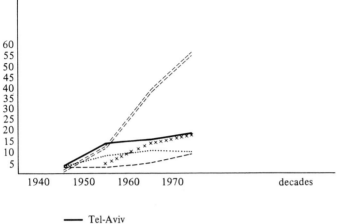

—— Tel-Aviv
– – – Jerusalem
······ Haifa
=== other cities
× × × public art institutions in the periphery

(c) *Increase in the number of private galleries*

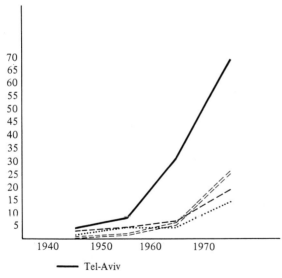

—— Tel-Aviv
– – – Jerusalem
······ Haifa
= = = other cities

Appendix B

a. Description of the population

Appendix table 1. *Artists by years of beginning of painting career in Israel*

	21–30	31–40	41–50	51–60	61–70	71–74	75–78
Painters (in %)	3.0	3.0	10.0	26.0	32.0	15.0	11.0

N = 477

Appendix table 2. *Artists by sex*

	Male	Female
Painters (in %)	63.0	37.0

N = 477

Appendix table 3. *Artists by sex and years of beginning of painting career (in %)*

	21–30	31–40	41–50	51–60	61–70	71–74	75–78
Female	7.7	40.0	31.9	35.3	36.4	45.5	37.5
Male	92.3	60.0	68.1	64.7	63.6	54.5	62.5

N = 477

180

Appendix table 4. *Artists by sex and by style of painting (in %)*

Style	Female	Male
Lyrical and Geometric Abstractionism	42.3	57.7
Conceptualism	23.8	76.2
Free Figurative	44.9	55.1
Surrealism	27.3	72.7
Naive	16.7	83.3
Expressionism	12.5	87.5
Realism	23.1	76.9

N = 438

Appendix table 5. *Artists by sex, by years of beginning of painting career, and by style of painting (in %)*

Lyrical and Geometrical Abstractionism

	21–30	31–40	41–50	51–60	61–70	71–74	75–78
Female	0.0	25.0	11.8	51.1	40.5	57.1	42.9
Male	100.0	75.0	88.2	48.9	59.5	42.9	57.1

N = 141

Conceptualism

	51–60	61–70	71–74	75–78
Female	20.0	12.5	30.0	40.0
Male	80.0	87.5	70.0	60.0

N = 37

Surrealism

	51–60	61–70	71–74	75–78
Female	25.0	13.3	50.0	16.7
Male	75.0	86.7	50.0	83.3

N = 42

Appendix table 5 (*cont*)
Free Figurative painting

	21–30	31–40	41–50	51–60	61–70	71–74	75–78
Female	12.5	44.4	42.9	33.3	54.3	54.9	53.8
Male	87.5	55.6	57.1	66.7	45.7	45.1	46.2

N = 147

Naive painting

	51–60	61–70	71–74	75–78
Female	0.0	14.3	100.0	0.0
Male	100.0	85.7	0.0	100.0

N = 17

Expressionism

	41–50	51–60	61–70	71–74	75–78
Female	0.0	0.0	28.5	0.0	0.0
Male	100.0	100.0	71.5	100.0	100.0

N = 16

Realism

	21–30	31–40	41–50	51–60	61–70	71–74	75–78
Female	0.0	0.0	0.0	0.0	50.0	0.0	25.0
Male	100.0	100.0	0.0	100.0	50.0	100.0	75.0

N = 13

Appendix table 6. *Artists by countries of origin and by years of beginning painting career in Israel (in %)*

	21–30	31–40	41–50	51–60	61–70	71–74	75–78
Israel	0.0	6.7	18.2	21.6	28.4	26.2	29.8
Eastern Europe	76.9	86.7	54.5	49.5	41.1	49.2	38.3
Western Europe	7.7	6.7	25.0	16.2	12.8	4.6	10.6
North America	7.7	0.0	2.3	5.4	3.5	6.2	10.6
Latin America	0.0	0.0	0.0	2.7	1.4	3.1	4.3
Asia and Africa	7.7	0.0	0.0	4.5	12.8	10.8	6.4

N = 436

Appendix table 7. *Artists by countries of origin, by years of beginning painting career, and by painting style (in %)*

Lyrical and Geometrical Abstractionism

	21–30	31–40	41–50	51–60	61–70	71–74	75–78
Israel	0.0	0.0	11.8	31.8	30.0	42.9	42.9
Eastern Europe	100.0	100.0	64.7	29.5	40.0	28.6	14.3
Western Europe	0.0	0.0	23.5	20.5	15.0	0.0	21.4
North America	0.0	0.0	0.0	6.8	2.5	7.1	7.1
Latin America	0.0	0.0	0.0	4.5	0.0	7.1	0.0
Asia and Africa	0.0	0.0	0.0	6.8	12.5	14.3	14.3

N = 136

Conceptualism

	51–60	61–70	71–74	75–78
Israel	20.0	56.3	40.0	20.0
Eastern Europe	40.0	12.5	30.0	0.0
Western Europe	0.0	12.5	10.0	0.0
North America	20.0	12.5	0.0	60.0
Latin America	20.0	0.0	0.0	20.0
Asia and Africa	0.0	6.3	20.0	0.0

N = 37

Surrealism

	51–60	61–70	71–74	75–78
Israel	25.0	33.3	27.3	50.0
Eastern Europe	75.0	33.3	54.5	33.3
Western Europe	0.0	20.0	0.0	0.0
North America	0.0	0.0	0.0	0.0
Latin America	0.0	6.7	9.1	16.7
Asia and Africa	0.0	6.7	9.1	0.0

N = 41

Appendix table 7 (*cont*)

Free Figurative painting

	21–30	31–40	41–50	51–60	61–70	71–74	75–78
Israel	0.0	11.1	15.8	10.5	20.0	10.5	30.8
Eastern Europe	62.5	77.8	47.4	63.2	54.3	63.2	53.8
Western Europe	12.5	11.1	31.6	18.4	5.7	10.5	7.7
North America	12.5	0.0	5.3	5.3	0.0	10.5	7.7
Latin America	0.0	0.0	0.0	0.0	2.9	0.0	0.0
Asia and Africa	12.5	0.0	0.0	2.6	17.1	5.3	0.0

N = 141

Naive painting

	41–50	51–60	61–70	71–74	75–78
Israel	0.0	0.0	50.0	100.0	0.0
Eastern Europe	100.0	66.7	25.0	0.0	50.0
Western Europe	0.0	0.0	0.0	0.0	0.0
North America	0.0	0.0	0.0	0.0	0.0
Latin America	0.0	0.0	0.0	0.0	0.0
Asia and Africa	0.0	33.3	25.0	0.0	50.0

N = 16

Expressionism

	41–50	51–60	61–70	71–74	75–78
Israel	0.0	25.0	14.3	0.0	0.0
Eastern Europe	100.0	50.0	57.1	100.0	100.0
Western Europe	0.0	25.0	28.6	0.0	0.0
North America	0.0	0.0	0.0	0.0	0.0
Latin America	0.0	0.0	0.0	0.0	0.0
Asia and Africa	0.0	0.0	0.0	0.0	0.0

N = 15

Realism

	21–30	31–40	41–50	51–60	61–70	71–74	75–78
Israel	0.0	0.0	0.0	0.0	25.0	0.0	0.0
Eastern Europe	100.0	100.0	100.0	100.0	25.0	100.0	100.0
Western Europe	0.0	0.0	0.0	0.0	0.0	0.0	0.0
North America	0.0	0.0	0.0	0.0	25.0	0.0	0.0
Latin America	0.0	0.0	0.0	0.0	0.0	0.0	0.0
Asia and Africa	0.0	0.0	0.0	0.0	25.0	0.0	0.0

N = 13

Appendix table 8. *Artists by style and by places of residence (in %)*

Style	A	B	C	D	E	F	G	H
Population	26.0	14.0	11.0	24.0	7.0	1.0	12.0	5.0
Lyrical and Geometric Abstractionism	28.0	9.3	11.0	26.4	9.3	0.0	10.1	5.9
Conceptualism	26.7	26.7	0.0	13.3	16.7	0.0	0.0	16.7
Surrealism	37.8	8.1	10.8	37.8	0.0	0.0	5.4	0.0
Free Figurative	28.5	10.8	13.1	26.3	3.6	0.8	13.8	3.1
Naive	15.4	23.1	23.1	23.1	7.7	0.0	7.7	0.0
Expressionism	10.0	60.0	0.0	10.0	10.0	0.0	0.0	10.0
Realism	10.0	20.0	20.0	30.0	0.0	10.0	0.0	10.0

N = 375
A = Tel-Aviv
B = Jerusalem
C = Haifa
D = Peripheral cities
E = Kibbutzim
F = Villages
G = Artists' villages
H = Abroad

b. Patterns of success

Appendix table 9. *Artists who exhibited in type 2 galleries by style of painting (in %)*

Style	21–78	70s
Population	32.0	30.0
Lyrical and Geometric Abstractionism	31.8	37.0
Conceptualism	47.2	46.6
Free Figurative	23.1	12.9
Surrealism	47.5	43.7
Naive	33.3	25.0
Expressionism	20.0	0.0
Realism	18.2	0.0

N = 433

Appendix table 10. *Artists who exhibited in galleries type 3 by style of paintings (in %)*

Style	21–78	70s
Population	13.0	12.2
Lyrical and Geometric Abstractionism	9.4	11.2
Conceptualism	33.3	26.7
Free Figurative	11.0	6.5
Surrealism	19.5	18.8
Naive	18.7	25.0
Expressionism	0.0	0.0
Realism	0.0	0.0

N = 433

Appendix table 11. *Artists who exhibited in galleries type 4 by style of painting (in %)*

Style	21–78	70s
Population	26.0	25.3
Lyrical and Geometric Abstractionism	27.1	44.5
Conceptualism	23.1	20.0
Free Figurative	27.9	19.3
Surrealism	36.6	18.8
Naive	18.7	25.0
Expressionism	26.7	33.3
Realism	8.3	0.0

N = 433

Appendix table 12. *Artists who exhibited in museums type 2 by style of painting (in %)*

Style	21–78	70s
Population	16.0	11.0
Lyrical and Geometric Abstractionism	21.2	14.8
Conceptualism	5.6	6.6
Free Figurative	16.9	9.7
Surrealism	15.0	18.7
Naive	6.7	0.0
Expressionism	13.3	25.0
Realism	30.0	0.0

N = 432

Appendix table 13. *Artists who exhibited in museums type 3 by style of painting (in %)*

Style	21–78	70s
Population	22.0	14.0
Lyrical and Geometric Abstractionism	22.7	7.5
Conceptualism	13.9	13.4
Free Figurative	23.1	22.6
Surrealism	17.5	12.5
Naive	13.3	0.0
Expressionism	33.3	33.3
Realism	10.0	0.0

N = 432

Appendix table 14. *Artists who exhibited in artists' houses by style of painting (in %)*

Style	21–78	70s
Population	27.0	16.2
Lyrical and Geometric Abstractionism	31.5	11.2
Conceptualism	16.7	13.4
Free Figurative	29.8	19.4
Surrealism	15.0	12.5
Naive	20.0	25.0
Expressionism	40.0	33.3
Realism	50.0	33.3

N = 432

Appendix table 15. *Artists who exhibited in public institutions (provisional exhibition-forums) by style of painting (in %)*

Style	21–78	70s
Population	37.0	37.7
Lyrical and Geometric Abstractionism	33.1	35.7
Conceptualism	22.2	26.6
Free Figurative	46.9	48.4
Surrealism	32.5	31.2
Naive	20.0	25.0
Expressionism	53.3	66.6
Realism	30.0	25.0

N = 433

Appendix table 16. *Artists–recipients of foreign prizes by style-groups (in %)*

Style	A	B	C	D
Population	14.0	9.0	3.0	2.0
Lyrical and Geometric Abstractionism	16.9	8.8	5.9	2.2
Conceptualism	16.2	16.2	0.0	0.0
Surrealism	4.8	2.4	2.4	0.0
Free Figurative	15.1	10.3	2.1	2.7
Naive	18.7	6.3	0.0	12.5
Expressionism	18.7	12.5	0.0	6.3
Realism	16.7	16.7	0.0	0.0

N = 467
A = Received prizes abroad
B = Received prizes only abroad
C = Received prizes abroad after Israeli prizes
D = Received prizes in Israel after foreign prizes

Appendix table 17. *Sources of income of those artists for whom painting is not the sole source of income by style-groups (in %)*

Style	A	B	C	D	E	F	G	H
Population	5.5	6.3	1.6	58.6	1.6	4.7	7.8	14.1
Lyrical and Geometric Abstractionism	0.0	4.8	2.4	66.7	0.0	2.4	2.4	21.4
Conceptualism	0.0	6.3	6.3	56.3	0.0	6.3	6.3	18.8
Surrealism	0.0	14.3	0.0	57.1	0.0	0.0	14.3	14.3
Free Figurative	9.3	4.7	0.0	51.2	2.3	7.0	16.3	9.3
Naive	16.7	16.7	0.0	16.7	16.7	16.7	0.0	16.7
Expressionism	16.7	0.0	0.0	83.3	0.0	0.0	0.0	0.0
Realism	0.0	25.0	0.0	75.0	0.0	0.0	0.0	0.0

N = 142
A = Book illustration
B = Stage setting
C = Art criticism
D = Art teaching
E = Gallery managing
F = Administrative position in art institutions
G = Applied art
H = Any combination

Appendix table 18. *Patterns of exhibiting abroad by style-groups (in %)*

Style	A	B	C	D	E	F	G	H
Population	30.3	19.4	3.9	8.5	3.9	22.6	1.2	10.2
Lyrical and Geometric Abstractionism	34.5	15.5	5.4	6.8	2.0	23.0	2.0	10.8
Conceptualism	19.5	17.1	12.2	7.3	4.9	26.8	2.4	9.8
Surrealism	27.3	20.5	2.3	18.2	6.8	13.6	0.0	11.4
Free Figurative	31.2	21.4	0.6	7.1	5.2	25.0	0.6	7.8
Naive	35.3	23.5	5.9	11.8	5.9	17.6	0.0	0.0
Expressionism	25.0	25.0	0.0	12.5	0.0	12.5	0.0	25.0
Realism	16.7	25.0	8.3	8.3	0.0	16.7	0.0	25.0

N = 433
A = Did not exhibit abroad
B = Exhibited abroad only in one-man shows
C = Exhibited abroad in Israeli group shows only
D = Exhibited abroad in foreign group shows only
E = Exhibited abroad in one-man and Israeli group shows
F = Exhibited abroad in one-man and foreign group shows
G = Exhibited abroad in foreign and Israeli group shows
H = Exhibited abroad in all types of shows

Appendix C

Major questions asked in the open interviews with the different sub-populations of the research subjects.

C1: Questionnaire for the artists

a. Criteria
 (1) What is art in your opinion?
 (2) What is a beautiful work of art? What is Beauty? What is truth in art?
 (3) What are the qualities of a good artist?
 (4) Which painters do you admire and why?

b. Connections
 (1) Are there people who treat your art as you would like them to? Who are they?
 (2) What do you think about other Israeli painters? Are any of them your personal friends? Who are they?
 (3) What do you think about galleries? Which galleries do you prefer? Why? Are any of the gallery owners your personal friends?
 (4) What do you think of art criticism in Israel? Are any of the critics your personal friends?
 (5) What do you think of curators in Israel? Are any of them your personal friends?
 (6) Who are your close friends?
 (7) What is your attitude toward the Israeli public in general?
 (8) What is the determinant factor in the artist's success, in your opinion?

c. Background
Age, origin, education. What is the source of your income? How did you arrive at the style in which you work today? Did you ever work in other styles? What was your first success? Where did you begin to exhibit? Where do you exhibit today? How many exhibitions do you have per period of time? What are your political inclinations?

C2: Questionnaire for the critics

a. Description of work

(1) What paper do you write for? Since when? Did you work for the same paper from the beginning? If not – for which paper did you write previously? How did you get your present position?

(2) What is your main activity as critic? How is your work administered, what are your duties? Do you have to visit all galleries, museums, how often, etc.?

b. Background
Age, education (where), political opinions.

c. Criteria

(1) What is your definition of art?

(2) What are the qualities of a good work of art?

(3) What are the qualities of a good artist? A definition, a number of names, the reason for the choice.

(4) What are the qualities of a good composition? Good drawing? Mastery of the color-plate?

(5) Does a good artist need a formal education? Why?

(6) Do Israeli artists satisfy questions 3, 4, 5?

(7) What is your definition of the critic's role?

d. Personal relation to art

(1) Do you buy paintings? How often? What kind of paintings? Where?

(2) Do you know artists personally? Gallery owners? Museum curators, etc.? Whom exactly?

(3) Does your personal relationship affect your criticism of these persons' work?

(4) What is your opinion of the general character and status of Israeli art criticism?

(5) Do you rely on the opinion of other critics? If yes – why?

C3: Questionnaire for curators

a. Background

(1) When did you enter your office?

(2) Education, previous occupations?

(3) What is the policy of the museum?

(4) Did the policy change under different curators and directors?

(5) What are your political inclinations?

b. Form of activity

(1) How are the responsibilities divided in the museum? Who is in charge of Israeli art and what are his/her rights and duties?

(2) How are paintings selected for the museum collection? How do you make a decision about organizing an exhibition for certain artists?

c. Criteria

(1) What is the function of the museum and how is it expressed in relation to Israeli art?

(2) What is art in your opinion?

(3) What are the qualities of a good work of art?

(4) What are the qualities of a good artist who deserves to be represented in the museum?

d. Connections

(1) How do you regard art criticism? What is the importance of art criticism for the public, to the museum?

(2) What do you think of the galleries? Which of them do you prefer? Why?

(3) How do you regard the public? In your opinion, is there any difference between the public of the galleries and the public of the museums?

(4) Do you know art collectors? Do you consult with them?

(5) Do you have personal friends among critics, curators, art collectors, artists?

C4: Questionnaire for the gallery owners

a. The form of business transactions

(1) How works of art, to be purchased or exhibited, are selected?

(2) What are the financial procedures related to exhibitions?

(3) Who determines the price? What are the prices of paintings in the given gallery?

(4) How is the list of invitations composed? Who is included in it?

b. The public

(1) What is the composition of the clientele of the gallery?

(2) What is the owner's opinion of this public, its artistic tastes, its knowledge and understanding in art?

(3) Does the public include personal acquaintances?

c. The owner's artistic taste

(1) What do you like in art? Why?

(2) What is your definition of art? What are the qualities of a good work of art? Who is the painter you like most? Why?

(3) What is your relation to the painters whose works are sold and exhibited in the gallery?

d. Background

(1) Age.

(2) When and why chose this occupation?

(3) Previous occupations, if any.

(4) For how long does the gallery exist?

(5) Were you acquainted with people related to the art world before becoming an art dealer? Who were these people?

(6) Education.

e. Connections

(1) What are the causes for the closing and opening of other galleries in your opinion? What do you think about other galleries?

(2) What is your opinion about Israeli art critics? Do you have any connections with them?

(3) What are your relations with museums?

(4) Do you visit different art institutions in Israel and abroad for the purpose of your occupation?

C5: Questionnaire for the officials of the Ministry of Education and Culture

a. Background

(1) Age, education.

(2) How did he/she enter the office? What were his/her previous occupations?

b. The office

(1) What is the function of the department or wing he/she heads? What are the responsibilities of other bodies?

(2) How is the work actually done? Who makes the decisions in the matters of culture and especially art and how? Who has the influence, the right to decide and why?

(3) What are the specific activities that compose his/her role?

c. Connections with art institutions

(1) What are his/her relations with museums, galleries, art schools, artists?

(2) What is the form and the amount of support museums receive? What are the demands from them in exchange?

(3) Is there some support of unaffiliated artists and in which form are they supported? What are the criteria of eligibility for support? Which painters were supported?

d. Criteria and judgment

(1) Does he/she and the Ministry of Education and Culture have any stylistic preferences? Which?

(2) Do his/her preferences or those of the Ministry influence museums? Should these preferences in his/her opinion have such an influence? If there are no influences why are the museums supported?

(3) What is art? What is good art?

(4) What are his/her political opinions?

C6: Questionnaire for the public

a. Form and intensity of relation to art

(1) Did he/she receive an invitation or came by himself/herself?

(2) Does he/she purchase paintings or just visit exhibitions?

(3) How often does he/she visit galleries, museums? Which galleries and museums?

(4) How often does he/she purchase paintings? Where? How much is he/she willing to spend?

(5) Does he/she exchange paintings with others?

(6) Which paintings (by whom?) he/she has at home?

(7) Does he/she visit galleries, museums in other cities and abroad?

b. Criteria and preferences

(1) Why does he/she purchase paintings and visit exhibitions?

(2) What is the kind of art he/she prefers?

(3) How did he/she make the last purchase? (Why this specific choice?)

(4) What is his/her opinion about figurative, abstract, avant-garde art?

(5) Which painters he/she knows personally?

c. Attitudes toward experts

(1) Does he/she read art criticism? What does he/she think of it? Does it influence him/her?

(2) Does he/she consult the gallery owner in which he/she usually purchases paintings?

(3) Does he/she rely on someone's opinions in matters of art?

(4) Personal connections with artists, critics, etc.

(5) Does he/she consider art as a realm of spiritual or political leadership?

d. Background
Age, education, profession, place of residence, political opinions.

Notes

Introduction

1 These are the terms used by Herbert Simon in his *Models of Man* (H. A. Simon, *Models of Man: social and rational*, New York: Wiley, 1957); "social" and "rational" are the two models of human behavior, the two fundamental categories into which all behavior may be divided.
2 All the interviewed were guaranteed absolute secrecy. Therefore, with the exceptions of few cases in which the subjects declared that they allow the use of their names, the quotations from the interviews have to be anonymous and are not supplemented with references. This footnote applies to the whole population of the subjects of this research. Concerning the questions presented before the interviewed in this specific population, see appendix C/c1.
3 For questions presented before the interviewed belonging to these populations see appendix C/c2, c3, and c4.
4 For questions presented before the interviewed see appendix C/c5, c6.
5 The first edition of this article was published in 1951.
6 Most voluminous and interesting material was gathered in the interviews with G. Talpir, the editor of *Gazit* and his wife and in the interview with the widow of the painter I. Paldi. These people followed Israeli painting from its earliest years.

1 Historical background

1 D. Levite, "The twenties – Exotics of Dunes and Camels," in B. Tammuz, ed., *The Story of Israeli Art from the Days of "Bezalel" in 1906 until Our Time* (Tel-Aviv: Masada, 1980), p. 38.
2 Quoted in ibid., pp. 38–39.
3 Ibid., p. 39.
4 Ibid.
5 Ibid., p. 50.
6 Ibid.
7 Ibid., p. 47.
8 Quoted in ibid., p. 53.
9 Ibid., p. 58.
10 Ibid., p. 60.
11 G. Yanay, *Gazit* (12–13), 1932.
12 Levite, "The thirties – the French Influence," in B. Tammuz, op. cit. pp. 69–72.

197

13 G. Efrat, "The thirties – the German influence" in Tammuz, ed., *The Story of Israeli Art*, p. 86.

14 Ibid., p. 87.

15 "The voice of the young Hebrew center," *Alef*, November 1951.

16 D. Levite, "1948–1964 – 'New Horizons'," in Tammuz, ed., *The Story of Israeli Art*, p. 151.

17 Y. Zalmona, "'New Horizons' – the entrepreneurial experience,' in *Kav*, 1, June 1980, p. 79.

18 Levite, "1948–1964," p. 152.

19 Catalogue of "New Horizons" exhibition 1949, Tel-Aviv Museum, 1949.

20 Levite, "1948–1964," p. 156.

21 Ibid., p. 153.

22 Ibid.

23 Ibid., p. 155.

24 Ibid., p. 162.

25 Ibid.

26 According to the interviews with artists – members of his group and other contemporaries. Concerning the same point, see G. Blas, *New Horizons* (Tel-Aviv: Papirus, 1980).

27 It is interesting that historians characterize the artists who opposed Lyrical Abstractionism as "marginal groups" (see Efrat, "The thirties," p. 213), while the distribution of artists by style shows that they represent half the population of painters at the time.

28 Quoted in Levite, "1948–1964," p. 187. See also the catalogue of "Exhibition of paintings and sculpture of members of the group of ten," Haifa, 1957.

29 Levite, "1948–1964," p. 187.

30 Ibid., p. 188.

31 G. Efrat, "From Socialist Realism to national symbolism," in Tammuz, ed., *The Story of Israeli Art*, p. 224.

32 Ibid., p. 222.

33 Quotes from: *Haaretz*, May 6, 1955; *Yediot Ahronot*, October 23, 1954; *Maariv*, August 22, 1955; *Zemanim*, May 27, 1954; *Jerusalem Post*, May 8, 1955; and *Maariv*, April 5, 1957.

34 *Masa*, January 14, 1954.

35 *Dvar Hashavua*, December 3, 1953.

36 The article is in the file "Group Exhibitions; 1950–1955" in the Israeli Art Archives of the Israel Museum.

37 *Dvar Hashavua*, March, 1957. The article is in the file "Group Exhibitions; 1956–1959" in the Israeli Art Archives of the Israel Museum.

38 *Haaretz*, March 23, 1955.

39 Quotes from: *Herut*, April 20, 1951; *Haaretz*, December 20, 1957; *Yediot Ahronot*, April 3, 1955; and *Yediot Ahronot*, August 22, 1955.

40 *Haaretz*, September 26, 1955.

41 *Zemanim*, March 3, 1954.

42 *Haboker*, June 1, 1954.

43 Quotes from: *Haaretz*, October 25, 1957; *Haboker*, May 17, 1957; *Haboker*, September 21, 1956; and *Yediot Ahronot*, April, 1956 (this last article is in the file "Group Exhibitions; 1956–1959" in the Israeli Art Archives of the Israel Museum).

44 *Lamerchav*, July 8, 1955.

45 *Maariv*, April 13, 1956.

46 Quotes from: *Haboker*, August 10, 1956; *Haboker*, September 9, 1955; and *Haboker*, March 2, 1956.

47 Quotes from: *Masa*, February 17, 1961; *Haaretz*, September 30, 1966; and *Yediot Ahronot*, 1966 (this last article is in the file "Group Exhibitions; 1966" in the Israeli Art Archives of the Israel Museum).

48 *Yediot Ahronot*, December 1971. The article is in the file "Group Exhibitions; 1971" in the Israeli Art Archives of the Israel Museum.

49 *Davar*, April 28, 1972.

50 *Haaretz*, October 11, 1954.

51 *Davar*, September 9, 1969. This article is in the file "Group Exhibitions; 1969" in the Israeli Art Archives of the Israel Museum.

52 *Haaretz*, September 25, 1970.

53 *Yediot Ahronot*, October 9, 1972.

54 *Al Hamishmar*, July, 1975. The article is in the file "Group Exhibitions; 1975" in the Israeli Art Archives of the Israel Museum.

55 *Haaretz*, May, 1970. The article is in the file "Group Exhibitions; 1970" in the Israeli Art Archives of the Israel Museum.

56 Quotes from: *Haaretz*, 1970 (in the file "Group Exhibitions; 1970" in the Israeli Art Archives of the Israel Museum); *Yediot Ahronot*, February, 1972 (in the file "Group Exhibitions; 1972" in the Israeli Art Archives of the Israel Museum); *Haaretz*, 1973 (in the file "Group Exhibitions; 1973" in the Israeli Art Archives of the Israel Museum); *Haaretz*, 1973 (in the file "Group Exhibitions; 1973" in the Israeli Art Archives of the Israel Museum).

57 Quotes from: *Davar*, July 25, 1975. *Lamerchav*, September 25, 1970. *Maariv*, May 21, 1971. *Haaretz*, 1973 (in the file "Group Exhibitions; 1973" in the Israeli Art Archives of the Israel Museum.)

58 *Yediot Ahronot*, June 11, 1971.

59 Several years elapsed, as they were bound to, between the time of the fieldwork for this study and its final publication. "Today" refers to the time of the fieldwork: 1979–1980.

60 Quoted in Efrat, "From Socialist Realism," p. 230.

61 Ibid., p. 235.

62 Ibid., p. 236.

63 *Art News*, May 1978, p. 44.

64 Catalogue of "Tazpit – an exhibition of Israeli painting and sculpture," Tel-Aviv, Tel-Aviv Museum, April–May 1964.

65 Quotes from Levite, "The sixties – foreign influences increase: '10+'," in Tammuz, ed., *The Story of Israeli Art*, pp. 248–250.

66 Quotes from ibid., pp. 247, 250, 251.

67 Catalogue of "'10+' – ten artists present exhibitions on different subjects in different techniques," Tel-Aviv, Alharizi Artists' House, February 1966.
68 Levite, "The sixties," p. 257.
69 Efrat, "The 'New Jerusalem' school," in Tammuz, ed., *The Story of Israeli Art*, pp. 278–279.
70 Quotes from ibid., pp. 280, 281, 288.
71 Ibid., p. 290.
72 Ibid., p. 292.
73 Ibid., p. 304.
74 Quotes from ibid., pp. 310, 312.
75 Catalogue of "Aklim 1974," Haifa, Museum of Contemporary Art, June–July, 1974.
76 Quotes from Efrat, "The 'New Jerusalem' school," p. 300.
77 Catalogue of "Leviathan Group" exhibition, Artists' House, Jerusalem, summer 1979. Artists' House, Jerusalem, summer 1979.
78 Efrat, "From Socialist Realism," p. 239.
79 I shall elaborate on this matter in the chapters on critics and curators.

2 The population of painters and the split into subsystems

1 Quotes from: H. Arnason, *History of Modern Art* (New York: Harry H. Abrams, Inc., 1977), pp. 189, 581.
2 Ibid., p. 703.
3 The N in the following tables relates to the total of valid cases only; it does not include missing values.
4 Concerning these other characteristics see appendix B/a: Description of the population.

3 Patterns of success

1 Naive painting was a very fashionable and commercially successful style in the 1970s. Naive painters are not professional painters and therefore, in most cases, they do not try to promote themselves. They are discovered by gallery owners who recognize the commercial value of their paintings, and this explains the high percentage of Naive artists who exhibit in the galleries of type 1 among the generation of the 1970s.
2 Concerning patterns of exhibition in other types of galleries, see appendix B/b: Patterns of success, tables 9–11.
3 For complete data on patterns of exhibition abroad, see appendix B/b: Patterns of success, table 18.
4 The concepts of "sponsored" and "contest" mobility were coined by Turner, in "Sponsored and content mobility and the school system," in *American Sociological Review*, no. 25: 855–867.

5 For complete data on sources of income, see appendix B/b: Patterns of success, table 17.
6 Concerning painters of the Land of Israel style and the French Expressionism who represent the classicists of the Free Figurative style-group, see chapter 1.
7 Concerning "New Horizons," see chapter 1.

4 The "gatekeepers" – critics

1 As distinct from the survey of newspapers in chapter 1, which deals with the actual behavior of the critics, this chapter discusses the explanations and justifications that critics give to their behavior and their perception of the "critic's role."
2 There is one critic in the group of "new critics" whose attitudes are different from the attitudes of his colleagues. In his opinion, works of art should answer professional requirements. Those which do not "do not belong to the discipline," and therefore are not the subject matter of art criticism. This critic got his position in a literary supplement the editor of which shared his opinions and wanted him to be a counterweight to a Conceptualist critic who wrote for the same newspaper. In the interviews conducted in the system connected to Conceptualist artists, this critic either was not mentioned at all or, when explicitly asked about, aroused very negative reactions.
3 G. Efrat, *The Definition of Art* (Tel-Aviv: Hakibutz Hameuhad, 1975).
4 Quotes from ibid., pp. 115–116.
5 Ibid., pp. 117–118.
6 Ibid., pp. 118–119.
7 Quotes from ibid., pp. 119–120.
8 See G. Battcock, *The New Art: A Critical Anthology*, *Minimal Art: A Critical Anthology*, and *Idea Art: A Critical Anthology* (New York: Dutton, 1966, 1968, and 1973); S. Gablik, *Has Modernism Failed?* (New York: Thames and Hudson, 1984); L. R. Lippard, *Changing: Essays in Art Criticism* (New York: Dutton, 1971); A. Olson, *Art Critics and the Avant-garde, New York, 1900–1913* (Ann Arbor, Michigan: University of Michigan Research Press, 1980); and P. R. Petruck, *American Art Criticism, 1910–1939* (New York: Garland Publishers, 1980).

5 The "gatekeepers" – curators

1 They never forget the failure of those who opposed innovations at the end of the past century (particularly those who opposed Impressionism). Therefore, the curators are afraid to reject an innovation which could be significant, since their success and good name in the eyes of future generations depend upon the sympathetic acceptance of such innovation.
2 This curator perceives the discovery of innovations as the only significant index of a curator's success.

3 It is important to see these things in the context of the museum's activity which unequivocally supports artists working in certain styles and boycotts "local art" which is created outside these styles.

4 See appendix B/b: Patterns of success, tables 12–15.

6 The "gatekeepers" – gallery owners

1 Concerning the overall picture of the increase in the number of the private galleries see appendix A/c.

2 Of course, not in all the galleries is it possible to find works by the same artists. Paintings by famous artists may be found only in prestigious galleries, while paintings by those artists who have only mediocre success or even less than that will be found only in the galleries which are not important.

3 This relates to the paintings by different artists, or to different kinds of paintings, such as oils versus water colors, and so on.

4 This may seem to be a rather reserved remark, but it is worthwhile to compare it with corresponding evaluations of the owners of avant-gardist galleries below.

7 The artists – attitudes of Conceptualists and Lyrical Abstractionists

1 Most of the painters who were interviewed for the purpose of this chapter are Conceptualists and only few are Lyrical Abstractionists. The interviews were divided in such a way because, as was already said, Conceptualism expresses the principles of the Abstract styles in the most clear fashion, and this is the group the advancement of which from the very beginning was connected to the world of art divided into two systems of promotions which differed in principle. Also, it was possible to interview most prominent artists among the Conceptualists, while most of such figures among the Lyrical Abstractionists had reached an advanced age which turned the task of interviewing them into a very delicate and not always efficient matter. However, although this reason should be stated together with others, it was the least important one.

2 G. Efrat, "A refugee in white," in *Haaretz*, weekly supplement, May 16, 1980, p. 27.

3 Catalogue of the exhibition of Pinchas Cohen-Gan, Tel-Aviv Museum, 1976.

4 Ibid.

5 P. Cohen-Gan in an interview to *Monitin* no. 18, February 1980, p. 19.

6 The Tel-Aviv Museum (see n. 3 above).

7 Ran Shchory in an interview to *The World of Art*, no. 13: November–December 1979, pp. 18–19.

8 The Tel-Aviv Museum (see n. 3 above).

9 P. Cohen-Gan, *Monitin* interviews, p. 119.

10 Efrat, "A refugee in white," p. 27.

11 The complete presentation of the attitudes of these painters required, as indicated of critics and curators, considerations of all the component parts including opinions shared by other painters and accepted by everybody in modern society. As indicated of critics and curators these opinions cannot be isolated,

they receive their meaning from the general context in which they are placed, namely, from that specific combination of opinions and propositions which it is our aim to describe.

12 Efrat, "A refugee in white," p. 27.
13 Ibid.
14 Cohen-Gan, *Monitin* interview, p. 119.
15 It is interesting to compare this pattern to the one among figurative painters – see next chapter – who present a totally different picture.
16 The concept of "school" is equivalent to the concept of "style-group."

8 The artists – attitudes of figurative painters

1 See E. Shils, "Ideology" in *The Intellectuals and the Powers and Other Essays* (Chicago: University of Chicago Press, 1972), pp. 23–42.
2 At the same time consideration of the Naive painters in the analysis of the patterns of success contributes to the understanding of the principles upon which the action is based in the two different systems of promotion.
3 D. Levite, "The twenties – exotics of dunes and camels," in B. Tammuz, ed., *The Story of Israeli Art from the Days of "Bezalel" in 1906 until Our Time* (Tel-Aviv: Masada, 1980), p. 33.
4 G. Efrat, "The Utopist art of Bezalel," in ibid., p. 28.
5 "Beauty" is the value which does not exist for the Conceptualists and Lyrical Abstractionists; it is totally different from the value of "Art." Art for figurative painters serves beauty; art itself is only a means or a secondary value. For Conceptualists, art serves only itself.

9 The publics

1 Concerning the questions presented before the interviewed, see appendix C/c5.
2 In the meaning that the spectators are able to reason their choices.
3 This requirement is inconsistent with the critics' view of their role, and it is doubtful whether the existing criticism can satisfy its public in this respect.
4 G. Gould and W. L. Kolb, eds., *A Dictionary of the Social Sciences* (London: Tavistock Publications, 1964), pp. 41, 558.
5 Ibid., p. 41.
6 The only problem is that a number of clinical psychologists were found in both publics. Other exceptions, those few cases in which we met a person whose education and or occupation was characteristic of the Conceptualists public, while the exhibition was figurative or vice versa, can be easily explained: these were either personal acquaintances of the artist (neighbors, school mates, etc.) or spouses of the usual representatives of the public consistent with the character of the exhibition.

7 This acquires special meaning when "good taste" is defined as love for the pure art only.

10 Conclusion

1 According to the testimony of G. Talpir, Dr. Kolb hesitated between Lyrical Abstractionism and what was called then Socialist Realism; his political inclinations were of a liberal character in which artists of both these styles shared. In the end, Dr. Kolb chose Lyrical Abstractionism as a more progressive kind of art.
2 According to the interviews with Conceptualist artists, critics, and curators, as well as foreign professional journals devoted to contemporary art, it may be concluded that the public of Conceptualist art can be a public of buyers. In the US, for example, there is a market for Conceptualist production. There are also some buyers, although not numerous, who belong to the public of this art in Israel.
3 G. Simmel, "Fashion," *American Journal of Sociology* no. 62 (1957), 541–558.

Index

Other books in the series

J. Milton Yinger, Kiyoshi Ikeda, Frank Laycock, and Stephen J. Cutler: *Middle Start: An Experiment in the Educational Enrichment of Young Adolescents*

James A. Geschwender: *Class, Race, and Worker Insurgency: The League of Revolutionary Black Workers*

Paul Ritterband: *Education, Employment, and Migration: Israel in Comparative Perspective*

John Low-Beer: *Protest and Participation: The New Working Class in Italy*

Orrin E. Klapp: *Opening and Closing: Strategies of Information Adaptation in Society*

Rita James Simon: *Continuity and Change: A Study of Two Ethnic Communities in Israel*

Marshall B. Clinard: *Cities with Little Crime: The Case of Switzerland**

Steven T. Bossert: *Tasks and Social Relationships in Classrooms: A Study of Instructional Organization and Its Consequences*

Richard E. Johnson: *Juvenile Delinquency and Its Origins: An Integrated Theoretical Approach**

David R. Heise: *Understanding Events: Affect and the Construction of Social Action*

Ida Harper Simpson: *From Student to Nurse: A Longitudinal Study of Socialization*

Stephen P. Turner: *Sociological Explanation as Translation*

Janet W. Salaff: *Working Daughters of Hong Kong: Filial Piety or Power in the Family?*

Joseph Chamie: *Religion and Fertility: Arab Christian–Muslim Differentials*

William Friedland, Amy Barton, Robert Thomas: *Manufacturing Green Gold: Capital, Labor, and Technology in the Lettuce Industry*

Richard N. Adams: *Paradoxical Harvest: Energy and Explanation in British History, 1870–1914*

Mary F. Rogers: *Sociology, Ethnomethodology, and Experience: A Phenomenological Critique*

James R. Beniger: *Trafficking in Drug Users: Professional Exchange Networks in the Control of Deviance*

Andrew J. Weigert, J. Smith Teitge, and Dennis W. Teitge: *Society and Identity: Toward a Sociological Psychology*

Jon Miller: *Pathways in the Workplace: The Effects of Race and Gender on Access to Organizational Resources*

Michael A. Faia: *Dynamic Functionalism: Strategy and Tactics*

Joyce Rothschild and J. Allen Whitt: *The Co-operative Workplace: Potentials and Dilemmas of Organizational Democracy*

Russell Thornton: *We Shall Live Again: The 1870 and 1890 Ghost Dance Movements as Demographic Revitalization*

Severyn T. Bruyn: *The Field of Social Investment*

Guy E. Swanson: *Ego Defenses and the Legitimation of Behaviour.*

Available from American Sociological Association, 1722 N Street, N.W., Washington, DC 20036.